STUDIES

Volume 9 Number 1 January 1995

FIRST PEOPLES:
CULTURES, POLICIES, POLITICS

Issue Editors:

TONY BENNETT
VALDA BLUNDELL

EDITORIAL STATEMENT

ultural Studies seeks to foster more open analytic, critical and political conversations by encouraging people to push the dialogue into fresh, uncharted territory. It is devoted to understanding the specific ways cultural practices operate in everyday life and social formations. But it is also devoted to intervening in the processes by which the existing techniques, institutions and structures of power are reproduced, resisted and transformed. Although focused in some sense on culture, we understand the term inclusively rather than exclusively. We are interested in work that explores the relations between cultural practices and everyday life, economic relations, the material world, the State, and historical forces and contexts. The journal is not committed to any single theoretical or political position; rather, we assume that questions of power organized around differences of race, class, gender, sexuality, age, ethnicity, nationality, colonial relations, etc., are all necessary to an adequate analysis of the contemporary world. We assume as well that different questions, different contexts and different institutional positions may bring with them a wide range of critical practices and theoretical frameworks.

'Cultural studies' as a fluid set of critical practices has moved rapidly into the mainstream of contemporary intellectual and academic life in a variety of political, national and intellectual contexts. Those of us working in cultural studies find ourselves caught between the need to define and defend its specificity and the desire to resist closure of the ongoing history of cultural studies by any such act of definition. We would like to suggest that cultural studies is most vital politically and intellectually when it refuses to construct itself as a fixed or unified theoretical position that can move freely across historical and political contexts. Cultural studies is in fact constantly reconstructing itself in the light of changing historical projects and intellectual resources. It is propelled less by a theoretical agenda than by its desire to construct possibilities, both immediate and imaginary, out of historical circumstances; it seeks to give a better understanding of where we are so that we can create new historical contexts and formations which are based on more just principles of freedom, equality, and the distribution of wealth and power. But it is, at the same time, committed to the importance of the 'detour through theory' as the crucial moment of critical intellectual work. Moreover, cultural studies is always interdisciplinary; it does not seek to explain everything from a cultural point of view or to reduce reality to culture. Rather it attempts to explore the specific effects of cultural practices using whatever resources are intellectually and politically available and/or necessary. This is, of course, always partly determined by the form and place

of its institutionalization. To this end, cultural studies is committed to the radically contextual, historically specific character not only of cultural practices but also of the production of knowledge within cultural studies itself. It assumes that history, including the history of critical thought, is never guaranteed in advance, that the relations and possibilities of social life and power are never necessarily stitched into place, once and for all. Recognizing that 'people make history in conditions not of their own making', it seeks to identify and examine those moments when people are manipulated and deceived as well as those moments when they are active, struggling and even resisting. In that sense cultural studies is committed to the popular as a cultural terrain and a political force.

Cultural Studies will publish essays covering a wide range of topics and styles. We hope to encourage significant intellectual and political experimentation, intervention and dialogue. At least half the issues will focus on special topics, often not traditionally associated with cultural studies. Occasionally, we will make space to present a body of work representing a specific national, ethnic or social tradition. Whenever possible, we intend to represent the truly international nature of contemporary work, without ignoring the significant differences that are the result of speaking from and to specific contexts. We invite articles, reviews, critiques, photographs and other forms of 'artistic' production, and suggestions for special issues. And we invite readers to comment on the strengths and weaknesses, not only of the project and progress of cultural studies, but of the project and progress of *Cultural Studies* as well.

Larry Grossberg
Janice Radway

* * *

Contributions should be sent to Professor Lawrence Grossberg, Department of Communication Studies, University of North Carolina, CB#3285, 115 Bingham Hall, Chapel Hill, North Carolina, 27599–3285, USA. They should be in triplicate and should conform to the reference system set out in the Notes for Contributors, available from the Editors or Publishers. Submissions undergo blind peer review. The author's name should not appear anywhere in the manuscript except on a detachable cover page along with an address and the title of the piece. Reviews, and books for review, should be sent to Tim O'Sullivan, School of Arts, de Montfort University, The Gateway, Leicester LE1 9BH, UK; or to John Frow, Dept. of English, University of Queensland, St. Lucia, Queensland 4072, Australia; or to Jennifer Daryl Slack, Dept. of Humanities, Michigan Technological University, Houghton, MI 49931, USA.

CONTENTS

· INTRODUCTION ·

TONY BENNETT AND
VALDA BLUNDELL

FIRST PEOPLES

The essays collected here derive from the conference 'Postcolonial Formations: Nations, Culture, Policy' that was held at Griffith University, Brisbane, in July 1993.[1] Hosted by the Institute for Cultural Policy Studies, the conference was organized by an international committee with Australian, Canadian, and New Zealand representatives and brought together a rich mix of critical scholars, cultural producers, and policy workers from each of these countries.[2] The purpose of the conference was to provide a forum for debate regarding the respects in which the forms of cultural politics and policies discernible in these (as they are customarily but now contentiously known) 'white settler societies' exhibit similar characteristics as they move into the postcolonial phases of their formation.

We say 'move into' as it was clear that few participants were interested to press the claim that any of these societies could claim postcoloniality as an achieved status. Yet there was always a double aspect to this argument. If Australia, Canada, and New Zealand are best described as being still in the process of decolonizing so far as their relations to Europe and, especially, Britain are concerned; if the development of economic, political and cultural forms and relations that will end their tutelage to overseas metropolitan powers are still in the process of being organized; then so also are they properly viewed as societies in which the forms and practices of colonialism survive internally, embedded in the systems and structures which regulate the relations between their initial 'settler' and subsequent migrant populations and their First Peoples. This thesis of 'internal colonialism' – a thesis developed in the context of First Peoples' struggles – thus attributes an

inherent double dimension to colonial relations in societies like Australia, Canada, and New Zealand, and thereby also demands that there be a double dimension to contemporary processes of decolonization. It is not enough to modify political and constitutional relations so as to create fully independent national polities and, within these, to fashion new symbolic forms of allegiance and identity that will recruit the support of their increasingly polyglot and multicultural citizenries. From a First Peoples' perspective, the structures of colonialism will remain substantially intact if the institutionalized forms of racism, oppression and discrimination, which, as the solidified legacies of the colonial era, continue to bear uniquely on indigenous populations, are not also dismantled.

There is, then, a doubly complex set of relations to be negotiated by decolonizing strategies within such societies. And it is this complexity which halts in their tracks those conceptions according to which, culturally, the process of decolonization is seen as depending on the organization of a national imaginary which, in being detached from earlier forms of cultural dependency on a metropolitan power, can help chart an autonomous symbolic course for the nation. Challenges to such views of the nation, of course, are not unique to 'white settler societies'. Multicultural debates in Britain and the United States, for example, have equally served such understandings of the nation with their historical eviction notices in the emphasis they place on the relations of diasporic culture and identity whose articulations with and within the cultural field of the nation are complex and varied. In Australia, Canada, and New Zealand, by contrast, the impact of debates regarding diasporic structures and processes has been more muted. This is partly because these societies have been considerably less affected by the diasporic dispersion of black peoples throughout the colonial era than has been true of either Britain or the United States. However, it is also because the more telling and pointed challenge to unified constructions of the nation has come not from the diasporic relations and identities which both exceed and criss-cross the nation's symbolic ambit but rather from relations of 'indigeneity' which, reflecting a territorial groundedness rather than diasporic dispersion, both precede and stubbornly refuse engulfment in a singular nationalized imaginary. And it is for these reasons that First Peoples' cultural struggles in these societies have resisted assimilation within the identity politics of multiculturalism: partly because the issues at stake in the politics of culture and identity are different in kind where relations of 'indigeneity' are concerned from those which characterize the multicultural pluralizing of diverse diasporic relations and identities; and partly because, for First Peoples, questions of culture and identity are always inextricably caught up with questions of self-determination and with questions of land.

Once such generalizations are made, however, they immediately need to be qualified. For, while their histories may share important similarities, there are equally important differences between both the past formation and present structures of Australia, Canada and New Zealand. In the New Zealand context, where the 'settler' population is relatively homogeneous and predominantly Anglo, the language of multiculturalism has no effective

currency. Instead, as Jeffrey Sissons shows in his discussion of the relations between biculturalism, bureaucracy and tribalism, it is the organization of bicultural relations between Maori and Pakeha that occupies centre-stage in both critical debates and policy processes bearing on the formation of a postcolonial society appropriate to New Zealand circumstances. In Canada, by contrast, the claims of Québec to an independent cultural and constitutional status give rise to a peculiarly complex set of relations whose unfolding will have significant consequences for Canada's First Nations and the constitutional contexts in which they will be able to pursue their claims.

Similarly, there are significant differences in the histories of the relations between the occupying and indigenous populations of these three societies. The patterns of their forcible occupation were different as were those of the resistances offered by the indigenous populations. The legal and substantive forms of the relations between the occupying colonists and the indigenous inhabitants were different, too. The most telling difference, over the long term, has been the doctrine of *terra nullius* – depriving Australia's First Peoples of any legal title to land and so also eliminating the need for entering into a treaty with them – which prevailed in the Australian context until the recent historic Mabo judgement.

When all these qualifications are made, however, there remain sufficient similarities to the patterns of First Peoples' cultural politics and policies in these countries to justify a number of further generalizations. In all three, for example, claims to significant degrees of cultural autonomy have formed an important component of First Peoples' struggles against the continuing effects of internal colonialism. Calls for an end to policies and practices that work against First Peoples' efforts to sustain their parent cultural traditions, while also transforming these in ways that reflect their own strategies and goals for articulating with the national culture, have thus been widespread and persistent in all three contexts. Allied to these calls have been equally insistent demands for the establishment of viable economic bases and local political structures of self-governance viewed as essential both in their own right and as a necessary precondition for a continuing tradition of autonomous cultural expression and development. The importance placed on the development of programmes for the maintenance of First Peoples' languages and on the need for First Peoples to have control over their own education are merely the most visible manifestations of this orientation.

The close association of these demands for cultural autonomy with land-rights movements has also marked them as distinctive. Again, the conditions of these struggles have often been different. In Canada, First Peoples claim an inherent right to self-determination, one that can neither be given nor taken away by Canadian laws, the court or a constitutional amendment. In New Zealand, recent struggles have focused on the need to fully implement the provisions of the Treaty of Waitangi whereas, as we have already indicated, overthrowing the doctrine of *terra nullius* has been the primary political objective within the Australian context. The similarities, however, are equally significant, for these efforts to settle land claims are intrinsically linked to the political aspiration to retain a capacity for

autonomous cultural development through their connection to both policies for economic autonomy and, through the revival of traditional tribal political structures, a degree of political autonomy.

These questions of land ownership have also been inextricably caught up with questions of cultural ownership. The most obvious and public issues here have concerned the custodianship of those First Peoples' cultural artefacts and remains held in museums and the demand that these be returned to First Peoples' custody. It is, moreoever, in the context of these demands that the relations between internal and external colonialism have been most readily discernible. For they are demands that have spilled beyond the framework of the nation to be pressed also in relation to those museums in the metropolitan centres of Europe and America where, under the relationships of exchange which governed colonial science, so much of this cultural property ended its colonial journeyings. However, the development and pursuit of these claims to cultural ownership has not just been a political matter. It has also entailed a critique and revaluation of both Western and First Peoples' knowledges, and of the relations between them. The political demands for the restitution of plundered cultural resources has thus been accompanied by far-reaching critiques of the disciplines of anthropology and archaeology while, at the same time, indigenous knowledges – theories of the sacred and of time, for example – have been positively revalued.

These critiques have formed part of a more general concern to detach the signifiers of aboriginality from their appropriative use in Western cultural practices and thus enhance their value to and for First Peoples. The use of aboriginal motifs within official state discourse to construct inclusive imageries of national identity, or to anchor these fledgling nations into the deep time of an indigenous past, have been compellingly and widely criticized. Challenges to touristic uses of First Peoples' cultures as part of a global trend to commodify so-called 'exotic' cultures for international pleasure-travellers have also been pressed with increasing vigour, especially as, more often than not, such touristic uses occur without consultation with, or much benefit (culturally or economically) to, First Peoples themselves. It is, then, not surprising that so many of the most important political protests of First Peoples should have been waged at cultural sites or in the context of celebratory cultural events. The protest embodied in the exhibition 'The Spirit Sings', staged in the context of the 1988 Calgary Olympics as part of the efforts of one First Nation to settle a land claim is a case in point. So, too, was the nationally co-ordinated march of protest through Sydney on 26 January (Australia Day) 1988 against the choice of 1988 – as the mark of 200 years of invasion – as a date of national celebration.

However, perhaps the most distinctive aspect of the contemporary configurations of First Peoples' cultural politics is the unique blend of the emphasis that is placed on both tradition and innovation. Gail Valaskakis, arguing that, for First Peoples, 'resistance is cultural persistence', goes on to say that the traditionalism to which this gives rise is 'continually negotiated in the discourse and practice of everyday life' (Valaskakis, 1993: 00). This nicely encapsulates the means through which the dual options envisaged by

European discourses – First Peoples must either remain as they were in the past or assimilate into the 'mainstream' European way of life – are being countered by the pursuit of a third strategy in which traditional forms of cultural expression are developed into distinctive contemporary indigenous cultures with their own creative roots and dynamics.

These, then, are among the issues explored in the essays collected here. The 'innovative traditionalism' of First Peoples' cultural practices and struggles is reflected on by a number of contributors. Stephanie Gilbert, an Aboriginal activist and researcher, outlines the respects in which, in Australia, First Peoples' struggles against discriminatory and oppressive colonial practices have both drawn strength from traditional cultural resources while also being inherently dynamic in their constant adjustment to changing contexts. Ann Sullivan and Jeffrey Sissons look in closer detail at similar processes in their complementary examinations of the revival of tribal structures and practices in contemporary New Zealand. Sullivan takes a long view, considering the effects of the early phases of colonization and subsequent economic policies in dismantling Maori tribal structures. She then outlines the circumstances which have prompted a revival of tribalism as a key component of strategies of indigenous cultural development in which economic, political and cultural considerations are integrally inter-connected. Jeffrey Sissons, in taking this conjunction of the revival of tribalism and the Maori cultural renaissance as his starting point, considers the delicate balancing act required to manage the relations between the informal, participatory-democratic organization of the 'life-worlds' of tribal communities and the formal, bureaucratic structures of the state if the latter are not to colonize the former and mould them in the state's own image. A similar concern with the relations between revived indigenous political systems and those of modern bureaucratic states informs James McDonald's discussion of the renewal of the practice of potlatching among the Tsimshian First Nation. The potlatch, McDonald suggests, is a hybrid institution, simultaneously cultural and political in its functioning, an innovative revival of traditional practices which serves to provide both a forum for amplifying aboriginal cultural values and a political mechanism for rearticulating the relationships of First Peoples to 'mainstream' Canada.

The need for a strategic blend of tradition and innovation also informs Rangihiroa Panoho's discussion of the relations between Maori and Western art. The question which Panoho, himself a practicing Maori artist, insistently and urgently poses, however, is: innovation on whose terms? The use of Maori motifs in commodified art produced for tourist consumption and the citation of such motifs in the high-art practices of modernism: these, Panoho argues, have much the same consequence for Maori artists in that both sap those motifs of their vitality to and for Maori culture, compromis-ing the resources that can be drawn on to nourish its continuing and creative development. Panoho's argument here is not for a lack of traffic between Western and Maori art; rather, his point concerns the need for such interactions to be much more sensitive to context if the result is not simply to be appropriative forms of 'visual colonialism'.

That such matters concern not merely the ethics of artistic practice but have, as Panoho argues, an institutional dimension is made clear in the contributions of Leonard Bell and Charlotte Townsend-Gault. Both of these, although from different perspectives, illuminate aspects of the highly problematic – and highly charged – relations of signification that are produced when art practices relating to First Peoples surface in the space of the art gallery. Bell's concern is with the changing currency of Charles Frederick Goldie's portraits of Maori figures. Pointing to the value and prestige which these have acquired within both Maori culture and the institutions of art history, Bell shows how the latter prevailed over the former in the exhibition New Zealand's National Art Gallery organized in 1990 to celebrate its acquisition of two Goldie paintings. Purportedly dedicated to the values of biculturalism, the lack of sensitivity which the exhibition displayed to the multiple significations of the Goldie images served only to contribute to their reinscription within the colonizing gaze of Western art.

If Bell's concerns focus on the chequered history of a Western artist's depiction of First Peoples, Charlotte Townsend-Gault's focus on the tensely productive relations that can be produced when First Peoples' art is exhibited in art galleries. Examining the 'Land, Spirit, Power' exhibition – a collection of First Nations art first exhibited at Canada's National Gallery in Ottawa in 1992 and which has subsequently toured nationally – Townsend-Gault, one of the curators of the exhibition, looks at the contradictory forms of reaction and response the exhibition elicited from the differentiated audiences it reached: members of the First Nations and non-native peoples. Gerald McMaster's concerns are complementary in considering the institutions of Western art from the point of the view of the varied stances and positions that native artists can adopt and deploy in relation to those institutions. In considering some of the tactics which have informed his own work as a practicing Cree artist as well as the work of Jimmie Durham, McMaster draws on the arguments of Michel de Certeau in advancing a view of the native artist as a trickster, operating in the border zones between cultures with as much 'injun-uity' as possible to exploit the creative and political tensions to which those zones give rise.

Simon During's concern is also with border zones, although of a different kind, in his consideration of the mobile interface between traditional Koorie narratives of the Dreamtime and Western fiction as represented by William Ferguson's Nanya. As 'the first piece of Aboriginal literary prose in print which is not a transcription of a traditional narrative', During argues, Nanya is a useful text for reflecting on the emergence of modern forms of aboriginal fictionality. In examining the specific fusion of sacred Koorie narrative motifs with Western narrative forms in Nanya, During suggests that, viewed in the context of the 1930s, when it was written, the story embodies a mixing of cultures which, while acceding to an assimilationist logic by enacting it in the very structure of its narrative organization, can also be read as an important statement of the need for a new, adaptive politics of cultural survival. Questions concerning how, where and by whom the sacred gets

spoken also preoccupy Ken Gelder and Jane Jacobs. Their interest is in the disjunctions that occur through the processes through which the Aboriginal sacred, 'much of which may well be unspeakable or secret . . . is negotiated outside of itself in the public domain'. What happens, they ask, when publicity and secrecy intersect? – a question they consider chiefly in relation to the very considerable political implications that will hinge on how these matters are negotiated in the jurisdiction of post-Mabo land claims.

The 'innovative traditionalism' of First Peoples has, of course, always faced two ways. If, as in *Nanya*, Western cultural resources have been drawn on to lend new forms of social mobility and adaptability to traditional indigenous forms, the use of traditional cultural resources to produce distinctive transformations of Western cultural forms and traditions has been equally important. The significance of such exchanges is clearly evident in the history of First Peoples' relations to modern media. These issues are central to Elaine Keillor's concerns in the thumbnail sketch she offers of the history of musical hybridization arising out of the meetings of First Peoples' and Western musics in the Canadian context. This provides a background for her consideration of the practices of contemporary native musicians such as Buffy Sainte-Marie, Robbie Robertson, Kashtin and Seventh Fire. In drawing on mainstream popular-music models, but reinterpreting these in accordance with traditional roots, Keillor suggests that these artists are contributing to the development of postcolonial musics. Helen Molnar's review of the present forms of government support for the development of indigenous media in Australia is motivated by similar concerns: the need for policies that as a matter of mainstream rather than marginal national media policy can support adequate structures for the expression and creative development of indigenous cultures in contexts and forms suited to the advanced technological sytems of the late twentieth century.

In the questions that they raise, in the distinctive configurations of the relations of culture, politics and policies to which they attest, the essays collected here suggest a number of ways in which a closer attention to First Peoples issues might prove, beyond their intrinsic importance, to be of more general relevance to cultural studies. Not the least of these would be the case they suggest for disconnecting questions of resistance from the generalized emancipatory rhetorics of liberationist politics. The perspective that, for First Peoples, resistance has taken the form of cultural persistence – of the endurance, against all odds, of distinctive systems of belief and forms of conduct – reveals the inadequacy of those approaches which theorize resistance solely in the form of a flirtatious game of 'textual poaching' in the space of 'the Other'. For it is clear that such persistence has entailed a continuing adherence to forms of social and cultural regulation deriving from indigenous traditions. What has been, and remains, at issue in such resistances is not an abstract dialectic of emancipation versus regulation but, precisely, which forms of social and cultural regulation are to prevail.

Similarly, although a number of the essays collected here would caution against being starry-eyed regarding the role which government policies have played, and continue to play, in relation to First Peoples' struggles, and while

there can be no doubting the importance of both traditional and newly emerging forms of self-organization among First Peoples, it remains true that, for the foreseeable future, securing adequate conditions for the maintenance and development of relatively autonomous indigenous political and cultural institutions and practices will depend on the kinds of 'contracts' that are struck with and within the mainstream systems of government. Indeed, Adrian Tanner's work suggests that negotiations of this kind occupy a unique place within the structures and processes of indigenous peoples' politics (Tanner, 1983). Since First Peoples' political claims rest on and are related to the further development of a special status and are therefore difficult to pursue through the regular mechanisms of party politics, Tanner argues, the links between indigenous political leaders and government bureaucracies are crucial to the political formations and operational modes of First Peoples. Although Tanner's arguments are developed with specific reference to Canada, the observation, made by a number of commentators, that in societies like Australia and New Zealand the field of operations for the 'organic intellectuals' of First Peoples is comprised by the interstices between their communities and the structures of government, suggests that the point has more general validity. There are, of course, still a few visionary cultural theorists whose world-historical gaze is too vast and sweeping to countenance such truck with the mundane realities of presently existing policy agendas. However, it is clear from the kinds of issues raised by Jeffrey Sissons, James McDonald and Helen Molnar that, far from nourishing such grand gestures of renunciation, the here-and-now practicalities of First Peoples' struggles require an organized and focused engagement with the bureaucratic mechanisms of government.

But if these are lessons for cultural studies, what has cultural studies to offer that will prove useful in relation to the distinctive aspects of First Peoples' cultural and political concerns? The question is not one that we shall address in detail here as our primary purpose in editing this collection has been to help put that question on the agenda rather than to answer it. We might, though, suggest a couple of pointers.

The first is that the cultural forms and relations of 'indigeneity' be accorded more attention. We have alluded to some of the issues that might be at stake here in our brief comments regarding the respects in which such forms and relations might usefully be considered in relation to, but as distinct from, those of diasporic structures and processes. The reasons why such issues have not been accorded much significance within the history of cultural studies to date are clear enough. However, as the internationalization of cultural studies proceeds apace, those reasons – which have essentially to do with cultural studies' metropolitan origins – ought to prove of diminishing relevance. To be clear, though, this is not a plea for more attention to be paid to the ex-Dominion outposts of Empire as these move, now, into their own postcolonial trajectories. Any adequate theorization of 'indigeneity' requires that First Peoples issues in such societies be placed in a broader and different comparative setting. It is estimated that over 300 million people, spread across all five continents, can be counted as

indigenous. The relations of culture and power in which such peoples are caught, and in relation to which their political and cultural objectives are defined, surely merit some 'mainstream' attention within cultural studies.

In the pursuit of such work, to come to our second point, the development of closer links between the projects of cultural studies and those of the reforming currents within anthropology and archaeology could well prove useful. The historical role that these disciplines have played in the colonial administration of First Peoples is well-enough known. And these remain highly contested knowledges, primary targets for First Peoples' critique. Yet, partly because of such critiques and partly because of the critical tendencies which have developed within anthropology and to a lesser extent archaeology, these are now among the major intellectual formations in which Western and First Peoples' knowledge are engaged in a taut but productive interchange. The capacity of perspectives derived from cultural studies to contribute to such an interchange is clear from some of the Foucaultian arguments now being applied in analysing the intrication of the relations between First Peoples and Western knowledges in the contexts of specific forms of power (see, for example, Attwood and Arnold, 1992, and Rowse, 1993). However, where this has proved useful, it has been because such arguments have taken their bearings from the present state of debates within these areas rather than aspiring to parachute cultural studies into them as an interdisciplinary solvent for all issues.

It may well be, too, that the development of such closer links will help cultural studies to develop a more cautious and critical account of its own history. The use of ethnographic methods within cultural studies has, of course, always been an area in which anthropology and cultural studies have intersected and criticisms of traditional ethnographic techniques of inquiry are now influential within both areas of work. That such criticisms can be brought to bear against some of the 'founding texts' of cultural studies has also been made clear by George Marcus's probing discussion of Paul Willis' work (Marcus, 1986). The effects of shared legacies, however, may go deeper than the level of investigative techniques. For the concept of culture as a whole way of life which has proved so crucial in the development of cultural studies was, Williams tells us, 'decisively introduced into English' (Williams, 1976: 80) by Edward B. Tylor in his *Primitive Culture* (1871), one of the founding texts of evolutionary cultural anthropology. Usually understood as opposed to and distinct from the restricted definition of culture associated with Matthew Arnold's understanding of culture as 'the best that has been thought and known', George Stocking's critical excavations in the history of anthropology suggest that, to the contrary, Tylor 'simply took the contemporary humanist idea of culture and fitted it into the framework of progressive social evolutionism' (Stocking, 1968: 87). How far this has affected the subsequent usage of the term and its deployment in cultural studies is a moot point, but one certainly worth examining.

Notes

1 A second collection of papers deriving from the conference has also been published as a special issue of *Culture and Policy* 6. This is available from the Institute for Cultural Policy Studies.
2 The conference was jointly sponsored by the Centre for Research on Culture and Society, Carleton University; the Department of Communication Studies, Concordia University; the Département de sociologie, Université de Montréal; the Institute for Cultural Policy Studies, Griffith University; and the Office of Arts and Cultural Development, the Department of Justice and Attorney General, Queensland State Government. The organizing committee comprised the following: Australia – Tony Bennett, Georgina Murray, Gillian Whitlock (Griffith University), Graeme Turner (University of Queensland); Canada – Martin Allor, Jody Berland, Gail Valaskakis (Concordia University), Valda Blundell, John Shepherd, Will Straw (Carleton University), Daniele Juteau and Elspeth Probyn (Université de Montréal); New Zealand – Avril Bell, Claudia Bell, Charles Crothers, Roger Horrocks, Nick Perry (University of Auckland), Graham Bassett (Massey University).

References

Attwood, Brian and Arnold, John (1992) editors, *Power, Knowledge and Aborigines*, Issue 35, *Journal of Australian Studies*, Melbourne: La Trobe University in association with the National Centre for Australian Studies, Monash University.

Marcus, George E. (1986) 'Contemporary problems of ethnography in the modern world system' in Clifford J. and Marcus, G. E. (1986) editors, *Writing Culture: The Poetics and Politics of Ethnography*, Berkeley: University of California Press.

Rowse, Tim (1993) *After Mabo: Interpreting Indigenous Traditions*, Melbourne: Melbourne University Press.

Stocking, George (1968) *Race, Culture and Evolution: Essays in the History of Anthropology*, New York: Free Press.

Tanner, Adrian (1983) editor, *The Politics of Indianness: Case Studies in Native Ethno-politics in Canada*, St John's, Newfoundland: Institute of Social and Economic Research, Queen's College, Memorial University.

Valaskasis, Gail (1993) 'Parallel voices: Indians and others.' Guest editor's introduction to *Canadian Journal of Communication* 18, pp. 283–98.

Tylor, Edward B. (1871) *Primitive Culture: Researches into the Development of Mythology, Philosophy, Religion, Language, Art and Custom*, 2 vols, London.

Williams, Raymond (1976) *Keywords*, London: Fontana.

RANGIHIROA PANOHO

THE *HARAKEKE* – NO PLACE FOR THE BELLBIRD TO SING: WESTERN COLONIZATION OF MAORI ART IN AOTEAROA

When Cyclone Bola hit I travelled down to the East Coast. Past Opotiki the willow trees were a great mess and the *harakeke*[1] were buried under the silt. The trees would never resuscitate but when I went back a fortnight later the *rito* were all standing up out of the silt. I haven't had that much contact with indigenous people (only those of North America, Canada and Hawaii), but it seems to me that those people have not fared as well with their culture, that they have lost a lot more than us. I think that is because we have learnt to be flexible. To survive under the mud and to bide our time and reemerge. The strongest thing that really meant was that we have retained life in our culture like the roots of the *harakeke*. It's like the *wairua*. Anybody who tries to separate the roots of a well-established *harakeke* plant has got a hard job ahead of them.

(Toi Maihi, Maori weaver[2])

Harakeke, a metaphor for cultural sustainability

In the above passage the artist Toi Maihi acknowledges both the harsh effects of colonialism on First Nation cultures and the resilience of societies like the Maori to cope with this weathering process. However, while areas such as those described on the east coast have recovered from Cyclone Bola and natural droughts, how well have Maori dealt with the ongoing effects of colonialism? The *harakeke* is used by Maori as a metaphor to describe the condition of the culture. In Maori *whaikorero* (oratory), the flax plant is compared to the productive nature of society and in some tribal groups – the Arawa tribal region of central North Island, for example – the *mate* (the deceased) is actually

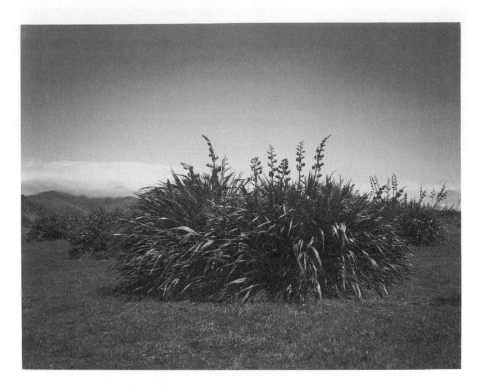

Figure 1. *Pa harakeke*, Kauetangohia marae, Cape Runaway, East Cape, New Zealand. Photo courtesy of Haru Sameshima.

referred to as the *papa harakeke* (the *tupapaku* – body – in its relationship with the earth and the flax) as an acknowledgement of the way the person has contributed to the growth of the family, and as a reference to both the natural life cycle of the deceased and to the plant's prolific growth.[3]

However, I would like to reapply the metaphor in a deeper way and use its different components to illustrate the ways in which Maori have been systematically dismantled in the economic, social, religious and political spheres of their culture. While these tangible parts of the culture have been affected, the deeper parts remain, although, as will be seen, they too are threatened. Maihi affirms the natural hardiness of a well-established *harakeke* with its tightly intermeshed root system. Despite the durable properties of the plant, there are more fragile parts of the flax which require protection and cannot be mishandled. Cutting the core of the *harakeke*, for example, like cutting the heart of the culture, affects the growth and indeed the survival of the whole plant. All First Nation cultures need to undergo a process of healing and rejuvenation, so sustenance can be returned to the heart from which so much has been taken.

About the *harakeke*

The *harakeke* is a very special plant for weavers. The flax leaf yields *muka* (inner fibre), a material used in some of our most prestigious *taonga* (treasures; notably *kahu* – cloaks – such as *korowai*, cloaks ornamented with black rolled cards). The plant is made up of a number of outer leaves which grow in fan-shaped formations (Figure 1), and two inner leaves. The outer leaves are called *awhi rito* or *matua* ('parents') and they protect the most important component – the *rito*, or heart of the plant.

The *pa harakeke* (flax stand) is carefully nurtured by Maori in the following ways:

– only a selection of outer leaves are cut so that the plant is not left exposed to the effects of weather;
– leaf trimmings are always returned to the *pa harakeke* to provide sustenance for its growth;
– the leaves are picked only when weather conditions are right;
– the leaves are cut at a certain angle so that rain water will run off;
– and, most importantly, the *rito* and *awhi rito* are never cut as this would cause the whole plant to die.

The outer and inner leaves rely on one another; the outer leaves help to feed the *rito*, the source of new growth which ensures the continuing life cycle of the *harakeke*.

I will be comparing the outer leaves of the *harakeke* with the resource base of Maori culture – its sea and forest assets – and the inner core of the plant with the very heart of the culture. The *awhi rito*, to me, represents the aesthetic manifestations of the culture – our language and our oral, musical, dance and visual art traditions. They express the soul, what Maihi would call the roots, of the culture and nurture and protect its heart, the *rito*.

The condition of the *harakeke*

For Pakeha (European New Zealanders), the outer leaves were initially the most visible and desirable parts of the Maori culture. Consequently the economic resources which once supported the culture have been depleted over the last 150 years. This has significantly affected the political and economic power of *iwi* (Maori tribal units). The *harakeke* plant has been stripped and it is still being stripped. This affects the health of the whole plant. Just as the taking of too many outer leaves impedes the growth and condition of the *harakeke*, so it is with the culture. The inner and outer leaves are inextricably connected. And as Maihi has pointed out, they allude to our links with one another. In supportive conditions there is an ordered and protective intermeshing; during storms there is a messy intertwining of leaves which affects the condition of the plant and its natural growth. Colonization has affected Maori society at its core and so our relationships with one another, our resource and our *iwi* base have been deeply changed through cultural intermixture. The condition of these outer leaves, whether

removed or contorted by weather, can have an impact on the health of the inner areas and their interrelationship within the plant system. Exploitation affects the less tangible depths of the culture as well. The taking of Maori seafood resources, for example, is not simply about the depletion of a commercial asset; it is tied into the heart of the culture.

Colonialism – the *harakeke* continues to be stripped

The Pakeha photographer Fiona Clark has explored these less tangible connections between the material resources and the soul of the culture. In her 1983 Taranaki Series, she depicted a number of *kuia* (older women) with various land and seascape features of importance to local Taranaki Maori. In the cibachrome image entitled *Tuti Love*, Clark showed not only the ongoing stripping of Maori assets, but also the spiritual connection of Taranaki Maori with their *kai moana* (seafood resources). The photograph featured Tuti standing in a bed of watercress. Holding the vegetable in her left hand, she stares directly at the camera. The text beneath the image reads, 'As well as kaimoana, Taraniki people rely heavily on inland waterways for food of many kinds. Pollution of these waters damages not only this food but the kaimoana as well' (published in calendar Taraniki 1983). Although Taranaki Maori have maintained access to their *kaawa* (seafood beds), their sea gardens have been and are continuing to be poisoned by industrial and domestic pollution, notably from the Motonui Synthetic Fuels Plant and the sewerage outfall near Waitara. Clark's images are a practical demonstration of the slow poisoning of the *harakeke* plant in an ongoing process not confined to a past history.

The sea and inland river areas which Love's tribe utilizes for food continue to be decimated by pollution. However, the importance of Clark's image is not simply the way it records tangible environmental abuse but rather its reference to the intangible effects of this abuse on the spiritual side of the culture. The poisoning of the outer leaves affects the health of the heart of the plant. This threatening of *kai moana* limits the local people in their practice of deeper cultural values. It diminishes the significance of the practical and spiritual rites connected with collection, protection, and restrictions on fishing grounds and shellfish beds. It limits the hosting of *manuhiri* (guests) and the enhancement of the tribe's *mana* or prestige. This *mana* has partly depended on the ability of North Taranaki *iwi* to provide generous quantities of seafood for their once-renowned *hui* (gatherings). So that not only have these resources been stripped; many aspects of the culture have been dismantled as a direct consequence. The same processes have had far-reaching political consequences entailing lack of crown and public recognition of tribal guardianship of natural resources. Because of the poisoning of resources Taranaki Maori are being forced to break the original tribal boundary restrictions placed on resource ownership. In Ted Nia's film *Te Atiawa o runga te rangi* (1993), a Taranaki *kuia* speaks of the tight regulations which once governed the exact location and timing of the collection of seafood resources by *hapu* (sub-tribal units) earlier this century.

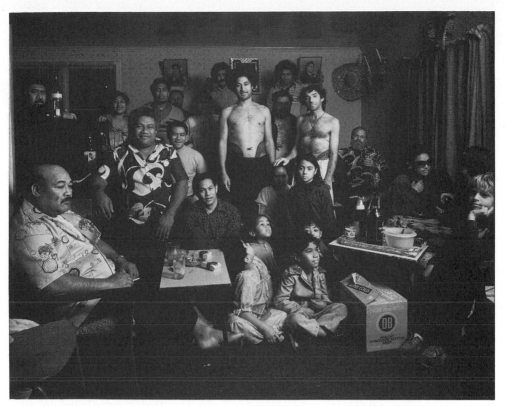

Figure 2. The *umusaga* for Fuimaono Tuiasau – the finishing ceremony of his tattoo; *photo* Mark Adams.

She voices strong disapproval against the disregard contemporary tribal groups showed for these *rohe* (ancient boundaries). The breakdown in tribal ownership, however, is probably largely due to the loss of sole ownership of resources and the pollution of traditional food sources by industry and local regional councils.

So what does remain with the *harakeke* plant? In a symbolic sense it is not much more than a small number of outer leaves, the three leaves at the centre of the *harakeke* – the *rito* –and the root system. It is the heart of Maori culture which has managed to survive the progressive dismemberment of so much of our resource base. Indeed, it is from this heart that the whole plant is currently being renewed. My concern is that while we have been fighting the loss of the outer leaves of our culture we have failed, until very recently, to pay much attention to the condition of the *awhi rito* of our society. The magnitude of the loss of our forest, land, and fisheries in Aotearoa helps explain the lesser amount of attention being given to the aesthetic manifestations of the Maori culture. However, I believe we are a holistic culture and it is against this background, where so much of the culture has been threatened, that Maori visual art forms and the whole issue of their appropriation by Pakeha in Aotearoa take on such significance. The cultural

dimensions of Maori society represent a last frontier (*rohe*). Once a space constantly intruded on, where colonial ignorance and dominance have blurred boundaries, today this is a site where cultural borders are being more critically challenged and defined by Maori.

Even our stories have been controlled

In the past much of the control over these cultural borders has been exercised by Pakeha artists both in their redefinition of Maori art forms and in their diagnosis of the culture through its representations. However, their frequently bleak or overly romantic diagnoses tell us more about the colonizers' perceptions of us than about our culture at the time. Take, for example, L. J. Steele's and C. F. Goldie's painting, *The Arrival of the Maoris* (1898–9). It is an interpretation of the landing of our *tupuna* (ancestors) in Aotearoa from Hawaiki, our ancestral homeland, painted in the epic thriller manner of Géricault's *Raft of the Medusa* (1818–19). Art historian Leonard Bell has pointed out the cultural inaccuracies in the work (Bell, 1993), but I think the important point to make here is that such paintings, like the theory of a great Maori fleet of AD 1350 proposed in 1898 by writer S. Percy Smith,[4] show Pakeha twisting Maori oral and visual traditions to support their own hypotheses. Central to these was the belief that Maori arrived accidentally at the mercy of the elements and that they displaced an earlier race, the Moriori. This displacement became a pretext for Pakeha colonization of Maori land and resources in the nineteenth century.

The Cherokee Indian artist Jimmie Durham pertinently describes similar attempts to control his tribal history in the following terms:

> The master narrative of the United States proclaims that there were no Indians here, just wilderness. Then that the Indians were savages in need of the United States, then that the Indians all died, unfortunately. Then, that the Indians still alive are:
> (a) basically happy with the situation
> (b) not the real Indians.
> Then most importantly that that is the complete story.
>
> (Durham, 1992: 55)

There is not a lot of listening going on and the master narrative is one that changes according to the designs and intentions of the narrator. The noble savage can become simply a savage when mishap occurs, as in Walter Wright's 1908 oil painting, *The Burning of the Boyd 1808*, where histories were fabricated to portray the Maori as treacherous and cruel. The painting shows a flotilla of *waka taua* (war canoes) carrying Maori warriors waving muskets and hand weapons. In the near distance the Boyd explodes in flames against a spectacular yet untypical sunset over the Whangaroa harbour. This incident, which took place a hundred years before Wright painted the work, involved the exercise of Maori law (*utu* – revenge) in retaliation for Pakeha cruelties or *hara* (serious breaches of Maori law – a sin). Thompson, the captain of the ship, had flogged and taken personal property from Te Tara, a

high-ranking young Maori working on board. On the Boyd's return from Sydney to the *rangatira*'s (chief's) tribal area, the mistreatment was reported to his people. This offence and the chief's *mana* (and that of his father) in the community demanded the taking of lives in recompense. The burning of the Boyd and many of the other incidents labelled by Pakeha as massacres in our history were, in fact, judgements executed within the legal framework of the Maori. This story, along with many others portraying Maori as savages, has only recently been more fairly reassessed (Simpson, 1993).

Against this background, then, my purpose in this paper is to outline and contribute to the growing concerns Maori have over the visual borrowing of their art forms by Pakeha. This neo-colonialism will be analysed with regard to the contentions of modernism that forms are universal and that all cultural material should be open to appropriation. From a Maori point of view, it's not the form that's being threatened but the values which underpin it – the very heart of a colonized culture. This heart and, by interconnection, all other cultural, economic and spiritual components, must be protected. Modernist practices of formal appropriation deny Maori control and power over their own cultural resources at a time when cultural regeneration is essential.

In Aotearoa the Maori have equally been disempowered by a range of other scenarios and historical formulae such as the 'dying Maori' motif promoted by Pakeha around the turn of the century. C. F. Goldie's painting, *The Widow* (1903), expresses metaphorically the supposed dying heart of the Maori culture.[5] The subject – our Nga Puhi *tupuna*, Harata Rewiri Tarapata – is an unknowing player in a drama which proclaims a culture reduced to dishevelled memorabilia. Sitting outside a rundown *whare* (traditional house), the *kuia* stares wistfully down; around her lay a broken *kete* (woven kit) and a tattered *whariki* (finely woven mat) – symbols of cultural detritus. Yes, the role of widow was a reality for her, but the implications of loss are more than simply that of her husband. Rather, she symbolizes the entire culture itself – a heavy burden for anyone to bear.

Forecasting the death of the culture has continued throughout the twentieth century. Cultural predictions can be particularly dangerous when they come from outsiders to the culture. The Dutch photographer Ans Westra immigrated to New Zealand in the 1960s. She was unaware of the complexities of Maori culture and the aspirations of its people when she produced images for the 1964 school publication, *Washday at the Pa*. In the provocative image captioned 'No good going to bed with cold feet', Westra showed Mutu, a young daughter of the Wereta family, warming her feet on a coal range. This black-and-white image provoked a powerful Maori reaction. It is culturally offensive for Maori to touch food surfaces with unclean parts of the body. You do not, for example, sit on a table used for food preparation or eating. And yet Mutu is shown with her feet on a food preparation surface. The artist's attempt to publicize the breaking of *tapu* and the weakening of *kawa* (cultural protocol) was strongly challenged by the Maori Women's Welfare League. In a recent interview Westra demonstrated a certain naivety and cultural arrogance in her belief that her images

were helping to dispel the myth that Maori traditions were a reality for young Maori in the 1960s. She:

> thought perhaps those children weren't aware of it [i.e., the kitchen surface areas] being a tapu area because customs vary from tribe to tribe. So I was aware of it and wanted to show that some of these customs were being lost, not being observed.
>
> (Leonard, 1988: 15)

The forced withdrawal of the publication from New Zealand primary schools, however, was evidence that some Maori were no longer prepared to be stereotyped by Pakeha. The cultural boundaries Westra had proposed were unacceptable. Such stereotypes take away Maori power to deal with their world in their own way because they actually affect Maori self-identity.

Cross-cultural dialogue – who is listening/who is talking?

There are many other stereotypes of course. The more recent rhetoric of biculturalism is possibly another way of looking at the cultural assimilation hinted at in some of Westra's *Washday at the Pa* images. Take, for example, the publicity on New Zealand television and in magazines during the 1990 Treaty of Waitangi celebrations: the Maori and the Pakeha child build a fire on the beach and roast *pipi* (shellfish) together. Authorized by the 1990 Commission and endorsed by the then Maori Governor General Sir Paul Reeves and the Maori Queen Dame Te Atairangikahu, the caption reads: 'So let the spirit of the Treaty move among us powerfully and bring us even closer together.' The issue at stake here is: what constitutes 'bringing us closer together'? Is the prospect envisaged merely a neo-colonialist version of earlier scenarios promoted by C. F. Goldie and L. J. Steele, where the First Nation sacrifices all for an identity devised by colonizers and endorsed by Maori leaders with a strong national profile? But whether the warm fuzziness and oneness of bicultural nationalism or the noble 'dying Maori' stereotype of social Darwinism, these cultural positions seem equally problematic in negotiating any meaningful journey across cultural terrain.

The problem in the visual arts is that the spirit of the partnership of the Treaty of Waitangi has never governed behaviour in economics, politics, or the arts. Pakeha art critic Jim Barr has argued with regard to partnership and assumed cross-cultural conversation in the arts, that:

> In most bicultural discussions it is often hard to believe that dialogue is meant to be a two way process. In the dialogue between Pakeha and Maori, one would have to say that it is way past time for Pakeha to move over from dominating the talking part of the process, and occupy the equally important and active role of listening.
>
> (Barr, 1993)

Pakeha dominance of the talking domain, then, has been at the expense of listening to the Maori voice. This lack of normal dialogue with their treaty partner has resulted in a monologue, and it is this monologue which has

facilitated the taking of the economic resources of Maori. There were other voices,[6] but the prevailing orthodox opinions have been Eurocentric. It is very easy to take from a culture from which one feels distanced and which has been pronounced dead or dying, a prognosis expressed by cultural commentators only a matter of decades ago. Writing on Maori art for the *Encyclopedia of New Zealand* in 1966, J. McEwen said, 'Their motifs have been used effectively in decorative schemes, but their original purpose and significance have vanished and with them the creative impulse' (McEwen, 1966: 83). This couldn't be further from the truth. The traditional meanings of Maori designs have been used and are still being used creatively in Maori community art forms and in work by individual Maori artists. Take, for example, the *koru* form used by Pakeha artists such as Gordon Walters. This bulb-shaped, painted design is still employed to tell stories and convey symbolism important to the identity of particular *iwi* and *hapu* in their community architecture. The *koru* forms on the *moko* (facial and body tattoo) and *hue* (carved gourd) expressed the *mana* of the person who wore or owned it.

The *koru* – a leaf in the *harakeke*

In the *whare whakairo* (carved Maori meeting-house), where Walters first began looking at the *koru*, the pattern is an integral part of interior decoration. These designs, some of which Walters used early on, have significant meanings in their cultural context. The *kowhaiwhai* (painted rafter panel) patterns which the artist studied in the late 1950s in the Ngati Kaipoho house *Te Hau ki Turanga* in Te Papa Tongarewa (Museum of New Zealand), for example, signify different food resources and therefore the deeper values discussed earlier with regard to Taranaki *kai moana*. This plucking of designs like the *koru* from their context can have an impact on the values the society seeks to retain as a whole, threatening the more fragile aspects of Maori culture.

The central concern remains that Walters's dialogue has not been with the values of a living Maori culture but rather with modernism in Europe and the United States. Walters's abstraction of the Maori *koru* motif uses tribal design to reinvigorate his own painting. The artist's statement which accompanied the 1966 exhibition of key works like *Te Whiti* confirms this interpretation: 'The forms I use have no descriptive value in themselves and are used solely to demonstrate relations (i.e. design)' (Walters, 1966).

My point here is that Walters's personal programme of hard-edge abstraction of the *koru* was at the expense of a culture. Anywhere else in the world his formalist justification would stand unquestioned, but here in New Zealand he has clearly been challenged. What is at stake here is not a spiral, not an apple tree that becomes an assemblage of horizontals and verticals as in Mondrian's series paintings. What is at stake is the symbol of a culture that deserves either to be left alone for Maori to develop or to be properly negotiated over for the betterment of Maori. There was never any fair sense

of exchange. I believe Western artists have, at the least, a moral obligation to enter into a dialogue with those First Nations which expands beyond the mere appropriation of form.

A design is a design all over the world

Formal abstractions of Maori symbols have continued in the work of Dick Frizzell and Dennis Knight-Turner. Their use of the *tiki*,[7] like Walters's use of the *koru*, is equally contentious. Though work by both artists possesses an underlying lack of dialogue,[8] their approaches are very different. Knight-Turner, like Walters, appears to have earnestly engaged in a programme of redefining an important Maori form as seen in his serial works. By contrast, Frizzell's 1992 *tiki* paintings seemed deliberately provocative and sensational but without much substance.

The universalism of design continues to be used to validate the programmes of both these artists. Knight-Turner believes 'a design is a design all over the world' (see Rayner, 1992: 1). This overlooks the fact that the *tiki*, like the *koru*, is unique to Polynesian cultures and, in particular, to the Maori. The motif is not only specific to *iwi* of Aotearoa but very special. The form was used in both carving and precious *pounamu* (nephrite) neck ornaments. Both genres possess spirituality and *mana*, in both the material used and the *tupuna* associated with the *taonga*.

Knight-Turner's overlooking of the specificity of the *tiki* seems to give him scope for constant usage of the form. 'For me,' Knight-Turner says, 'the tiki is the most important motif in my life and I will always want to use it' (Rayner, 1992: 1).

Frizzell's approach is much more aggressive. It is primarily concerned with the repudiation of any restrictions that might be put on his individual artistic freedom:

> I come along and put my hand in and grab a tiki it's 'No, you're not allowed that one – put it back – but that's horseshit. The idea that you can keep a culture alive by choking it to death is ridiculous. You can't put a patent on a culture.
>
> (Casserly, 1993)

Judging from the legal damages the Aboriginal bark painter Johnny Bulun Bulun received from Flash Screenprinters, Queensland, artists from First Nations can claim copyright over their visual heritage.[9] Frizzell's response characterizes the Western belief that controlled exchange with any aesthetic form is an inhibiting and therefore negative process. Both approaches don't really offer much scope for dialogue with Maori, although Frizzell's use of the *tiki* in the paintings *Wacky Tiki* and *Grocery Man with Moko* is nothing more than gross opportunism and marketeering of a special part of Maori culture's artistic and spiritual heritage. Of Frizzell's synthesis of the *tiki* facial form, using Casper the Friendly Ghost and your local grocery icon the Four Square man, the Maori film-maker Merita Mita says the works are

'totally meaningless bereft of *wairua*, bereft of *mauri* [life-force], not *tapu* and therefore without *mana*' (Casserly, 1993). The fact that Frizzell can only bluster in response to this type of criticism by Maori illustrates the sort of distance which characterizes Maori and Pakeha positions on, and perceptions of, appropriation. The sort of cultural monologue that he and others have been engaged in has to improve if we are to move beyond the kind of mono-directional and imposed forms of cultural change advocated by Frizzell when he says, 'in the end it just comes down to this thing of change. Things have to change' (Casserly, 1993).

The feeding of the *harakeke*

So what changes have occurred? Are there any models for successful cross-cultural dialogue in Aotearoa? What would constitute a fairer sense of exchange? I think there are and always have been examples of Pakeha artists and writers who have not simply taken from Maori culture but have sought to return something as well. I have promoted Theo Schoon's work in contrast to that of his contemporary, Gordon Walters, as I believe his use of the *koru* involved some very practical returns to Maori culture (see Panoho, 1992). These include a return to the growing and carving of *hue*, the recognition of the *wairua* in early South Island Maori cave painting, its importance and its documentation and the publication of a book after years of researching *pounamu*. It is my belief that these contributions have returned sustenance to the culture, that they have helped feed the *harakeke* plant.

Some artists are not only making their own expressive statements but they are voicing the concerns of Maori people as well. In Canada you have artists from within tribal cultures like *Kwa wa ku wa kwa* such as David Neel, who in works like *Self Portrait with a Kwa wa ku wa kwa chief* (1990) are collaborating with their First Nation subject. The whole point of this series on *Kwa wa ku wa kwa* chiefs and elders seemed to be about establishing links between the photographer and sitter. Neel seemed primarily interested in restoring a positive image of *Kwa wa ku wa kwa* leadership and reinforcing the *mana* of these people. This can be done even in ordinary situations, such as in the image with *Mary Hayes* working with fish – a treasured spiritual and material resource for her people. Equally, *kai moana*, or seafood, for the Te Ati Awa people is not simply a food resource but something which embodies *mana* for the tribe. Its collection and supply for guests and the tribal rites connected with it are as important as the practical sustenance provided.

The Pakeha photographer Fiona Clark, like Neel, has used the camera not as an intrusive tool but as something which promotes Taranaki *kuia* and their special connection to *kai moana*, such as the mussels which *Wharewera Bezems* (Taranaki Series, 1983) holds up to the camera. In a wider sense these images record the battle of these women to save their resources. There is clearly dialogue and a great deal of co-operation going on here.[10] The sitters directed the way in which they would be presented and waived their strong convictions against the use of photography because of the urgency of their message.[11]

Rather than recording a supposedly dying culture as Eldson Best is doing in James McDonald's image *Hone Nukunuku, Eldson Best, Paratene Ngata, Waiomatatini, 1923*, Pakeha photographers such as Clark and Mark Adams have worked with Maori and Pacific Island cultures they have understood and experienced as being alive and highly adaptive (see Figure 2, p. 15). These images, like McDonald's, are documentary, but they also present the culture as vital and worthy of attention. In Adams's work the Samoans shown are willing participants, proudly displaying their tattoos, or *pe'a*, a design form at the heart of their culture. The transplanted cultural context of the Auckland living room where the tattooing takes place affirms this change rather than being a judgement on cultural impurity. The fact that both artists are actually promoting the political aspirations of their subjects could only have come through dialogue with the culture. The Pakeha painter Tony Fomison, who features in this photograph by Mark Adams, also carries compelling evidence on his body that cultures can be engaged with at deeper levels. Fomison bears the *pe'a*, the result of numerous visits made to the home of his *tufuga ta tatau* (tattoo expert), Su'a Sulu'ape Paulo. If Fomison's relationship with some sectors of the Auckland Samoan community was problematic, his endurance of the painful tattooing process was actually evidence of his standing and his appreciation of the art form and the culture which affirmed it.

Unless Pakeha artists allow this sort of involvement over the way Maori are represented and the context in which their cultural art forms are used, then visual colonialism will continue in Aotearoa.

I wanted to finish here with the image with which I began. There is a *whakatauki* (proverb) that talks about the *harakeke* plant[12]:

> *Hutia te rito o te harakeke*
> *kei hea koe e te komako e ko*
> *ki mai ki ahau*
> *he aha te mea nui*
> *maku e ki atu*
> *he tangata, he tangata, he tangata*

> If the centre shoot of the flax is pulled out
> the flax will die, leaving no place for the bellbird to sing.
> If I was to ask what was the most important thing?
> I will answer: it's people, it's people, it's people

The life of the *tupuna* who spoke these words was threatened. Today aspects of the Maori culture are in a similar predicament. How will the *komako* sing, asks the *whakatauki*, when the *rito* of the culture is torn out? How can the soul and *wairua* of Maori culture continue to survive if those symbols that constitute the heart of the culture are taken? Maori culture has been opened up enough to service the demands and interpretations of Western artists. It's time the *harakeke* plant was left alone to rejuvenate itself and sustenance not simply taken but returned to it. Tending a live, struggling culture is more important than propping up a sick and dying one.

Glossary

awhi rito or *matua*	the outer leaves which protect the inner core of the plant
hapu	sub-tribes
hara	serious breaches of Maori law; a sin
harakeke	flax plant
Hawaiki	our ancestral homeland
hue	carved gourd
hui	gatherings
iwi	Maori tribal units
kaawa	seafood beds
kahu	cloaks
kai moana	seafood resources
kawa	cultural protocol
kete	woven kit
komako	bellbird
koru	a bulb-shaped design, possibly derived from the unfolding of the fern frond
kowhaiwhai	painted rafter panel
kuia	older women
kuia	elderly woman
mana	standing, prestige
manuhiri	guests
mate	the deceased
mauri	life force
moko	facial and body tattoo
muka	inner fibre of *harakeke*
pa harakeke	flax stand
Pakeha	European New Zealanders
papa harakeke	the *tupapaku* (body) in its relationship with the earth and the flax
pipi	shellfish
pounamu	nephrite
rangatira	chief
rito	the core, the baby or the heart of the plant
rohe	tribal boundary markers; e.g., rivers, mountains, rocks
taonga	treasure or treasures, notably *kahu* (cloaks) such as *korowai*
Te Papa Tongarewa	Museum of New Zealand
tufuga ta tatau	tattoo expert
tupuna	ancestors
utu	revenge
wairua	spirituality
waka taua	war canoes
whaikorero	oratory
whakatauki	proverb
whare	traditional house
whare whakairo	carved Maori meeting-house
whariki	finely woven mat

Notes

1 The glossary on page 23 defines all Maori terms used in this article.
2 Interview with Toi Maihi and Alan Wihongi, Wellington, 3 November 1993.
3 Emily Schuster and Diggeress Te Rangituatahi Te Kanawa, Lecture/ demonstration, School of Design, Wellington Polytechnic, 7 May 1993.
4 Smith, who died in 1922, edited the *Journal of the Polynesian Society*. In his book *Hawaiki: The whence of the Maori* (1898), he constructed a past for the pre-European Maori. Smith's material, first published in the *Journal of the Polynesian Society*, made reference to the migration of the Maori in a great fleet and their displacement of a mythical Moriori race upon landing in Aotearoa.
5 A reproduction of this painting accompanies Leonard Bell's article in this issue.
6 Art historians like Eric McCormack who produced books such as *Omai*, devoted to the life and work of the Tahitian interpreter present on Captain Cook's voyage. Film-makers such as John O'Shea in epics like *Broken Barrier*, Pacific Films, 1952.
7 The *tiki* is a form used especially in carving and in nephrite neck ornaments. Its origins and exact meaning are debated, but it would appear that the *tiki* figure is usually represented in a foetal position. This form is possibly associated with fertility as with a number of other motifs in the Maori visual aesthetic.
8 Turner did consult with local Wanganui Maori in the work he was doing with the *tiki*, but this seems to have been done as a measure of protection as it contradicts his stated position with regard to the irrelevance of tribal ownership in his exploration of the design.
9 Bulun Bulun received legal damages from Flash Screenprinters, Queensland, for reproducing without permission, on mass-produced T-shirts in 1988, the dreaming story represented in his bark painting *Sacred Waterhole* (1980).
10 I acknowledge here the current tension experienced between North Taranaki Maori and Clark over the control of her images. I don't feel this takes away from the original intentions of Clark but rather points out the complexity of cross-cultural dialogue in the arts.
11 These *kuia* follow the teachings of Te Whiti o Rongomai and Tohu out the effect of the camera. These nineteenth-century Taranaki prophets believed that the photograph could diminish the *mana* of the individual.
12 The original tribal use of this proverb was by the Te Aupouri – a tribe occupying the far north of Te Ika a Maui (the North Island).

References

Barr, Jim (1993) Cross cultural dialogue panel discussion, School of Design, Wellington Polytechnic, 1 June.
Bell, Leonard (1992) *Cultural Constructs*, Auckland: Auckland University Press.
Casserly, Paul (1993) 'Interview with Dick Frizzell', *Stamp Magazine: Music, Film, and More*, Aotearoa: Tamaki Makaurau.
Durham, Jimmie (1992) 'A central margin', *Art Journal* (Fall), New York: College Art Association.
Leonard, Robert (1988) 'No good going to bed with cold feet: Ans Westra's *Washday at the Pa* and the debate surrounding it', *Photofile* (Spring).
McEwen, J. (1966) *Encyclopedia of New Zealand*, in A. H. McLintock, editor, *An Encyclopedia of New Zealand*, vol. 11, Wellington: Government Printer: 83.

Mita, Mirata (1993) 'Ticked Off', *Stamp: Music, Film, and More*, Aotearoa: Tamaki Makaurau.

Panoho, Rangihiroa (1992) 'Maori at the centre, on the margins', in *Headlands*, catalogue of the Museum of Contemporary Art, Sydney: 122–34.

Rayner, Paul (1992) 'Dennis Knight-Turner: Turner's Tiki', *Sarjeant Gallery Newsletter* 20: 1.

Simpson, Tony (1993) *Art and Massacre*, Wellington: The Cultural Construction Company.

Walters, Gordon (1966) 'Artists' statement', Auckland: New Vision Gallery.

LEONARD BELL

THE COLONIAL PAINTINGS OF CHARLES FREDERICK GOLDIE IN THE 1990S: THE POSTCOLONIAL GOLDIE AND THE REWRITING OF HISTORY

O ne of the most successful artists (perhaps the most successful) in New Zealand from the mid 1980s into the 1990s – successful in terms of market value and sales, attention from leading art galleries and museums, popular esteem, and space and time devoted to his work and career by the media, both print and electronic – is a painter, who died in Australia in 1947. That is C. F. Goldie, born in Auckland in 1870, trained in Paris, 1893–7, at the Academie Julian, at which the prestigious Academic painter, Bouguereau, had taught. From around 1900 Goldie specialized for the rest of his life in oil paintings of Maori – mostly single-figure studies of elderly models, in both Maori and European dress, resigned, melancholic or sleepy-looking, their physical appearance and accompanying artefacts meticulously detailed, and equipped with titles such as *Memories, One of the Old School, The Last of the Chivalrous Days, A Noble Relic of a Noble Race*. These paintings were anecdotal or narrative pictures, rather than portraits (Bell, 1980: 70–93; 1991: 88–92). They visualized, as the titles suggest, a past and a present that was largely a European invention; not just Goldie's, but one that had strong currency in late colonial culture generally – the notion of the 'passing' or the dying of the 'old time Maori' (Bell, 1980; 1992); at a time, it ought to be noted, when the Maori population was in fact rising, and many Maori, both individually and collectively, were resisting further colonialist encroachments on their remaining lands and cultural autonomy (Pool, 1977; Williams, 1969; Walker, 1990).

With paintings of this kind, works that were technically and formally highly accomplished, Goldie quickly became very successful – financially, critically, popularly. In 1901 he was called 'the first painter in New Zealand' (*Observer*, 16 November 1901); one whose works would be praised 'even in the great art centres of the world' (*Auckland Star*, 28 June 1903), as indeed

they were to be, particularly in London and Paris in the 1920s and 1930s. In 1910 Goldie was described as 'probably the most successful painter of the Maori in a commercial sense' (*New Zealand Freelance*, 8 October 1910) – and, while at times in New Zealand his critical fortunes have ebbed, commercially his paintings have always been sought after, always at the top end of the art market. The commodity value of Goldies lept in the 1980s; in tandem with the global art market boom then, in particular with the reinvigorated market for paintings. With Goldie this climaxed in 1990, when the National Art Gallery, now part of the Museum of New Zealand, purchased two of his paintings, *Darby and Joan* and *The Widow* (both 1903), for $900,000, the highest price ever paid for paintings by a New Zealand artist.

This acquisition generated immediate controversy. The Gallery bought the paintings from two art dealers, Dunbar Sloane of Dunbar Sloane and European Art Limited, an international art investment company based in Wellington, and Grahame Chote of the International Art Centre of Auckland. They had purchased, in a joint venture, the two works for $150,000 only shortly before. The enormous mark-up in price, the contentious nature of which was exacerbated by the fact that the National Art Gallery had been informally offered *Darby and Joan* and *The Widow* for $300,000 in 1989, attracted extensive media exposure and criticism of both the Gallery's administration and the dealers (*North and South*, April 1991: 53–63). During this brouhaha the artistic qualities of the paintings were also, often acrimoniously, debated.

Goldie's paintings have struck chords in different socio-cultural milieux for a variety of reasons. From the outset his paintings of Maori subjects provided a prime model and stimulus for other European artists. Paintings in the manner of Goldie, sometimes straight copies, proliferated – from the 1910s and 1920s, for instance, in the work of Vera Cummings and Maud Burge, right through to the present with the paintings and illustrated books of, for example, Kristin Zambucka (1971) and Harry Sangl (1980). Goldie's paintings have been extensively reproduced – probably more so than any other New Zealand artist – in books, prints, posters, calendars, post and greeting cards, tapestries and bric-à-brac of various kinds. A recent newspaper article on tourism and the arts quoted the proprietor of a shop specializing in prints and reproductions: 'Tourists try to return home with a piece of New Zealand. Goldies are the first choice for the foreign clientele' (*Sunday Star*, 6 December 1992). There have been several large, very expensive, lavishly illustrated books on Goldie, some of which have themselves become collectors' items.[1] The Auckland City Art Gallery will be mounting a large retrospective of Goldie's paintings in 1996 or 1997. Since the mid 1980s the life and works of Goldie have spawned a play by Peter Hawes, first staged at a leading Wellington theatre, the Downstage, and several television films; one titled *Goldie: The Film* and another which was part of a 1992 series, *Bungay on Crime*.[2] This dealt with the 1985 criminal prosecution of Karl Fedor Sim, otherwise a dealer and collector, for forging Goldies. Convicted on forty charges, Sim changed his surname to Goldie and

the initial of his first name to 'C'. Presumably any further paintings or drawings he produced in the manner of the original Goldie could legitimately be signed 'C. F. Goldie'. Goldie was also responsible for another celebrated court case; a libel case arising out of the National Art Gallery's purchase of the two Goldies in 1990 – a case which was front-page news and a primetime TV news item for a couple of weeks in 1992.[3]

The prestige of Goldie and his paintings, and their continuing life, have also led to paintings by a now forgotten late-nineteenth-century English artist with the same surname and first name being attributed to the New Zealand Goldie – namely two paintings in the Farm Street Jesuit Church in Mayfair, London. One of these represents the death in China of St Francis Xavier, coincidentally and aptly in the circumstances a Catholic patron saint of New Zealand.[4] Here you have an ironic reversal – the colonial or postcolonial Goldie 'consuming' his namesake in the imperial and metropolitan centre.

The GOLDIE phenomenon

In various forms, in various media, then, Goldie's paintings, and Goldie, have posthumously proliferated and circulated – much more widely than in the lifetime of the artist. Charles Frederick Goldie, an actual person, has become a capitalized GOLDIE – not just a 'Great Artist', not just a high-priced commodity, but a much more complex and multi-faceted cultural phenomenon; one which can be related to what might immediately seem mutually exclusive or conflicting discourses. This GOLDIE incorporates not only just the original paintings, but the copies, variants, reproductions, forgeries, and the diverse events that the life and works of the actual artist have stimulated or participated in.

Fundamental to this phenomenon are the multiple uses, significations, meanings Goldie's paintings can have for different people or groups of people. There is a Wallace Stevens poem 'Thirteen Ways of Looking at a Blackbird' (1955: 92–5); Goldie's paintings offer at least as many possibilities. I have noted already some of the uses and meanings Goldies have had, or which have attached themselves to Goldies – as visualizations of the colonialist notion of the passing of the 'old-time Maori'; as valuable commodities, good investments, bullion; as something distinctively, uniquely 'New Zealand'; as a high-rating, audience-attracting news item. To these could be added, for instance, the well-known American art theorist, Suzi Gablik's (1982a: 16) reading of Goldie as a kind of primitivist, albeit Academic style: his paintings of elderly Maori 'captured' for her 'something that has been lost track of in rational, secularised Western civilisation'. In contrast, a contemporary New Zealand artist, Judy Darragh, widely known as the 'Queen of kitsch', has produced 'Goldie Liteups' (1987) – simulations of original Goldies, combined with cheap trinketry, Christmas lights, shells, and touristic bric-à-brac like plastic *tiki*. This is Goldie postmodernized; works that come out of the GOLDIE phenomenon, and which, Darragh

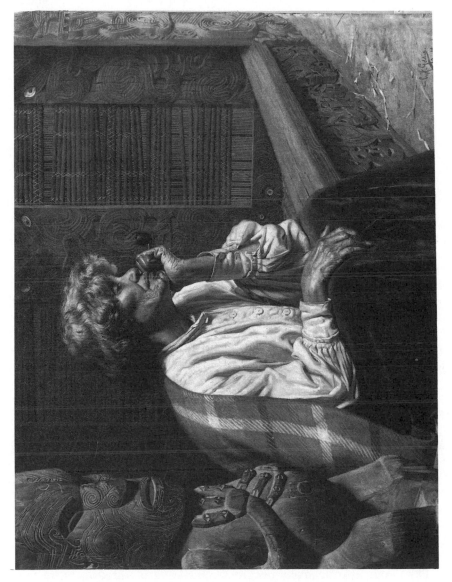

Figure 1. Darby and Joan: Ina Te Papatahi, Ngapuhi, 1903: Museum of New Zealand.

(1992: 137) claims, celebrate Goldie and his subjects, rather than demeaning or making fun of them. Some viewers, though, think otherwise.

Goldie's paintings have been regarded too in terms of ethnological or anthropological documentation, insofar as they can function as meticulous and accurate records of Maori material culture, *moko* (tattoo) and physiognomy (Simmons, 1974: 37–8). Further, Goldie's Maori images have functioned as exotic curiosities; as testimony to certain European attitudes in the colonial period; as emblems of imperial and colonial power and control of indigenous people, with the 'natives' passive, compliant, 'captured' on canvas, vicariously possessed (Bell, 1991). They have been seen too as fine turn-of-the-century examples of Academic painting in New Zealand,[5] and conversely and negatively as examples of a debased, moribund style of painting,[6] mechanistic, unimaginatively photographic-like and lifeless (*The Triad*, 10 June 1912; 10 August 1918).[7] Yet in contrast, Goldie's paintings are now routinely and positively cited as an integral part of New Zealand's 'cultural heritage' (*National Business Review*, 20 December 1990) – the main reason, it would seem, that the National Art Gallery paid such large sums to acquire the two Goldies in 1990; works regarded as among the best that Goldie had produced, and which were described by Margaret Austin, the former Labour Government Minister of Arts and Culture, who supported the purchase, as 'part of the soul of this nation' (*New Zealand Herald*, 1 December 1990).

This list does not exhaust the possible meanings and uses of Goldie's paintings, or the contestation over their values. Lastly, for the purposes of this paper, and importantly, given the picture I have presented so far, some Goldie paintings have taken on considerable value and prestige among Maori people. In particular the kin, the descendants of the models in Goldie's paintings can see the works as embodiments of the spirituality and *mana* (prestige, authority) of their forebears, as visualizations of the being of actual people, as affirmations of tribal and cultural identity and links with the past (Bell 1991; 1992: 256–8). In Maori cultural contexts Goldie's paintings can have symbolic and metaphysical values, uses and meanings completely different from the aesthetic, commercial, historical, ethnological and touristic functions they have had or can have in other contexts. Some Maori have effectively appropriated for their own purposes images that were originally produced for exclusively European audiences and buyers. It ought to be noted, though, that there is not homogeneity of response among Maori people. Maori have evaluated Goldie's paintings negatively too.

The range and variety of interpretations and assessments of Goldie's paintings have been so great and at times conflicting that the same picture in different contexts effectively becomes a different picture. Such are the multiple meanings and uses that Goldies have generated, that it would be impossible to resolve them into a single homogeneous Goldie, or for that matter, into *a* Goldie in/for European contexts and *a* Goldie in/for Maori contexts. Whether positively or negatively regarded and however interpreted, what is clear is that Goldie and his paintings have a central place in

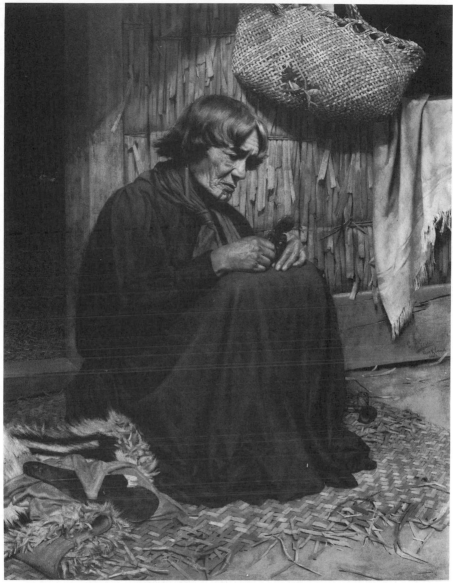

Figure 2. The Widow: Harata Rewiri Tarapata, Ngapuhi, 1903: Museum of New Zealand.

New Zealand culture – culture in both the sense of the 'fine arts' and in the sociological/anthropological sense.

The museum display

The National Art Gallery's purchase of the two Goldies, *Darby and Joan* (Figure 1) and *The Widow* (Figure 2), in 1990 was both a result of and

recognition of this, and an act that, because of the controversy it caused, further accentuated Goldie's conspicuously pre-eminent status in New Zealand. Never have paintings in New Zealand been the centre of such media attention as these two. The Gallery's acquisition and presentation of the works led to even more contestation over the meanings and values of them; with what seemed like an attempt by the Gallery to recruit the paintings for a particular ideological programme. It is this reconstitution of the paintings as supposed embodiments of late 1980s–early 1990s biculturalism that I will now investigate. What meanings were given priority by the Gallery? And how does the Gallery's construction of Goldie relate to the paintings' past, their original uses and meanings? And what do their present uses and presentation say about the uses of the past in the present?

First: some details about the circumstances of production and initial use of the two paintings. *Darby and Joan* and *The Widow* were first exhibited at the annual Auckland Society of Arts show in 1903 – an exhibition opened by the Governor-General of New Zealand, the Earl of Ranfurly. The paintings, widely regarded then as two of the best ever executed in the colony, were presented as a gift to the Countess of Ranfurly as a farewell honour in the same year. They returned with the Ranfurlys to their estate in Dungannon, Ulster, where, after hanging for a short time in the dining room, they were installed in a 'New Zealand' room, with a collection of Oceanic artefacts. The paintings remained in the Ranfurly family until purchased by Dunbar Sloane and Chote, and then by the National Art Gallery, which ascribed to them 'historical significance far beyond anything in the national collection' (*National Business Review*, 20 December 1990).

The paintings are typical of Goldie's work of the period in terms of subject and its treatment. While the identities of the two models for the paintings were and are known, Ina Te Papatahi for *Darby and Joan* and Harata Rewiri Tarapata for *The Widow*, these paintings were not produced as portraits. They were anecdotal or narrative paintings, as the titles suggest. That Goldie's paintings operated in this way was recognized at the time. For instance, a reviewer of his Maori paintings wrote: 'Each and every one of them has a story to tell' (*New Zealand Herald*, 15 December 1905). The title, *Darby and Joan*, originated in an eighteenth-century English song; Darby and Joan signifying an old couple, long-time partners, touchingly still closely attached to one another (*Oxford English Dictionary*, 1989 IV: 247). In Goldie's painting Joan presumably is the old woman, Darby the carving, an ancestor figure. Goldie's models were actors in stories of his invention – stories that in the colonial context related to that European view of Maori culture as of the past; inevitably to be supplanted by an allegedly more progressive and superior European culture.

However, the values and meanings of paintings can change radically over the years, depending on their uses, and on the cultural and institutional contexts in which they are placed. In the case of *Darby and Joan* and *The Widow*, repatriated to New Zealand, the descendants of the models see the works, not in terms of narrative, but as portraits of Ina Te Papatahi and

Harata Rewiri Tarapata – portraits which generate strong emotional response (Bell, 1991).

How then did the National Art Gallery negotiate the business of the shifting, clearly unstable meanings of Goldie's paintings? The inaugural presentation and display of the works from May 1991, after the controversy of their purchase and sustained media attention, was a major event, or rather a series of events extending over several months. There was a Maori welcome, an unveiling and grand opening, followed by symposia and lectures about the paintings and the painter. It has been observed that how an exhibition is mounted, the manner of presentation and the rhetoric accompanying a display of objects or images can be more important, more primary to the generation of meaning than the objects or images themselves (Bennett, 1988: 73) – an observation worth bearing in mind with the National Art Gallery's inaugural exhibition of the Goldies.

An entire large gallery was set aside for just the two paintings. They were displayed in a manner very different from the usual in a contemporary art museum, and very different from their original displays, either at the Auckland Society of Arts or in the Ranfurly's home in Ireland. In the National Art Gallery they were set on individual panels about three feet out from the gallery walls. Each painting was separately spot-lit in an otherwise darkened, somberly-lit gallery – lit so that the light seemed to emanate from within the paintings themselves, to come from within as if they were more than paintings, as if magical incarnations of the figures. Or they appeared like large transparancies, bringing to mind the popular late nineteenth–early twentieth century medium of the magic-lantern show. Stephen Greenblatt (1991: 49) has commented on museums' use of 'boutique' lighting, in attempts to give objects a sense of wonder or mystery – wonder or mystery derived not from the objects themselves, but from the apparatus of commercial display. The presentation of the Goldie's could be seen in this way also.

The titles of the paintings were in large letters, also spotlit about eighteen inches above the paintings – an unusual mode of titling that implied some extra-special status. These were not the original titles, but new titles, the names of the models and their tribe, *Ngapuhi*, with no indication of the original titles on the panels. Information panels on the wall opposite, though, did note the original titles without giving them any undue emphasis. Also on the opposite side of the gallery from the paintings were large sofas where the museum visitor could refer to a folder with a selection of articles about Goldie and further information on his work and career generally – mainly newspaper articles in the celebratory mode about the paintings' acquisition and return to New Zealand. On the wall on this side of the gallery too was a poem, in English and Maori, addressed to the two people who modelled for Goldie. The poem had been written and delivered by Selwyn Muru, a well-known artist, writer and broadcaster, at the unveiling of the paintings. Between the two paintings, but set closer to the wall, was a huge (about 8 × 10 ft) blown-up photograph (originally published in an early 1900s illustrated news weekly) of Goldie working in his studio with a male Maori model.

The overall installation – the glowing paintings in the darkened gallery, with blue-grey walls and dark red sofas, the blown-up photograph – constituted a very effective piece of theatre. This theatricalized mode of presentation for a special exhibition focusing on a single painting or small group of paintings brought to mind the mass entertainment spectacle of the 'Great Picture' shows of the mid to late nineteenth century – for instance, the presentations of the grandiose landscape paintings of Frederic Edwin Church in the USA (Avery, 1986: 52–72; Kelly, 1988).

So with the Goldies the National Art Gallery adopted a theatricalized mode of presentation, in which the paintings were made into something quite different to, or radically removed from, their original status and effect – icons charged with new meanings and value, which, some might argue, were projected on to them from the outside, rather than revealed from within the works themselves. These were not Charles Frederick Goldie's Goldies, but GOLDIES; constructions built to service certain requirements of the contemporary moment.

The theatricalized and highly charged nature of the installation, that this exhibition was something extra-special, was announced before the prospective viewer entered the gallery. In the foyer, on either side of the entrance, were displays of Maori artefacts – *mere* (hand-held weapon), *papahou* (carved box), *heitiki* (neck pendant), *kete* (flax basket) – some of which allegedly belonged to Goldie. Suspended above each display were large (about 3 × 2 ft) perspex panels with information in gold lettering about the Ranfurlys and the paintings, which were described as if they were originally painted as portraits, with no mention of the original titles. The panels informed the visitor of the National Art Gallery's new policy of collecting 'rare historical works of great historical significance to this country and its people'. At the base of each panel in large gold capital letters was the name GOLDIE, with a blown-up reproduction or simulation of his signature superimposed on it.

Complications

Consider the possible reasons for, and effects of, this mode of presentation, in relation both to the phenomenon of GOLDIE in New Zealand culture, and to the uses and meanings of the paintings in their original contexts; the Goldies, that is of Charles Frederick Goldie and the audience for whom he painted them. The National Art Gallery was, and the Museum of New Zealand is, committed to a programme of biculturalism. That means giving recognition and space to Maori as well as Pakeha (European New Zealand) culture, to the views and concepts of both cultures about art and the ways it should be handled.[8] In striking contrast, then, to art gallery practices which prevailed in New Zealand until recently, in which aspects of Maori culture and history were displayed in a manner that catered primarily for non-Maori cultural requirements, the bicultural approach seeks to provide for the voices and views of Maori, hitherto largely excluded or marginalized. Such a policy is undoubtedly laudable, a positive step. It is also in line with

'advanced' museological theory and practice elsewhere in the world, especially in Britain, Europe and North America, by which museum spaces, exhibitions, displays are organized with consideration for the interests and views of indigenous peoples and/or previously marginalized or subordinated social or ethnic groups. This can involve curatorial consultation or collaboration with members of such groups over the form and manner of an exhibition in which they have an interest (Hooper-Greenhill, 1992; Vergo, 1989).

In respect of the exhibition of the two Goldies at the National Art Gallery, the adoption of an approach of this kind could be seen as a recognition that for Maori, in particular the descendants of the models, the paintings have specific uses and meanings of an emotional and spiritual order, which, as noted, are quite different from those they have had, and still have, in various other contexts, or for other groups of people. That is, some aspects of the exhibition could be seen as a most praiseworthy attempt to open up art gallery space for the Maori relatives of the models, as well as an attempt to widen the awareness of other visitors of what such paintings can mean to Maori.

That, though, is not the complete story. The presentation of the paintings also had its problematic aspects. Other dimensions of the image of Goldie and his paintings were promoted or foregrounded by the National Art Gallery; and, given the history of Goldie's paintings and the GOLDIE phenomenon, some features of the inaugural display allowed quite different readings, even if these were unintended by the curators of the exhibition.

The still standard art museum treatment of European art and artists from the Renaissance on is primarily geared to the iconography of the unique, individual artist, the 'Great Artist', seemingly existing above and beyond day-to-day social and historical relations (Duncan, 1991). An extensive museum and academic art-history industry is geared to perpetuating this figure or entity. The National Art Gallery Goldie exhibition conformed to this approach in several fundamental respects. There was the huge photograph of Goldie between his supposedly great paintings, besides which stood a chair, allegedly from Goldie's studio – bringing to mind Van Gogh's well-known paintings of the empty chairs of Gauguin and himself,[9] and allowing the association of Goldie with those 'Great Artists'. There was Goldie's signature, the mark and sign of his individuality, his uniqueness, also blown-up, writ large, and set in gold. Gold, of course, is regarded as the purest of metals. It can connote purity of mind and spirit (as, for instance, in its use in late medieval or Gothic altarpieces).[10] In this instance that purity extended to Goldie's enterprise. That, at least, could be a connotation. And there was the very name Goldie – also in gold – conveniently lending itself to the accentuation, by association, of high status and the mystique of the 'Great Artist', who had, through his creative acts, contributed so much to the 'national heritage'.

However, the construction of this image of Goldie, of the artist and of his work, depended on several significant exclusions from, or alterations to, the historical record, or minimizations of aspects of the paintings that were in

fact central to their original contexts of production and use. For instance, the change of the titles, the presentation of the paintings simply as celebratory portraits of recognizable individuals, rather than narrative paintings in which the individuals were models for characters invented and directed by the artist, could be seen as a misrepresentation of the paintings in terms of their original context of use. This involved too a virtual erasure of that ideological dimension of the paintings – namely, the manner or the mechanics of their participation in the uneasy relationships between colonizing Europeans, either dominating or seeking to dominate, and colonized and subordinated Maori; a denial of the extent to which Goldie's paintings, widely reproduced and seen, both contributed and gave striking formulation to negative stereotypes about Maori culture and prospects and Maori-European relations in the colonial period.

The National Art Gallery presented an almost wholly positive picture, as if Maori and European shared a past that was primarily one of unity and harmony as manifest in these 'great', supposedly celebratory paintings of Maori by a European – as if Goldie and his subjects too had shared an equal relationship, in which one party did not make use of, or take advantage of the other. This was particularly suggested by the huge blown-up photograph of Goldie and one of his Maori models taking tea in his studio; an image that in the context of the National Art Gallery could connote domestic ease, comfort, being at home with one another. Yet the inclusion of other photographs, other information about the relationships of Goldie and his models, would have given a very different picture of these relationships. For instance, the Auckland City Art Gallery has a photograph of Goldie trimming the beard of an elderly Maori model, making his face, with the tattoo no longer obscured, more picture-worthy for a European audience. The very fact that Goldie could do this, given Maori sensitivity about touching the head, points to Goldie's dominance in the situation. And there is another photograph[11] of an elderly chief in Maori dress in Goldie's studio, as in the photograph in the National Art Gallery exhibition, accompanied by a young European woman, also in Maori dress, reclining against his thigh, with her hand touching his *mere*, which rests on his knee; another situation, directed by Goldie, which suggests his dominance. It ought to be noted too that the relationship between Goldie and his Maori models usually had a financial basis, in that he paid them to sit for him. Letters show that they were not always content with the sums he offered them.[12] Furthermore, there is an extraordinary story from about 1903, which came from Alfred Hill, the well-known composer and friend of Goldie, of Goldie's practice of locking his Maori models up in his studio when he went out for a meal (Thomson, undated: 102). That contrasts with the image of quiet domesticity implied by the National Art Gallery's use of the photograph.

Could the National Art Gallery's inaugural display of the two Goldies, then, be seen as a formation of an unblemished past – a past in which any sense of friction or exploitation was masked or ignored; a doctoring of the past; a presentation in which the less pleasant aspects of that past were not addressed, when, it may be argued, they need to be in the interests of present

Maori-Pakeha relationships? If a prerequisite for understanding an art object involves an appreciation of its original meanings and uses for the audience for which it was intended, the National Art Gallery exhibit could be regarded as insufficient.

The Gallery's handling of the meanings of Goldie's paintings in present New Zealand society was also limited. For example, a prime feature of Goldie's work now was largely ignored; the dominant meaning Goldies have for many, perhaps most, people in New Zealand today, namely their financial value, their investment potential, their commodity status. Ironically, the very price the Gallery paid for the works was evidence of this. Indeed, the major factor in the controversy over the purchase was the price paid; the widespread belief that the Gallery had paid too much, that a bad investment had been made. The Gallery responded to this criticism by stating that the commodity status of the Goldies was not one of its concerns, that in the museum context as part of the 'national heritage', the paintings transcended the possibly grubby dealings of the market-place. But is that possible these days? Visitors to any exhibition inevitably bring with them a complex, a plurality of attitudes, expectations, preconceptions – and the Goldie/bullion/dollar sign equation would have been frequently among them.

Ironically, the National Art Gallery's own use of the colour gold in the entrance could have cued, whether wittingly or unwittingly on the part of the curators, such a response, since gold, besides connoting purity of mind and spirit, can also signify monetary value. And further, again probably unintentionally, pointing to the fundamental synonymity of Goldie (the name helps) and monetary value, was the lettering on the perspex signs in the entrance foyer. The typeface and use of word as image brought strongly to mind the nationally well-known works of New Zealand artist Billy Apple, whose main concerns over the last decade have been the commodity status of art, the conditions under which it is traded, and the inevitable complicity these days of art, artists and the processes of commodification (Burke and Curnow, 1991) – processes which otherwise the National Art Gallery sought to transcend or minimize. A retrospective of Apple's work in 1991 was titled *As Good as Gold* and featured a piece from 1985–6, the height of the art and finance boom, of which Goldie's paintings were a major beneficiary, entitled *Golden Apple*. It was literally that; a work in which art was one with gold itself. Given the extensive media exposure that Billy Apple and his work have had in New Zealand, could the name Goldie in gold on gold, given its echoes of Billy Apple's work, have escaped the dominant meaning of Goldie's paintings as financial treasure, rather than, or before, aesthetic or spiritual treasure?

Unreliable categories

That was just one of the contradictions that the National Art Gallery display threw up. Another related to the problem of Goldie's paintings in terms of GOLDIE, a free-floating sign in New Zealand popular culture – one that has

attracted a variety of uses and meanings in the realms, often overlapping, of the touristic, popular entertainment, 'news', and kitsch bric-à-brac, all of which are integral to the 'social life' of Goldies/GOLDIE in New Zealand today. On one hand, the Gallery simply ignored this in opting for a simple bipartite Goldie – namely Goldie the 'Great Artist' and Goldie for the Maori kin of the models. Yet, on the other hand, some of the advertising and promotional material for the inaugural exhibition and some of the supplementary material available in the Gallery shop traded in the Goldie as popular and Pop sign. For example, *Darby and Joan* and *The Widow* were available in postcard and greeting-card form, somewhat in conflict with the presentation elsewhere in terms of spirituality. And advertisements in 'Entertainment in Wellington' pamphlets and brochures available in hotels, motels, at the airport, for example, located this exhibition in the realm of entertainment and spectacle. Within this the meanings that the paintings could have for the descendants of the models became part of a public spectacle for others. To the extent that this was so, ironically the Gallery perpetuated to some degree that treatment of aspects of Maori culture that had its origins in the colonial period – at events, for instance, like the Christchurch International Exhibition of 1906–7, which included a Maori village (Cowan, 1910) – in which otherwise private aspects of Maori life were/are displayed for public and non-Maori entertainment and, supposedly, edification. Without impugning the undoubtedly different motives of the curators, was a consequence of the National Art Gallery display, perhaps, a kind of neo-colonialist co-option of Maori?

In terms of museological practice, the Gallery's inaugural Goldie display can be regarded as innovative and forward-looking *and* simplistic and backward-looking. On one hand, in terms of Maori-European interactions, the presentation involved a progressive recognition and celebration of the meanings and uses the paintings could have for some Maori; on the other hand it could be seen as a retrogressive, largely uncritical acclamation of an allegedly great artist, and a continuation of the museum as a 'temple of art', in the nineteenth-century sense, its contents outside or above history. Seen from this perspective the exhibition appeared historically amnesiac. The paintings were presented too as if the radical developments in art historiography and critiques of traditional art history over the last fifteen or so years had never taken place.

One wonders what was the aim of this odd yoking together of what might seem incompatible partners. Was it in the supposed interests of some kind of supra-historical unity; part of an attempt to construct or impose a partnership between Maori and supposedly Pakeha concepts and ways of seeing? Or, in terms of the European Goldie, could the presentation be seen as a demonstration, no doubt unwittingly on the part of the curators, of the syndrome, 'If you don't like the past, change it, or suppress it'?

Whatever the case; the bi-partite presentation, in particular in respect of Goldie and non-Maori, was at odds with the 'street realities' of Goldie's images in all their complexities and ambivalences, contradictory uses and meanings; the heterogeneity of the GOLDIE phenomenon. Goldie's images

and/or images derived from Goldie's paintings have had, and continue to exert, considerable power in a variety of sometimes conflicting ways. It has been remarked that images by themselves, autonomously, contextless (if that is possible), do not have power; that the power comes from the interactions between people and images and from the needs and desires that people project on to images (Freedberg, 1989). The National Art Gallery's presentation of the Goldie paintings came across like an attempt, even if unintended, to dictate responses, to allow just two kinds of power, as if there were a single, homogeneous Maori way of seeing and evaluating Goldie's paintings and a single homogeneous non-Maori way, when in actuality there are not. The presentation seemed like an attempt to fix certain meanings and values for Goldie and his paintings into a neat and tidy package, rather than opening up the field, recognizing the multiplicity of uses and meanings that Goldie's paintings have and generate in all their messiness and contradictoriness. Engaging with this latter phenomenon could be central to, indeed necessary for, a really and truly effective biculturalism in the area of museum practices and the handling of past and present in relation to visual representations, insofar as a positively functioning biculturalism, it could be argued, would require addressing, rather than minimizing or overlooking, both the past and what is actually happening now outside the art gallery and museum.

Notes

1 Notably Taylor and Glen (1978, 1979). Earlier books, which were primarily vehicles for the colour reproduction of Goldie's painting of Maori subjects, include *Art and the Maori: a set of colour plates by the famous New Zealand artist, C. F. Goldie, with a description by Allan Porter* (1948); and *New Zealand Paintings by C. F. Goldie* (1968).

2 *Goldie: The Film*, directed by Greg Stitt, which looked at Karl Sim's forgeries, Peter Hawes's play, and Goldie's art generally, was first screened on New Zealand television, 12 December 1986. The episode on the Sim trial in *Bungay on Crime* screened on 23 December 1992.

3 Hamish Keith, formerly Chairman of the National Art Gallery Council, sued Television New Zealand over an item, featuring a 'Mr Beamish Teeth', in a satirical programme, *More Issues* (1990), which he claimed defamed him. The jury found that Keith had been defamed and awarded him an amount equal to his legal costs (*New Zealand Herald*, 5 December 1992), a decision which went to appeal. The Court of Appeal has ordered a new trial over the amount of damages Keith should receive.

4 The painter is most likely to be Charles Goldie, a London genre and narrative painter, who exhibited at the Royal Academy from 1858 to 1879 (Graves, 1905: 2, 260–1; Wood, 1978: 179). The two paintings in the Farm Street Jesuit Church are attributed to the New Zealand Goldie in a booklet, *Farm Street Church of the Immaculate Conception: A Short History and Guide*, available at the church. Bénézit (1976: 5: 93), a major dictionary of artists, confuses the two Goldies.

5 Jenny Harper, Director of the National Art Gallery, at a symposium, 'Sentimental Parlour Pieces or Great Works of Art? A discussion on the artistic and

cultural significance of paintings by C. F. Goldie', Wellington City Art Gallery, 3 April 1991.

6 For example, Tony Lane, artist and a panellist at the same symposium.

7 The critical evaluation of Goldie's paintings in New Zealand in the first decade of the century was generally ultra-positive. The periodical, *The Triad*, published the few dissenting opinions: 'One tires very quickly of the sameness of this indefatigable artist's work' (10 June 1912); 'His work has too much of the machine-made art' (10 August 1918).

8 In respect of this, note, for instance, *Te Papa Tongarewa: Museum of New Zealand News*, March 1993: 1: 'The new museum will be one of the first public institutions in the country modelled on bi-cultural commitment.' Cheryll Sotheran, the recently appointed Chief Executive, is quoted:

> If we remain in a situation where we simply consult with Maoridom about what they want to see happening in a Pakeha-run museum we have not made a step forward. This is their museum too and I would like to see a Maori perspective spread throughout the museum and not limited to the Maori department. Their perspective should pervade the museum, just as the Pakeha perspective will pervade it.

9 Van Gogh, *Gauguin's Armchair* (1888, V. W. Van Gogh Collection, Laren); Van Gogh, *The Chair* [Van Gogh's] *and the Pipe* (1889, Tate Gallery, London). Van Gogh's paintings were inspired by the English artist, Luke Fildes's illustration, *The Empty Chair, The Graphic*, 1870, a commemorative tribute to Charles Dickens, a 'great man'.

10 Re the symbolic meanings or connotations of gold, the mineral, and/or gold, the colour, see, for instance, Stephen Bann and William Allen (1991: 49) and Cooper (1978: 40, 74).

11 *Goldie Notebooks*, Auckland Institute and Museum.

12 Kamariera Te Wharepapa to C. F. Goldie, *Goldie Notebooks*, 15 July and 19 October 1907.

References

Art and the Maori: a set of colour plates by the famous New Zealand artist, C. F. Goldie, with a description by Allan Porter (1948), Auckland: E. Allan Brooker.

Avery, Kevin (1986) 'The Heart of the Andes Exhibited: Frederic E. Church's window on the equatorial world', *The American Art Journal* 18(1): 52–72.

Bann, Stephen and Allen, William (1991) 'Janis Kounellis and the question of high art', in Bann and Allen (1991) editors, *Interpreting Contemporary Art*, London: Reaktion Books Ltd.

Bell, Leonard (1980) *The Maori in European Art: European Representations of the Maori from the Time of Captain Cook to the Present Day*, Wellington: A. H. & A. W. Reed.

—— (1991) 'Two paintings by C. F. Goldie: their brilliant careers', *Art New Zealand* 59: 88–92.

—— (1992) *Colonial Constructs: European Images of Maori 1840–1914*, Auckland: Auckland University Press.

Bénézit, E. (1976) *Dictionaire Des Peintres, Sculpteurs, Dessinateurs et Graveurs*, Paris: Librairie Gründ.

Bennett, Tony (1988) 'Museums and "the people"', in Lumley, Robert (1988) editor, *The Museum Time Machine: Putting Culture on Display*, London and New York: Routledge: 63–85.

Burke, Gregory and Curnow, Wystan (1991) *As Good as Gold: Billy Apple Art Transactions 1981–91*, Wellington: City Art Gallery.

Cooper, J. C. (1987) *An Illustrated Encyclopaedia of Traditional Symbols*, London: Thames & Hudson.

Cowan, James (1910) *Official Record of the New Zealand International Exhibition of Arts and Industries, held at Christchurch, 1906–7*, Wellington: Government Printer.

Darragh, Judy (1992) 'Interview with Marilyn McFadyn', in Clark, Trish and Curnow, Wyston (1992) editors, *Pleasures and Dangers: Artists of the Nineties*, Auckland: Longman Paul: 137–8.

Duncan, Carol (1991) 'Art museums and the ritual of citizenship', in Karp, Ivan and Lavine, Stephen (1991) editors, *Exhibiting Cultures: The Poetics and Politics of Museum Display*, Washington D.C.: Smithsonian Institution Press: 88–103.

Freedberg, David (1989) *The Power of Images: Studies in the History and Theory of Response*, Chicago: Chicago University Press.

Gablik, Suzi (1982a) 'New Zealand report', *Art New Zealand* 23: 14–16.

—— (1982b) 'Report from New Zealand', *Art in America*, 70: 35–9.

Goldie Notebooks, MS 438, Auckland Institute and Museum.

Graves, Algernon (1905) *The Royal Academy of Arts: A Complete Dictionary of Contributors and their Works from its Foundation in 1769 to 1904*, London: Henry Graves & Co Ltd and George Bell & Sons.

Greenblatt, Stephen (1991) 'Resonance and wonder', in Karp and Lavine (1991): 42–56.

Hooper-Greenhill, Eileen (1992) *Museums and the Shaping of Knowledge*, London and New York: Routledge.

Karp, Ivan and Lavine, Stephen (1991) editors, *Exhibiting Cultures: The Poetics and Politics of Museum Display*, Washington, D.C.: Smithsonian Institution Press.

Kelly, Franklin (1988) *Frederic Edwin Church and the National Landscape*, Washington, D.C.: Smithsonian Institution Press.

Lumley, Robert (1988) editor, *The Museum Time Machine: Putting Cultures on Display*, London and New York: Routledge.

McLeod, Rosemary (1991) 'There's no brawl like an art brawl', *North and South* April 1977: 53–63.

New Zealand Paintings by C. F. Goldie (1968), Auckland: New Zealand Art Publishers.

Pool, D. I. (1977) *The Maori Population of New Zealand, 1769–1971*, Auckland: Auckland University Press.

Sangl, Harry (1980) *The Blue Privilege: The Last Tattooed Maori Women*, Auckland: Richards Publishers in association with W. Collins.

Simmons, David (1974) 'C. F. Goldie: Maori portraits', *AGMANZ* [Art Galleries and Museums Association of New Zealand] *News* 5(2): 37–8.

Stevens, Wallace (1955) *The Collected Poems*, London: Faber.

Taylor, Alister and Glen, Jan (1978) *C. F. Goldie (1870–1947): His Life and Painting*, Martinborough: Alister Taylor.

—— (1979) *C. F. Goldie (1870–1947): Prints, Drawings and Criticism*, Martinborough: Alister Taylor.

—— (1993) *C. F. Goldie: Famous Maori Leaders of New Zealand*, Auckland: Alister Taylor Publishers.

Thomson, John (undated) 'Alfred Hill: 1870–1960: his life and times', MS Papers 1713, Wellington: Alexander Turnbull Library.

Vergo, Peter (1989) editor, *The New Museology*, London: Reaktion Books.

Walker, Ranginui (1990) *Ka Whawhai Tonu Matou: Struggle Without End*, Auckland: Penguin.

Williams, J. A. (1969) *Politics of the New Zealand Maori: Protest and Cooperation, 1891–1909*, Seattle and London: University of Washington Press.

Wood, Christopher (1978) *Dictionary of Victorian Painters*, Woodbridge, Suffolk: Antique Collectors Club.

Zambucka, Kristin (1971) *Faces from the Past: The Dignity of Maori Age*, Wellington: Reed.

ANN SULLIVAN

THE PRACTICE OF TRIBALISM IN POSTCOLONIAL NEW ZEALAND

Introduction

T
ribal government was governing in New Zealand before the
Pakeha (European) arrived, before Columbus supposedly dis-
covered America in 1492 and before the great 'British Empire'
colonized much of Africa, Asia and the Pacific. The purpose of
this paper is to examine the strength of the tribe in New Zealand by
examining the strategies used by governments since the signing of the Treaty
of Waitangi in 1840 to maximize the pursuit of individual wealth and
power. Prior to colonization, a united nation did not emerge because the
tribes fought, traded, built alliances, possessed their own leaders and
governed their own geographic areas to maintain and sustain their
individual economic, political and social organizations. Whereas tribal
government did not parallel the legal, rational bureaucratic model of
Europe, distinct tribal governments did exist.

Like other indigenous peoples, Maori had developed a highly sophisti-
cated governing system that emphasized the collective good by subjecting
individual freedoms to social constraints that were enforced through a
kinship system. However, the colonizing powers were able to effectively use
the conflict between the tribes to quickly dominate and gain economic and
political control of the country. The colonial government swiftly enacted
and enforced laws that denied tribal or communal ownership of land. The
individualization of land title resulted in many tribes barely able to make a
subsistence living from their remaining lands. By the 1940s there was a
considerable migration of Maori from their rural lands to urban areas in
search of employment opportunities. Government social and economic
policies undermined the traditional tribal structures and sought to assimilate
and integrate Maori into the Pakeha way of life. Today, New Zealand
governments still ignore the importance of tribal organization even though
policies and the means of implementing those policies fail to improve the
major disparities between Maori and non-Maori on all socio-economic
indicators.

Cultural Studies 9(1) 1995: 43–60

Land alienation

When the Treaty of Waitangi was signed between Maori and the British Crown it set in place characteristics of contemporary New Zealand society while at the same time recognizing the tribal nature of Maori society. Article Two of the Treaty of Waitangi recognizes *tino rangatiratanga*, that is, tribal chieftainship – it is the recognition that Maori society was, and is, tribal.

People descended from a common ancestor make up the tribe in New Zealand, although Ritchie (1992: 113) defines it more narrowly as an association of people who have regular and face-to-face contact. *Whakapapa* or genealogical links determine who belongs to the tribe and form the basis of communal rights, obligations, co-operation and loyalties.[1] Each tribe has its own history, territorial base, dialect and mythology.[2] In contemporary times these are still the cornerstones of Maori life in New Zealand even though social, political and economic structures differ with each tribe.

Tribal identity, *whanaungatanga* (kinship, collective development and loyalty), has enabled Maori to survive as a distinct and separate people in spite of the assimilation practices of previous governments[3] and in spite of the loss of their land which is the very essence of Maori identity. The land may be lost (temporarily) but regardless of colonization and all deprivations caused by the introduction of capitalism, each tribe has its own regions which ancestrally and in terms of the Treaty, they still feel is their *turangawaewae* – that is, land with which they strongly identify. Considerable historical evidence has shown that Maori social organization is centred on tribalism. Testimony given to the Waitangi Tribunal[4] (1988: xiv) demonstrates that in pre-European times, the economic base of a tribe was frequently based on inter-tribal trading practices with coastal tribes taking the produce of their fisheries to distant inland tribes for barter and trade. By the 1820s various tribes were involved in the provisioning of whaling ships and by the 1830s were exporting their goods overseas to Sydney (Waitangi Tribunal, 1988: xv). Tribally the means of production were based on kinship and the major means of subsistence was communally held land (Firth, 1972).

Prior to the signing of the Treaty of Waitangi the British attitude to the Maori people, while somewhat paternalistic, was relatively humanitarian. Furthermore, before the claim to sovereignty in 1840, the relations between Maori and the British had been relatively cordial and certainly mutually advantageous as Maori traded goods and the British obtained services and provisions (Orange, 1987: 6–13).

Colonization gave the impression that tribalism would disappear or at the least be rendered ineffective. Article One of the Treaty of Waitangi granted the British Crown the right to make laws in order to govern (*kawanatanga*) with the implication that the Maori could not expect to retain the full range of powers they had exercised before contact with the colonizers. Article One did not relinquish *tino rangatiratanga* (Maori sovereignty), although in practice that has occurred. Maori argue that in exchange for governing

(*kawanatanga*) rights, under Article Two, the Crown was obliged actively to protect 'their Lands and Estates Forests Fisheries and other properties'. Instead, since 1840 a systematic effort has been made to remove land and resources from the Maori and, as a matter of course, eradicate the power and strength of the tribes.

> The Treaty inaugurated an era of systematic colonisation. Colonisation brought an immediate demand for Maori land for settlement, and administrative structures and political policies were required to bring about satisfaction – predominantly for the Pakeha settler.
>
> (Kawharu, 1977: 296)

Colonial demands for land meant that government institutions dealing with Maori affairs have been in existence since the first British Resident, James Busby, was appointed to office in 1833, but there is no acknowledgement in law of the existence of a collective identity such as a tribe even though the Crown has sporadically recognized the tribal nature of Maori social organization in various limited forms.

Limited decentralization giving recognition to the influence of tribalism did take place between the years 1840 and 1846 when a department with the title of Protectorate was created by the British Crown to concentrate on Treaty and land issues. The under-secretary of the department believed that recognition should be made of Maori custom to strengthen relations between Maori and the Crown and that British legal principles and practices needed to be modified to accord with Maori custom and practice. Acknowledging tribal practices was considered to be a means of fulfilling the directives from the Secretary of State (in Britain) that required the Crown to watch over Maori interests and promote Maori religious, intellectual and social advancement (Butterworth, 1974: 5–8). Since the majority of Maori did not have access to the Government and the Crown was limited in its ability to purchase the available Maori land (even though land sales could only be made through the Crown and not directly with the settlers), it made sense to the Protector of Aborigine Affairs to promote a decentralized system of administration whereby the tribes could be involved. Hence the Native Exemption Ordinance (1844) prevented the police from arresting Maori outside Pakeha towns and in disputes involving Maori alone no magistrate could serve a summons until two chiefs of the injured party's tribe laid a complaint. Furthermore, no Maori could be imprisoned for a minor offence and compensation could be demanded rather than imprisonment for crimes of theft (Butterworth, 1974: 8–9).

This was rather pragmatic acceptance by the colonial government of its inability to deal with tribalism but it was replaced in 1846 by a Residents Magistrates Courts Ordinance which allowed Magistrates to disregard the tribal chiefs (Sorrenson, 1981: 176). In 1846, when George Grey was appointed as governor, centralized policies were quickly implemented. 'Grey believed that the best solution to native problems was to amalgamate the indigenous population into British society as quickly as possible' (Butterworth, 1974: 9). According to Butterworth (1989), Grey abolished

the Protectorate Department because he did not accept that there was any need for separate laws or a judicial system pertaining solely to Maori. By centralizing control of Maori affairs and denying Maori much formal involvement in the political system, Grey was able to pursue settler demands for more and more Maori land.

Interestingly, section 71 of the 1852 Constitution Act recognized tribal government and stated that Maori could:

> govern themselves according to their own laws customs and usages, provided they were not repugnant to general principles of humanity for the government of themselves in all their relations to and dealings with each other.

The Act also provided for Maori districts so that Maori custom and laws would prevail, but no districts were ever proclaimed (Sorrenson, 1981: 177), and the provisions were never implemented even though they were not repealed until 1986. Attempts to form regional councils (*runanaga*) by several tribes under the 1852 Constitutional Act proved to be impossible. Tribes such as those in the Waikato, the heart of *Kingitanga*,[5] rejected the *runanga* (council) proposals and the scheme only achieved limited success at the local level (Butterworth, 1989: 8–10) due no doubt to tribal loyalties taking precedence over regional considerations.

Following on from this, the 1858 Native District Regulation Act ostensibly allowed for regional Maori councils or *runanga* to be given some influence in the making of local bylaws. It was a token gesture, however, as they were under the direct control of a Pakeha governor and section 6 of the Act stated that while regulations were to be made with the general assent of the 'Native' population, this was to be 'ascertained in such a manner as the Governor may deem fitting'. Section 2 (7) allowed the governor to make regulations

> for the observance and enforcement of the rights duties and liabilities among themselves, of tribes communities or individuals of the native race, in relation to the use occupation and receipt of the profits of lands and hereditaments.

Maori were therefore greatly restricted in what they were allowed to do. Maori were given the illusion of limited decentralization but were in fact tightly controlled by the central administration which regulated the policies allowing local *runanga* to deal with minor and civil disputes between Maori.

For example, a number of minor positions were created for Maori assessors, Maori police and Maori mail carriers but, again, these positions just carried out policies on behalf of government in limited areas of delegated responsibility rather than embodying any significant devolution of power. When Native schools were put under the auspices of the Education Department, when a government sub-department was assigned to handle land purchases and when Native reserves were transferred to the Public Trust and the Defence Department (Butterworth, 1974: 11), then it seems apparent that central control of Maori was a primary concern of Grey since

his policies quickly removed any limited autonomy Maori had on matters of crucial importance to them.

Government policies, rather than decentralizing control to Maori, were designed to undermine Maori resistance to land sales, resistance which was evident with the formation of several land resistance movements such as the *Kingitanga* and *Kotahitanga*.[6] The culmination of Maori dissatisfaction and discontent at the rapid loss of land was the 1860s land wars era, when government was forced to formally acknowledge the tension between Maori and Pakeha.

Liberal-democratic philosophy was used to justify the transferring of tribally owned land to named individuals, hence providing the vehicle for land alienation – the purchasing or leasing of Maori land. The Native Land Act of 1862, as amended in 1867, allowed for certificates of title to Maori land to be issued in the names of ten of the owners. It was an obvious strategy to undermine the whole concept of tribalism and to control Maori by undermining their very strength – collectivity! Sutch (1969: 81) states that:

> the object of the Native Land Act was . . . to bring the great bulk of the lands of the North Island which belonged to the natives . . . within the reach of colonisation. The other great objective was, the detribalisation of the natives . . . to destroy if it were possible the principle of communism which ran through the whole of their institutions, upon which their social system was based, and which stood as a barrier in the way of all attempts to amalgamate the native race into our own social and political system. It was hoped that by individualisation of titles of land, giving them the same individual ownership we ourselves possessed . . . their social status would become assimilated in our own.

The idea that land can be owned by individuals and exploited for profit is a fundamental assumption of capitalism that has pervaded the economic philosophies of New Zealand governments since the signing of the Treaty. It is from this that Pakeha political and legal systems have been developed to reflect the private-ownership concept of land.

The monopolistic rights of the Crown over the sale of Maori land, which the settlers resented because of the length of time it took to acquire land through the bureaucracy of government, coupled with Maori dissatisfaction with their right to sell and the consequences of selling, eventually led to the establishment of the Native Land Court (which has survived through to today). According to Kawharu (1977: 296), Maori perceived the Court as initially serving to stabilize and reinforce the traditional social structure of Maori society because it confirmed and recorded 'collective' land rights. The first certificates of title can thus be regarded as proof of the existence and entitlement of such rights. However, the awarding of title and the listing of individual names on the title deeds facilitated land sales for the settlers. Only the consent of those listed on the deeds had to be acquired and sales occurred frequently without regard for the tribal rights to the land as a whole. 'The Native Land Court was an effective instrument in breaking communal resistance to land sales' (Sorrenson, 1981: 186). Furthermore, The Native

Land Act of 1865 consolidated government or central control over Maori affairs and Maori land but, more importantly it abolished pre-emption and allowed settlers to purchase Maori land direct (Sorrenson, 1981: 177). It provided a particularly effective means of alienating Maori land, one of its worst consequences being that it began the individualization of land. The net effect of this legislation on tribal communities has been that:

(i) succession to titles has separated those who have the right to determine the occupier and the terms of his occupation, from the occupier and, to an increasing extent, from the community itself; (ii) pastoral production by occupiers has dismantled the co-operative economic structure of family and community.

(Kawharu, 1977: 301)

The Land Wars of the 1860s, coupled with the individualization of Maori land title, resulted in substantial economic deprivation, but it did not expunge the spiritual and cultural attachment Maori have to the land, although Reeves, writing in 1898, would have us believe otherwise:

Partial civilization has been a blight to their national life. It has ruined the efficacy of their tribal system without replacing it with any equal moral force and industrial stimulus. It has deprived them of the main excitement of their lives – their tribal wars – and given them no spur to exertion by way of substitute. It has fatally wounded their pride and self-respect, and has not given them objects of ambition or preserved their ancient habits of labour and self-restraint. A hundred years ago the tribes were organized and disciplined communities. No family or able-bodied unit need starve or lack shelter; the humblest could count on the most open-handed hospitality from his fellows. The tribal territory was the property of all . . . The chief was not a despot, but the president of a council, and in war would not be given the command unless he were the most capable captain.

(Reeves, 1987: 61)

Reeves correctly captured the essence of tribalism but his observations on the effects of the development of a capitalist market for land on the efficacy of tribal government coupled with the belief that tribalism would disappear are incorrect. Certainly a concerted effort was made to assimilate Maori into a capitalist culture. For example, Ward (1983: 187) describes some of the justifications used. He quotes a government official of the day stating that the settler desire for land could not be considered greed but rather an anxiety to extend settlement. Settlers were not seeking individual wealth but the spread of civilization. Others, according to Ward (1983), argued that the free trade in land that the Maori were exposed to was a 'healthy play of individual competition'. The very ruthlessness of capitalist competition and the grab for land was thrust upon Maori society without any moral or ethical concern. However, tribalism did not disappear nor was the tribal nature of Maori society destroyed; rather, it accommodated itself in complex and varying ways for the new economic and social relations of the time.

By the late nineteenth century, the extent of land alienation, including millions of acres confiscated or illegally purchased (*AJHR*, 1908, 1921, 1928), resulted in an indigenous population barely able to make a living through subsistence farming. Consequently many provided contract or casual labour to Pakeha farmers (Sutch, 1969: 84). But while this loss of land may have disrupted tribal society the fact that Maori labour was organized on the tribal notion of communalism means that these new economic realities were adapted to distinctive tribal ways:

> In the North, small migrant groups found work away from the village, returning regularly to sustain traditional kinship based relationships. The Kingites . . . mobilize[d] a large labour force on tribal lands. . . On the East Coast . . . as in Northland, migrants continued to identify with their home communities and take part in traditional exchanges there. In the Wairarapa, . . . most economic activity was directed towards sustaining traditional economic relationships.
>
> (Andrews, 1975: 81)

In the Waikato, communal plantations had to meet the daily household needs as well as sustain the gatherings of the King movement (Kawharu, 1977: 84). Many of the economically unsustainable blocks of land resulted in a Maori workforce that had to become relatively mobile and this, of course, did disrupt the traditional tribal way of life. In the North, most of the migration was to the gum fields, although some found work in transport services, resulting on occasions in entire settlements being deserted by all but the very old and very young. While workers movement tended to be outside the traditional kin-based groups, relationships within and between families, according to Andrews (1975: 82), were little disturbed since, for many, participation in a money economy was simply a new means of fulfilling traditional obligations in giving bigger feasts or making gifts to a wider range of kin.

By the early twentieth century the Maori population was largely dispossessed of its lands (Firth, 1972, Metge, 1976, Kawharu, 1977).[7] The centralized administrative system of government permitted the excessive alienation of Maori land and didn't change even in 1899 when James Carroll became the first Maori to gain a seat in Cabinet. Holding the portfolio of Minister of Native Affairs from 1899–1912, Carroll attempted to have the tribal nature of Maori society legally recognized and was instrumental in having two pieces of legislation passed which did delegate some powers to the tribes – but only on a social level and certainly not with regard to Maori land alienation. For example, the Maori Councils Act of 1900 set up district or community councils to promote Maori welfare, and the Maori Lands Administration Act of 1900 was a system of Maori-dominated land councils that encouraged land leasing. Paternalistically, it was considered to be in Maori interests to lease land since it would slow down the rate of Maori land sales, but land leasing is still a form of alienation.

The Maori Councils Act 1900 appeared to recognize that Maori organization took place at a local or community level since Maori councils

were formed in nineteen tribal districts essentially to operate as a form of local self-government with the objective of promoting welfare programmes. According to King (1981: 290) the covert plan of government – and hence the support for the legislation – was to undermine support for Maori movements such as *Kotahitanga* and *Kingitanga* which were providing tribal unity, leadership, and also resisting further land alienation in its various forms. However, the councils tended to be underfinanced, were generally ineffective and within ten years were basically impotent. Many of the tribes perceived the government idea of Maori councils as impinging on their tribal independence and so refused to co-operate with the Act.

Due to pressure from the settlers for more land, the Land Councils were transformed into Land Boards in 1905 and membership became dominated by Pakeha rather than Maori. The consequent effect was that Land Boards tended to serve Pakeha (to facilitate the sale of land from Maori to Pakeha) rather than Maori interests, and they removed the tribal nature from which the Councils had originally operated (King, 1981: 285). Pakeha land purchases continued unabated. It wasn't until the 1940s that any further recognition was given to communal Maori social organization.

The post-war era

Until 1945, three-quarters of the Maori population remained rural while the Pakeha population congregated in the main urban areas (Pool, 1991: 123, 105). Butterworth (1974) describes the 1920–50 period as a rural Maori renaissance even though there was insufficient land to support the people, and in spite of the fact that most of the land retained was only economically marginal at best (Dalziel, 1990). Maori disaffection with the Pakeha resulted in a self-imposed isolation which helped to retain and consolidate the community or tribally based organization of Maori life.

Relative isolation was not to last, however. Maori were soon called up to actively participate in World War II and Maori tribal structures were utilized for the war effort very effectively. Those Maori who volunteered for overseas service were allotted to different companies according to their tribal areas. 'A' company was *Tai Tokerau*, 'B' Company was *Te Arawa*, 'C' company *Tai Rawhiti*. Collectively the Maori Battalion could be called pan-tribal, but its internal structures were very definitely tribal. The cohesiveness and solidarity of the Maori Battalion worked because it was based on an authentic Maori model rather than being centred on some Western egalitarian model which individualizes social and political relations, generally in terms of individual freedom and individual rights.

The Post World War II period was a time of accelerated social change in New Zealand, and industrialization and increasing employment opportunities meant that a rapid urbanization of Maori took place. The post-war era threatened the strength of the tribal base, mainly because of migration from tribal to urban areas (see Pool, 1991: 153). Even then, government policy recognized Maori geographically rather than tribally. A substantive piece of legislation that Metge (1976: 207) argues was 'to give Maoris a degree of

self-government' was the Maori Social and Economic Advancement Act of 1945. The Act was designed to 'make provision for the social and economic advancement and the promotion and maintenance of the health and general well-being of the Maori community' (s 1). In other words, the objective was to improve the socio-economic status of Maori people. The Act provided for 'tribal' committees that operated both at a flax-roots (local) level as well as at the regional level with functions regulated so as to be involved with social welfare and *marae* (local community) administration. Unfortunately, there was very little political autonomy, let alone self-government. The Crown delegated the implementation of the welfare policies, under the direction of the Department of Maori Affairs, to the Maori committees which, according to King (1981: 295), numbered 381 by 1949. The reality of the operations of the committees was that they did not function on a tribal basis. Membership was open to any Maori who resided in a particular area; kinship and tribal links were not a required requisite. Geographic rather than tribal rights were the basis of the 'tribal' committees and their membership, and while the term 'tribal committee' was in common usage for many years it was less than satisfactory (Metge, 1976: 208). Ostensibly this Act was to promote development at a tribal level but the small allocation of funds hardly allowed for any tribal initiatives and anyway virtually all sections of the Act were 'subject to the approval of the Minister'. Recognition of tribal or community organizations was tightly controlled by the Crown.

The rapid urban migration of Maori after World War II subjected Maori to tremendous cultural pressures so that modifications to the traditional way of life had to be made in order to survive (see Walker, 1990; Metge, 1976; Oliver and Williams 1981; Salmond, 1976). Demographic changes provided government with additional opportunity to try and assimilate Maori and to impose structures that denied tribalism and traditional leadership roles, since most *kaumatua* (tribal elders) remained on their traditional rural lands. Hence a change could be seen in the political climate by the 1960s.

Government policy relating to Maori Affairs in the 1960s was aimed at 'integrating the two species of New Zealanders' as recommended by the Report on the Department of Maori Affairs (Hunn, 1960). The Hunn Report acknowledged the social inequalities between Maori and Pakeha and integration rather than assimilation became the stated objective.[8] The solution to the 'Maori problem', according to Hunn, was to blatantly deny and remove any implicit recognition of established tribal authority. The report promoted the urban drift as the quickest and surest way of integrating the two 'species' of New Zealanders. A large movement of Maori from the economically depressed rural areas to the cities was quite evident by the late 1950s (see Pool, 1991) and government welfare policies for Maori in the 1960s centred around providing additional housing and vocational training. In the 1960s integration leading to assimilation was clearly evident in the 'pepper-potting' policy for housing.

In Rotorua, Tauranga and certain country areas . . . blocks of Maori land have had to be subdivided into building sites, thus laying the foundations

consciously but regretfully, for all-Maori settlements . . . Investigation is under way as to the possibility of buying . . . sections from the Maoris and reselling them to Europeans to achieve a mixed community.

(Hunn, 1960: 41)

Tribal segregation and concentration was considered to be an obstacle to assimilation (Trlin, 1984: 173).

The paternalism inherent in the Hunn Report became the basis of government policies towards Maori in the 1960s. For example, Maori committees, when first set up under the 1945 Maori Social and Economic Advancement Act, were called 'tribal' committees. The 1962 Maori Welfare Act, however, omitted the word 'tribal', which conformed to the explicit 'integration' message of the Hunn Report. The renamed Act of 1962 still allowed for people from different tribes to come together and in 1978 there was a total of 367 elected Maori committees (Stokes, 1978: 36). The non-tribal intent of the legislation is evident when one looks at the substantial number of committees in relation to the existence of approximately twenty-three major tribes (Ritchie, 1990: 5).[9] Additionally, the 1962 Act added two further hierarchical tiers to the structure of the local councils, establishing district Maori councils and a national New Zealand Maori Council.

Given that there were only nine district Maori Councils, each of which provided three members on the New Zealand Maori Council, the district Councils and the national Council cannot be seen to be truly representative of Maori tribes. Their structure is based on regionalism and does not necessarily have a membership structure which is representative of the local tribespeople. Indeed, according to Metge (1976: 209) some of the councils, such as those in Auckland and Wellington, represented over 30,000 Maori while others represented districts of only 500 or so people. Furthermore, because each district Maori Council is subject to the control of the New Zealand Maori Council and is required to act in accordance with all directions, general or special, given to it by that Council (Maori Welfare Act, 1962, s 16), it seems reasonable to conclude that autonomy and limited sovereignty would be difficult to exercise under these conditions. It is the very nature of tribalism which has prevented Councils from acting on behalf of the tribes but, once again, government was determined not to recognize Maori on a tribal basis. Eventually the Maori Welfare Act (1962) was renamed the Maori Community Development Act and this came into force in 1981 but there were no substantive changes to the Act. Any paternalistic connotations of the title were removed, but this did not alter the basic government attitude towards Maori people. The 'tribe' was still not acknowledged in law.

Under the Labour government of 1984–90 the agenda was set to be changed. Labour promised to recognise '*iwi*' or tribal authorities and passed the Runanga Iwi Act 1990 to allow tribal authorities to implement programmes on behalf of government in a manner more consistent with the tribal values of the Maori. This was a response to a national Economic

Summit (Hui Taumata 1984) between government and Maori tribal representatives which concluded with a call to government for limited *tino rangatiratanga*: that is, tribal control of services to Maori people. Since government had failed to ensure Maori parity with the Pakeha (European) on any socio-economic indicator, the 1984 summit requested that government reassess its policies and programme-delivery services. The summit suggested to government that the tribes themselves best knew the needs of their people. If equality and equity were to be achieved between the indigenous people and those of the dominant culture, then Maori people operating from their traditional base of tribalism could, at the very least, do no worse than government. It was argued that the tribes themselves should be given the opportunity to reduce social, economic and cultural inequalities. The principles agreed to at the 1984 Hui Taumata were that Maori objectives needed to be defined by Maori and that Maori needed to have control of resources through a Maori delivery system, for example Maori Trust Boards, tribal authorities or other similar tribal organizations (see proceedings of the Maori Economic Development Summit Conference 1984).

The elected National Government of 1990 under the guidance of its new Minister of Maori Affairs (Mr Winston Peters), very quickly set in motion the necessary legislation to repeal the Runanga Iwi Act 1990 and, by 13 December 1990, what was believed to have been a move towards the decentralizing of government power to the tribes is now once again being centrally controlled by national government (see the *Ka Awatea* Report, 1991). The Maori Affairs policies of the 1990 National Government indicate that government would prefer to deal with Maori pan-tribally rather than on an individual tribal basis. It has negotiated with an organization that is a confederation of Maori tribes (National Maori Congress)[10] for the dispersal of surplus Crown-owned railways land; contracted with a pan-Maori women's organization (Maori Women's Welfare League) for the delivery of a smoke-free health programme (*Dominion*, 2 July 1992); and negotiated a fishing deal in 1992, with Maori who only represent a few Maori tribes.[11]

The fishing deal has caused considerable dissension among Maori tribes. Mahuika of Ngati Porou (*New Zealand Herald*, 25 September 1992) encapsulates the considerable ill-feeling towards the fishing deal with his comment that it may be a sound commercial venture but the cultural price was high and individual tribes should have the right to determine their own affairs. Various tribal organizations[12] objected to being overridden by the fishing deal, which government insisted was a 'full and final' settlement terminating Maori commercial fishing rights guaranteed under the Treaty, and went to the Court of Appeal in an attempt to prevent the deal going ahead but the case was dismissed.

That is not to say that pan-Maori organizations do not have a place in Maori politics. The New Zealand Maori Council has had considerable political impact in recent years. It was made a statutory body by a National Government, it receives some government funding, and it is used by the

National political party as an advisory body on Maori affairs similar to the manner in which the Labour Party uses its four Maori Members of Parliament,[13] hence its strong identification with the National Party. The Council has been politically active since its inception and while its primary focus has been that of land it has also been involved with many significant political and social issues (Walker, 1990: 207–8). For example, it applied to the High Court in March 1987 to prevent the transfer of Crown assets to State Owned Enterprises, claiming that this was unlawful and contrary to section 9 of the State Owned Enterprise Act 1986, which states that 'Nothing in this Act shall permit the Crown to act in a manner that is inconsistent with the principles of the Treaty of Waitangi'. Indeed the Council was successful in its application insofar as its actions were responsible for the passing of the Treaty of Waitangi Act 1988. The Maori Council has taken the Crown to court over forestry ownership and, while not preventing the sale of forests, it did prevent the land from under the forests being sold. It took part in negotiations that resulted in 10 per cent of the New Zealand fishing quota being obtained for Maori fishing and members of the New Zealand Maori Council have played a substantial part in obtaining for Maori 50 per cent ownership of the Sealords fishing company.

Nevertheless, there are a considerable number of Maori who believe the pan-tribal New Zealand Maori Council should relinquish its political role to that of the National Maori Congress which has approximately forty-five tribes affiliated to it. Hohepa (Nga Puhi runanga chairperson), has argued that the New Zealand Maori Council has not served the interests of Maori well, and Mahuika (Ngati Porou), says that the Council has been restricted because of its regional base. He is also of the opinion that Maori are more comfortable with the confederation structure of the National Maori Congress (*New Zealand Herald*, 18 July 1990). But there is clearly an important and significant role that the New Zealand Maori Council has taken in pursuing Maori interests which should be recognized as being complementary to tribal interests although it does not represent Maori tribes. No pan-Maori organization or confederation is able to speak on behalf of all Maori tribes.

Acceptance and recognition of the tribe by non-Maori in contemporary times is still difficult. Even cases that go before the Waitangi Tribunal to look into breaches of the principles of the Treaty of Waitangi can only be brought by either a Maori, or a group of Maori. A tribe is not recognized as a legal entity and so any collective action taken by the tribe today is usually carried out by tribal organizations recognized under the Maori Trust Board Act 1955.

Non-Maori people in New Zealand tend to deny or ignore the existence of tribes in New Zealand, or at the very least to minimize their importance and persistence. Attitudes of paternalism toward the Maori have been and are still common. Elsdon Best, an ethnologist writing in 1924 stated: 'The peculiar communal system under which the native lived prevented the development of true family life' (Best, 1974: 100). Eric Schwimmer commented that the loss of land destroyed Maori social structure since the chief no longer had *mana* (pride, prestige, status) over the whole of the tribe's

territories and that 'individuals henceforth stood essentially on their own, even though a sentimental tribal cohesion continued' (1966: 122). A former Prime Minister, Mr G. Palmer, as recently as 1988, was quoted as saying, 'because Maori society is based on *iwi* (tribes) there is no one clear set of Maori opinion. From a political point of view that takes a lot of getting to grips with' (*New Zealand Herald*, 7 June 1988). It is to be hoped that after 153 years the government will soon 'get to grips with' the reality of Maori tribal organization.

Conclusion

The effect of colonization and attitudes of paternalism and assimilation on Maori tribes has been disparate and experiences differ from tribe to tribe – hence Maori insistence on reminding the world that Maori people are *whanau, hapu, iwi* then Maori. In other words, collectively they may be Maori but primary identification is with the family, the sub-tribe and the tribe. The Tainui tribe in the Waikato, for example, have suffered heavily with *raupatu* (land confiscation) following the Land Wars of the 1860s and 1870s. Ngati Porou of the East Coast, on the other hand, lost little land but has had many people migrate to other regions of the country (most do, however, retain links with the people at home). The central North Island tribe Tuhoe, is a very closely knit tribe which has a very strong economic base from which it operates. In the south-west of the North Island the Taranaki tribes, however, lost most of their lands during the 1860s and since then have had a constant struggle to provide for their people. Over the years most Taranaki Maori have had to migrate out of the area to find employment.

Nevertheless all Maori tribes have had to cope, in varying degrees, with technological adjustment, land losses and the continuing processes of change. Unfortunately, this process has been one of dependency rather than one of control. Maori tribes have not been able to determine their own course of development. Economic dependency has risen because of the lack of a resource base. Without control or ownership of land, forests or fisheries (as guaranteed under Article Two of the Treaty) it is little wonder that many Maori have been dependent upon state handouts to survive.

The move from rural subsistence living to a capitalist wage culture pressurized traditional values and lifestyles but the tenacity of tribalism, Maori identity and Maori culture prevailed. Walker (1990) clearly articulates the struggles faced by the newly urban Maori and many of the determined efforts made to avoid cultural assimilation. Maori voluntary and religious organizations such as the Maori Women's Welfare League, the Ratana and Ringatu churches, as well as tribal organizations and sports and cultural groups had, by the end of the 1960s, ensured Maori values and culture survived being transplanted into an urban environment and paved the way for the emergence of contemporary political activism. *Nga Tama Toa* (young warriors) protested the Treaty of Waitangi celebrations; Dame Whina Cooper led the Land March of 1975; the occupation of Bastion Point

in 1977 received tremendous media coverage; as did the 'racist parody of the *haka*' performed by Auckland University engineering students (Walker, 1989: 40). In recent years there has been continual protest over the 6 February Waitangi Day celebrations, controversy which continues because it is argued that Waitangi Day celebrates a Treaty of broken promises.

Culturally, initiatives such as *kohanga reo* have been a great success in providing pre-school children (and their parents) with a place to learn their own language, *taha Maori* has been introduced into most primary schools, and by 1989 there were 6,744 children in bilingual classes. Furthermore, by 1990 there were also six *Kura Kaupapa Maori* – schools that provide total immersion in Maori (*Ka Awatea*, 1991: 17). Initiatives such as this, coupled with the pride of Maori in international art exhibitions such as *Te Maori*, along with the impact of the Waitangi Tribunal on Maori and non-Maori alike, have heralded a raising of consciousness, a renewal of pride in things Maori and a determination to use the due process of law to oblige 'both' parties to recognize and honour the terms of the contract that was signed in 1840 between the Crown and the Maori people.

The setting up of the Waitangi Tribunal in 1975 to consider Maori grievances relating to the Treaty of Waitangi and particularly the 1985 legislative changes which extended the tribunal's jurisdiction to consider claims dating back to the 1840s, has seen a restoration of *mana*, particularly for and of the tribe. While the Waitangi Tribunal can only make recommendations to Parliament and has no powers to implement or realize any of its recommendations, it has had the effect of legitimizing and acknowledging the tribal grievances and injustices of the past. Self-esteem, tribal confidence and *mana* have risen accordingly.

Maori political and economic strength is derived from the tribe. Virtually all Maori land incorporations and trust boards operate from this basis, and since they hold the purse strings for various Maori initiatives, so they must also be the source of strength and inspiration (Mahuta, 1978: 26). Mahuta argues that the resurgence in cultural awareness, or the lifting to consciousness of cultural values and institutions, has been strongest at the tribal level:

> Vine Deloria argues that from the foundation flows the sense of 'peoplehood' which ultimately acts as a barrier between the individual and outside intervention. Applied to the Maori context, the concept of tribalism can be translated in terms of *whanaungatanga*, or relationship based on kinship or fictive ties between members of the group. What Deloria seems to be saying is that the future of all modern society lies in the newly-defined tribal sovereignty.
>
> (Mahuta, 1978: 2)

Since the signing of the Treaty of Waitangi, Maori people have accepted the imposition of the British Westminster model of 'responsible' government, thus legitimizing the Crown's role in New Zealand. Maori have also respected the ancient Pakeha Magna Carta doctrine as well as Pakeha traditions. At the same time, political and legal recognition of Maori tribalism by the Pakeha has been ignored. Tribalism and the concepts of

communality, the traditions of individual obligations and accountability to the community and the notion that political power is best exercised by consensus decision-making undermines the philosophical, individualistic principles of Western liberalism, capitalism and representative government.

Fortunately, the heightening self-confidence and an expanding 'educated' Maori élite who are reclaiming their own heritage and reinforcing the strong societal base on which Maori people have developed is recognition of both the persistence of tribalism and of the critical role the tribe plays in Maori development. In contemporary times the strength of the Maori people still lies in the concept of tribal affiliation.

Notes

1 This is not necessarily the case with all tribal societies. In Africa, for example, this definition would effectively exclude many groups which have a residential basis such as the Luo, Lugbara or Gusii (Gulliver, 1969: 10).

2 Buck's (1977: 435) experience in translating a Maori orator to a mixed audience is enlightening: 'The speaker insisted on reciting each of the ten Po in spite of my whispered suggestion that he avoid monotony . . . What appeared monotonous to the European part of the audience gave pleasure to the Maori present and above all, no matter what errors might be revealed by a comparative study, the tribal version was the correct rendering for that tribe.'

3 See the Royal Commission on Social Policy which 'recognises that policies in the past have been restricted by narrow perspectives and department isolation' (1988: 75).

4 The Waitangi Tribunal was set up by government in 1975 to consider claims from any Maori who considers he or she, or any group of Maori of which he or she is a member, is prejudiced by any legislation, policy of practice by or on behalf of the Crown which is inconsistent with the principles of the Treaty of Waitangi (Department of Statistics, 1990: 195).

5 The *Kingitanga* or King movement was an attempt to halt colonization by uniting tribes into an anti-land-selling confederation (Sorrenson, 1981: 180).

6 *Kotahitanga* (unity) like the *Kingitanga* movement sought to unite the tribes to prevent further losses of Maori land and it also attempted to establish a separate Maori parliament.

7 In 1990 the total of Maori freehold land, which is subject to the jurisdiction of the Maori Land Court, totalled only 1,305,698 hectares out of 26,900,000. This is only 4.85 per cent of the total land mass of New Zealand (Department of Statistics, 1990: 415, 416).

8 Policies do not reflect any substantive move away from the assimilationist approach, however.

9 The 1991 census identified 82 *iwi*, Nga Puhi being the largest with 92,976 members and a group with only 3 members.

10 The National Maori Congress which was established in 1990, is headed by Ngati Tuwharetoa paramount chief Sir Hepi Te Heuheu; te arikinui Dame Te Atairangikahu of Tainui; and until his death in 1992 the Ratana church leader Reo Hura. It has approximately 45 *iwi* affiliated to it.

11 Government agreed to provide a Maori Fishing Commission with $150 million to buy a half share of Sealords Products Ltd in a joint venture with Brierly Investments. The Crown also agreed to allocate 20 per cent of new fish quota to

Maori fishing interests if other species are added to the quota. But all Maori litigation over commercial fishing claims is to be withdrawn.

12 Te Runanga O Wharekauri, the Ngatiwai Trust Board, Te Runanga A Rangitane O Wairau.

13 Four parliamentary seats have provided Maori with separate representation since 1867. In the 1930s the Labour Party attended to the social welfare needs of Maori and since then the four Maori parliamentarians have aligned with the Labour Party.

References

AJHR (1908, 1921, 1928) *Appendices to Journals of the House of Representatives*.

Andrews, C. L. (1975) 'Aspects of development, 1870–1890', in *Conflict and Compromise: Essays on the Maori Since Colonisation*, I. H. Kawharu, editor, Wellington: A. H. & A. W. Reed.

Best, E. (1974) *The Maori As He Was*, New Zealand: A. R. Shearer, Government Printer.

Buck, P. (1977) *The Coming of the Maori*, New Zealand: Whitcoulls Ltd.

Butterworth, G. V. (1974) *The Maori People in the New Zealand Economy*, Auckland University: Department of Anthropology.

—— (1989) *End of an Era. The Department of Maori Affairs 1840–1989*, New Zealand: GP Books.

Dalziel, P. (1990) 'Economists' analyses of Maori economic experience, 1959–1989', Canterbury, New Zealand: unpublished paper, Department of Economics and Marketing, Lincoln University.

Department of Statistics (1986) 'Maori population and dwellings', *Census*.

—— (1987a) *New Zealand Census of Population and Dwellings*, Series C, Report 9.

—— (1987b) *New Zealand Official Year Book 1987–88*, Wellington.

—— (1990) *New Zealand Official Year Book 1990*, Wellington.

—— (1992) *New Zealand Official Year Book 1992*, Wellington.

Dominion 30 August, 7 November 1991, 30 January, 29 February, 14 May, 22 May, 2 July, 7 July, 13 July, 14 July, 1 August, 5 August, 1 September, 4 September 1992.

Firth, R. (1972) *Economics of the New Zealand Maori*, Wellington: Government Printer.

Gulliver, P. H. (1969) editor, *Tradition and Transition in East Africa*, London: Routledge & Kegan Paul.

Hunn, J. K. (1960) *Report on the Department of Maori Affairs*, New Zealand: Government Printer 24 August.

Ka Awatea (1991) Report Commissioned by the Minister of Maori Affairs, New Zealand.

Kawharu, I. H. (1977) *Maori Land Tenure*, London: Oxford University Press.

—— (1989) editor, *Waitangi. Maori and Pakeha Perspectives of the Treaty of Waitangi*, Auckland: Oxford University Press.

King, M. (1977) *Te Puea. A Bibliography*, Auckland: Hodder & Stoughton.

—— (1981) 'Between two worlds', in *The Oxford History of New Zealand*, Wellington: Oxford University Press.

Mahuta, R. (1978) 'Race relations in New Zealand' in Stokes (1978).

—— (1986) 'Planning for major change. A Maori viewpoint. The Tainui case', paper presented at the NZ Planning Institute Conference, New Zealand, 15 May.

Maori Economic Development Summit Conference (1984) *He Kawanata*, 31 October.

Metge, J. (1976) *The Maoris of New Zealand: Rautahi*, London: Routledge & Kegan Paul.

Minister of Maori Affairs (1991) *Ka Awatea*, New Zealand.

New Zealand Herald, 7 June 1988, 28 July 1988, 30 August 1988, 18 July 1990, 25 September 1992.

Oliver, W. H. and Williams, B. R. (1981) editors, *The Oxford History of New Zealand*, Wellington: Oxford University Press.

Orange, C. (1987) *The Treaty of Waitangi*, New Zealand: Allen & Unwin.

Pool, I. (1991) *Te Iwi Maori. A New Zealand Population Past, Present and Projected*, New Zealand: Auckland University Press.

Reeves, W. P. (1987) *The Long White Cloud*, New Zealand: Penguin Books.

Ritchie, J. R. (1988) 'From devolution to evolution', in *Working with Maori Authorities*, New Zealand: unpublished paper, Centre for Maori Studies & Research, University of Waikato.

—— (1990) 'Tribal development in a Fourth World context. The Maori Case', working paper.

—— (1992) *Becoming Bicultural*, New Zealand: Huia Publishers: Daphne Brasell Associates Press.

Royal Commission on Social Policy (1988) *Future Directions*, Volume 11, New Zealand.

Salmond, A. (1976) *Hui*, New Zealand: Reed Methuen.

Schwimmer, E. (1966) *The World of the Maori*, Wellington: A. H. & A. W. Reed.

Sorrenson, M. P. K. (1981) 'Maori and Pakeha', in *The Oxford History of New Zealand*, H. Oliver and B. R. Williams, editors, New Zealand: Oxford University Press.

Stokes, E. (1978) editor, *Nga Tumanako*, National Conference of Maori Committees, August.

—— (1981) 'Rural settlement on Maori land: the role of section 438 trusts', paper presented at the New Zealand Geography Conference, Wellington, New Zealand, August.

—— (1990) *Te Raupatu o Tauranga Moana. The Confiscation of Tauranga Lands*, a report prepared for the Waitangi Tribunal, University of Waikato, New Zealand.

Sutch, W. B. (1969) *Poverty in Progress*, Wellington: A. H. & A. W. Read.

Trlin, A. (1984) 'Changing ethnic residential distribution and segregation in Auckland', in *Tauiwi. Racism and Ethnicity in New Zealand*, P. Spoonley, C. Macpherson, D. Pearson and C. Sedwick, editors, New Zealand: The Dunmore Press.

Waitangi Tribunal (1988) *Muriwhenua Fishing Report: Report of the Waitangi Tribunal on the Muriwhenua Fishing Claim*, New Zealand: Government Printer.

Walker, R. (1978) 'The role of Maori committees and the school committee', in Stokes (1978).

—— (1984a) 'The political development of Maori people in New Zealand', paper presented to the Conference of Comparative models of Political Development and Aboriginal Self-determination, Calgary, 16–17 March.

—— (1984b) 'The genesis of Maori activism', in *The Journal of the Polynesian Society*, September: 267–82.

—— (1985) *Nga Tumanako* Maori Representation Conference.

—— (1987) *Nga Tau Tohetohe Years of Anger*, New Zealand: Penguin Books.

—— (1989) 'The role of the press in defining Pakeha perceptions of the Maori', in *Between the Lines*, P. Spoonley and Walter Hirsh, editors, New Zealand: Heinemann Reed.

—— (1990) *Ka Whawhai Tonu Matou Struggle Without End*, New Zealand: Penguin.

Ward, A. (1983) *A Show of Justice*, New Zealand: Auckland University Press/ Oxford University Press.

JEFFREY SISSONS

TALL TREES NEED DEEP ROOTS: BICULTURALISM, BUREAUCRACY AND TRIBAL DEMOCRACY IN AOTEAROA/NEW ZEALAND

Introduction

In 1968, Eric Schwimmer introduced the term 'biculturalism' into New Zealand academic discourse in the introduction to his book *The Maori People in the Nineteen Sixties*. It was not until the early 1980s, however, that the term gained wider public acceptance. Writing in 1976, Metge noted that although Schwimmer's work had 'greatly stimulated discussion at the academic level', the term 'biculturalism' had 'hardly passed into general currency' (Metge, 1976: 309). A major difficulty, as Metge reported it, was that the concept encouraged a restrictive emphasis upon two main groups. Metge suggested that a relationship of understanding and equality between Maori and Pakeha (European) might provide a 'model' for other ethnic-group relationships in New Zealand. By 1982 the term 'biculturalism' had gained a measure of official recognition. In his 'Opening Statement' in *Race Against Time*, the Race Relations Conciliator proposed that 'A New Zealand national identity must be based on a firm foundation of bi-culturalism through which multi-culturalism can emerge' (1982).

In the same year, Ranginui Walker, a Maori academic who was frequently called upon by the media to give authoritative voice to Maori concerns, took up the bicultural cause in his weekly *Listener* column:

> The Pakeha in-word 'multi-culturalism' has negative connotations for Maoris because it denies the basic reality of biculturalism. New Zealand is a bicultural country. The primary task of the Maori is to convert the Pakeha to recognise that reality and to modify the country's institutions to incorporate compatible Maori values. Biculturalism is predicated on the basis that there are *tangata whenua*, indigenous people of the land, and non-indigenous colonisers.
>
> (Walker 1982)

Cultural Studies 9(1) 1995: 61–73

In the ensuing idealist debate over the appropriateness of different brands of 'culturalism' ('mono', 'bi', or 'multi'), Schwimmer's original formulation was largely forgotten. For Schwimmer, biculturalism would be of limited value unless it was accompanied by 'inclusion'. This, in a usage derived from Talcott Parsons, referred to full citizenship in three senses: equal civil rights; full sharing in the processes of government and the exercise of power; and equality of resources and capacities necessary to make equal rights into fully equal opportunities (Schwimmer, 1968: 11). Although this concept of inclusion was of potentially greater political and economic significance for ethnic relations in New Zealand, it was only the elusive, poorly defined term 'biculturalism' that was taken up by leaders and policy-makers. Partly, this was a reflection of a more widespread idealization of ethnicity in New Zealand during the 1970s and 1980s (Sissons, 1992), but it also reflected a reluctance by governments to seriously address questions of Maori political and economic empowerment. As I have noted elsewhere (Sissons, 1994), growing economic and social inequalities between Maori and Pakeha, combined with increasing pressures for greater Maori autonomy, encouraged an elaboration of bicultural symbolism. However, counter-pressures from a predominantly Pakeha electorate ensured that such state-directed displays rarely prefigured institutionalized power-sharing.

Although the concept of 'inclusion' had become divorced from that of 'biculturalism' by the early 1980s, the link between the two was to be re-established in a new form during subsequent debates about the significance of the Treaty of Waitangi. This treaty, signed by Maori leaders and representatives of the British Crown in 1840, promised that, in accepting British governance (*kawanatanga*), Maori would retain their chiefly autonomy (*rangatiratanga*) and the undisturbed possession of their lands, fisheries and other treasures. From 1984 the Treaty was widely represented as a charter for social partnership, promising equal recognition of Maori and Pakeha cultures (especially languages) and, less conservatively, as a contract promising Maori self-determination. In effect, the latter meant *at least* full Maori economic and political inclusion within the wider nation as proposed by Schwimmer. Ironically, therefore, there is a sense in which the Treaty discourse of the late 1980s transcended the bicultural rhetoric of the early 1980s only to rediscover Schwimmer's original 1960s policy agenda. Of course, Schwimmer's generally conservative proposals did not envisage that economic and political inclusion would be pursued in terms of the Treaty or that it would entail tribally based self-determination. He did, however, stress that inclusion should not require abandoning Maori forms of organization. Inclusion was not equivalent to assimilation or integration.

The term 'renaissance' properly refers to a revival of art, linguistic forms and other aspects of 'high' culture based on the models of an earlier era. It is not inaccurate, therefore, to describe the rapid expansion of Maori language programmes (especially *kohanga reo*, Maori language pre-schools), Maori literary and artistic achievements (including the exhibition of traditional art, *Te Maori*, which opened in New York in 1984, and Maori television) and the growth of Maori Studies in universities during the 1980s as a 'Maori

renaissance'. However, these highly public developments in what Schwimmer termed the 'expressive aspects' of Maori culture are merely the more visible manifestation of a push for political and economic inclusion that has been gathering momentum over the past decade. One indicator of this struggle has been a bewildering proliferation of new organizations articulating and pursuing Maori aspirations. These range from local community groups to new tribal, pan-tribal and state structures. Indeed, rather than view the Maori renaissance as primarily a 'cultural' phenomenon directed towards biculturalism, I suggest it might be more usefully regarded as an essentially political phenomenon directed towards full inclusion in the three senses proposed by Schwimmer. An obvious objection to this view is that the ultimate political goal for many Maori leaders, past and present, has been the recovery of *tino rangatiratanga* (absolute autonomy) with respect to the tribal control over lands, fisheries and culture. While this is certainly so, a deep irony remains in that this path necessarily leads through the prickly thickets of party politics, government legislation and business partnerships, the negotiation of which become ends in themselves.

In this paper I argue that, given the pressures to adapt tribal relations and associated norms and values to the requirements of state bureaucracy and a capitalist economy, political and economic inclusion inevitably furthers the rationalization of Maori tribal life. This rationalization and the associated centralization of knowledge and expertise threatens the participatory-democratic base of the Maori renaissance. Concerted efforts will therefore be required to strengthen this base if the renaissance is to realize its bicultural and emancipatory potential. I develop this argument by first situating the Maori renaissance in relation to the trajectories of other social movements in New Zealand during the 1970s and 1980s. I then go on to discuss, as a case study, efforts by the major South Island tribe, Ngai Tahu, to reconcile the forces of centralized bureaucracy and tribal democracy.

The Maori renaissance as a new social movement

Historically, the recent Maori renaissance has had close ties with women's liberation, peace (anti-nuclear) and environmental movements in New Zealand. All began, or became more significant, as new forms of political action in the early 1970s, influenced by the success of civil rights movements in the United States. Their appearance signalled the beginnings in New Zealand of a transition towards what Offe has termed a new political 'paradigm' (Offe, 1985). Offe argues that in Western democracies prior to the mid 1960s an 'old paradigm' of welfare-state consensus prevailed within which the key political values were growth and security. Economic growth was assumd to be continuously possible and, accordingly, political debate centred around the distribution of rewards via the welfare state and union-management bargaining. Security was provided through (1) welfare-state guaranteed income, health and housing, (2) national defence, and (3) domestic law and order. This dual focus upon growth and security coincided

with an emphasis upon civil privatism. In other words, politics could and should be left to established institutional organizations (political parties, unions, etc.) while the majority of the population involved themselves in a de-politicized sphere of work, leisure and family-centred consumption.

Since the 1970s, the negative consequences of growth, the inability of the welfare state to ensure a fair distribution, particularly in terms of gender and ethnicity, a growing *in*security in terms of employment, nuclear weapons development, and social disorder have seriously undermined the stability of the old paradigm. This has been associated with a progressive breakdown of civil privatism – the personal has become political. As insecurity and the negative consequences of growth impacted on the once more private realms of the family, neighbourhood and community, these realms were opened up to increasing bureaucratic 'colonization'. The resulting politicization took the form of an increasing participation, particularly by students, teachers and others of the new middle class, in 'new social movements' – movements that sought to bridge the gap between a re-politicized civil society and established state institutions. The political 'closure' that had characterized the welfare-state consensus was vigorously challenged, as previously excluded issues and interests were forced on to the political agenda (Scott, 1990).

The arrival, in New Zealand, of a new paradigm, in Offe's sense, was clearly announced with the formation, in 1970–1, of a range of new activist organizations. These included the urban-based Maori activists Nga Tama-toa, the Wellington and Auckland Women's Liberation Fronts, Ecology Action and Peace Media, the latter opposed to French nuclear testing. By 1975, these movements had achieved a strong national presence and were beginning to effectively influence established political structures. The Maori Land March of 1975, during which thousands marched the length of the North Island to demand a halt to sales of Maori land, ensured that continuing Maori land alienation would become a political issue of national significance; International Women's Year conferences, Rape Crisis Centres and Women's Refuges were challenging established patriarchy; the Values Party, a fore-runner to the Green Party, took 5.2 per cent of the total vote in the 1975 general election. By the end of 1984 all of these movements had brought about significant institutional transformations within the state arena. The 'partnership' principles, said to be embodied in the Treaty of Waitangi, were officially adopted, and the powers of the Waitangi Tribunal, an advisory body established in 1975 to report on breaches of the Treaty since that date, were extended. It could now consider all breaches since 1840, the year the Treaty was signed. A Ministry of Women's Affairs and a Department of Conservation were addressing feminist and green issues. Nuclear ships were officially banned from New Zealand ports (Clements, 1988; Dann, 1985; Walker, 1990).

New Social movements occupy an intermediate 'political space' between civil society and the structures of state and capital. In the language of Habermas, they mediate life-world and system, seeking to make the latter more accountable to the former (Habermas, 1987). The strength and

Local life-world	Tribal and Pan-tribal	State system
marae committees	tribal trust boards and runaunga	Te Puni Kokiri (Ministry of Maori Affairs)
Maori Women's Welfare League branches	New Zealand Maori Council	Maori Development Corporation
urban support and activist networks	Maori Women's Welfare League	
culture and youth groups	National Maori Congress	Treaty of Waitangi Fisheries Commission

Figure 1. Examples of political structures linking Maori life-worlds and state system.

continued influence of these movements depends largely upon their retaining an active, relatively informal, life-world dimension as they penetrate and seek to influence systemic structures based on bureaucratic power and instrumental rationality. The institutionalization of Maori women's and green movements within the New Zealand state over the last twenty years or so means that their organizational structures now form a complex web linking local life-world concerns to systemic interests. While this web is potentially empowering of community groups it also facilitates an intensified 'colonization' of their life-worlds by rational bureaucratic administration. This rationalization of Maoridom, women's interests and environmental protection has the potential to stifle democratic challenges to capitalist development and established state structures. Ends are technocratically defined in accordance with systemic priorities and imposed in a top-down manner rather than being negotiated from the bottom up. In order to counter this tendency it is essential for new social movements to retain and defend their ability to set and re-define political agendas at the system level while remaining firmly grounded in local life-world concerns.

For the Maori renaissance this means: (1) ensuring, with legal guarantees, that tribal and pan-tribal organizations have effective inputs into state decision-making and (2) the development and maintenance by these bodies of a strong participatory-democratic base. As shown in Figure 1, Maori tribal and pan-tribal organizations occupy an intermediate position between life-world and system. (This figure illustrates relationships between different organizational forms that underpin the Maori renaissance, and is by no means presented as a comprehensive listing).

The theoretical (and ideal-typical) sliding-scale from life-world organizations to system organizations corresponds to a shift from sites of relatively informal, consensus-based decision-making to arenas of more formal

bureaucratic administration and control. At the life-world end of the scale are kin-groups associated with *marae* (ceremonial spaces with a meeting-house and dining-hall), local women's groups, urban and land protest networks and educational groups. These are locations in which, ideally, consensus decision-making procedures take precedence over those directed by bureaucratic rationality. At the system end of the scale more formal, bureaucratic decision-making ideally predominates. Among the most potentially influential mediating organizations capable of translating life-world interests into the language of the system are tribal trust boards and *runanga* (councils). By forcefully articulating life-world concerns at the systemic level these organizations have the potential to further the democratic empowerment of Maoridom. However, in the pursuit of economic and political inclusion they also have the potential to further its bureaucratization.

Ngai Tahu tribal democracy

One tribal organization that grappled consciously with the contradiction between participatory democracy and bureaucracy during the latter half of the 1980s was the Ngai Tahu Maori Trust Board. This Trust Board was established in 1946 to administer compensation monies paid by the government to the major South Island tribe, Ngai Tahu (or Kai Tahu). During 1988 and 1989, while pursuing major land and fisheries claims before the Waitangi Tribunal, the Trust Board initiated a debate within the tribe concerning possible future representative and administrative structures. In the remainder of this paper I discuss the results and some of the implications of their work in this area. My information is drawn from notes taken during tribal meetings called by the Trust Board and from discussions with Ngai Tahu leaders (See also O'Regan, 1989: 259–61).

The abolition of the Department of Maori Affairs in 1989, in favour of a more decentralized tribal delivery system for government services, forced many tribes to define more explicitly their membership, boundaries and representative structures. The Department of Maori Affairs was replaced by a smaller Ministry of Maori Affairs, charged with research, monitoring and policy-advice functions, and an Iwi Transition Agency, charged with facilitating the establishment of Iwi (Tribal) Authorities, legally constituted corporate identities able to enter into contract with government departments for development projects, job-training, and social welfare service delivery (Fleras, 1991). Complementing this devolution of administration, the government considerably expanded the number of Maori advisers within the public service and associated 'quasi-autonomous' bodies.

At an early stage in this process the Ngai Tahu Maori Trust Board recognized that it would need to maintain a clear distinction between, on the one hand, its own Ngai Tahu policy agenda (*kaupapa*) for managing its own resources and those due to the tribe in compensation for breaches of Articles I and II of the Treaty of Waitangi and, on the other hand, the government's

devolution agenda which merely dealt with services due to Maori people as New Zealand citizens under Article III of the treaty:

If we are going to receive benefits from administering devolution it is because we can deliver more effectively to our tribal structure. Therefore the arguments on the issues of devolution do not have anything to do with your rights as a tribesperson. This is to do with your rights as a citizen. This is an important point to make.

(Speaker at a Trust Board meeting, Arowhenua, 10 December 1988)

At *hui* (meetings) held on *marae* throughout the South Island during 1988 and 1989 there was a widespread consensus that any representative structure established in accordance with the government's devolution agenda had to be accountable to the tribe as a whole. Time and again it was stressed that tribal *mana* (power, authority) must flow from *papatipu runanga* (councils representing local kin-groups) upwards or inwards to their representatives on a tribal council. Consensus decision-making procedures would ideally follow the same pathway.

An initial ideal structure, widely supported by the tribe, was consistent with the desire to maintain a distinction between a life-world of tribal democracy and strategic activities within the sphere of systemic power and procedure, with the latter being accountable to the former. As shown in Figure 2, the Runanganui o Tahu (Great Council of Tahu) would become the major policy-making body for the tribe as a whole. It would reach decisions, usually by consensus, at *hui* involving representatives from each of the tribe's *papatipu runanga*. The resulting tribal policy (*kaupapa-a-iwi*) would become the basis for decisions made by the Trust Board. An executive of this Board would contract with government departments for the delivery of services and the management of work and economic development schemes. This structure placed the legally constituted Trust Board (its membership defined under the Maori Trust Boards Act) under the *mana* of the tribe. In so doing, it would also reconcile two potentially contradictory forms of representation. On the one hand, individuals could influence the actions of the Trust Board through *traditional* channels, expressing their views at *papatipu runanga* and Runanganui levels. On the other hand, the Maori Trust Boards Act required that the eight members of the Trust Board be *elected* through a balloting of individual beneficiaries every three years. The Trust Board would therefore become doubly accountable to the tribe.

In subsequent discussions of this structure at the local *papatipu runanga* level the requirement that the Trust Board be accountable to the Runanganui was consistently endorsed. For example, the Runanga Otakou emphasized that:

Our *papatipu runanga* must be given its proper status as the primary source of influence to the functional base of the *iwi* [tribe]. From the *papatipu runanga* comes direction to the *iwi*, melded together by the wisdom of the Runanganui o Tahu, implemented through the administrative base of the Ngai Tahu Maori Trust Board.

(Runanga Otakou, 1989)

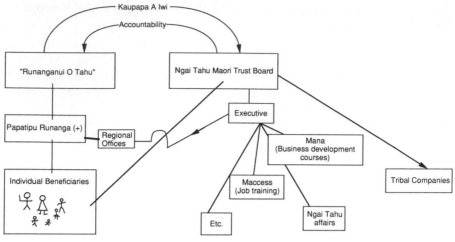

Figure 2. Proposed tribal structure, 1989.

This conception was visually represented by Kuao Langsbury, a member of the Runanga, as *mana* and decisions flowing into a central core from a periphery of *papatipu runanga* (Figure 3).

Ngai Tahu leaders clearly recognized that the results of their structural rethinking would have a crucial influence on the future direction of the tribe's political, economic, and cultural development. In making the Trust Board more accountable to the tribe and by strengthening the participatory

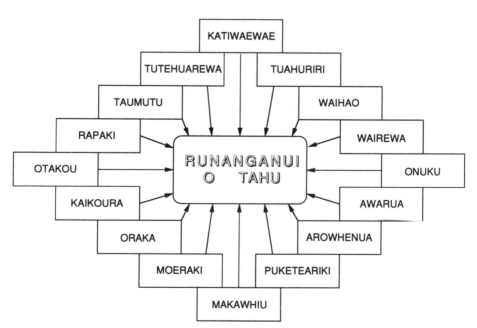

Figure 3. Ideal tribal structure (Runanga Otakou view), 1989.

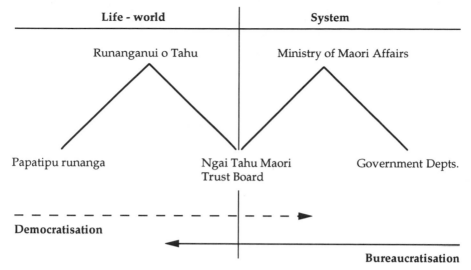

Figure 4. Structural position of Ngai Tahu Maori Trust Board, 1990.

base of the tribe, Ngai Tahu were vigorously defending their autonomy and tribal sovereignty. They were also deliberately positioning the Trust Board to become an intermediary, or buffer, between the tribal life-world of consensus politics and the state system of bureaucratic hierarchy.

Figure 4 shows that, as an intermediary between a tribal life-world of participatory-democracy and a state system of legal control, the Trust Board was to be positioned at the confluence of two potentially opposed forces: democratization and bureaucratization. The ability of the Board to ensure strong local participation in government policy-making while limiting state interference in the affairs of the tribe would depend upon its ability to ensure that the government and its agencies became more publicly accountable to the Runanganui and the *papatipu runanga*. It was stressed that this accountability was required of the Crown as a party to the Treaty of Waitangi. Ideally, there would be a clearly defined line of accountability that began with the Crown, passed through the Trust Board and the Runanganui, and ended with members of the *papatipu runanga*. Again, this ideal was no more than was promised in the Treaty.

But by mid 1990 the Labour Government's devolution agenda was losing support within official circles and was beginning to appear unworkable to many Maori leaders, particularly those living in urban, multi-tribal communities. Following the election of a National Government, the devolution process was officially abandoned and the Runanga Iwi Act, under which Iwi Authorities had been legally defined, was repealed. This meant that the legal personality of Ngai Tahu had to be redefined for the purposes of Treaty claim negotiations and settlement. During 1991, therefore, the tribe debated a number of alternative structures intended to ensure the continuity of its *tino rangatiratanga* (chiefly autonomy), while at the same time securing the necessary government recognition. As a result of

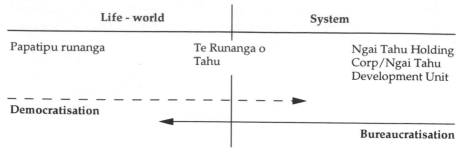

Figure 5. Proposed structural position of Te Runanga o Tahu.

these deliberations, it was decided to seek the abolition of the Ngai Tahu Maori Trust Board and to press for legal recognition, via an Act of Parliament, of the tribal council, now named Te Runanga o Ngai Tahu, as the representative of the tribe's collective interests. The proposed legislation also defines the traditional boundaries of the tribe, specifies tribal membership, confirms a structure of 18 constitutent *papatipu runanga*, and requires the Runanga to adopt a charter to ensure its accountability to the tribe. The charter will specify the manner in which the *papatipu runanga* will appoint representatives to Te Runanga o Ngai Tahu and set out the duties, powers and obligations of this Runanga. This legislation, Te Runanga o Ngai Tahu Bill, was introduced into Parliament in July 1993 and it is currently before a Parliamentary Select Committee.

An important reason for seeking the abolition of the Ngai Tahu Trust Board was that its actions were and are 'ringed with restrictions imposed by paternalistic governments' (O'Regan, 1989: 259). Indeed, until recently, the Trust Board was required to seek approval from the Minister of Maori Affairs before spending more than $400. Ngai Tahu argue that these restrictions on their autonomy, based on the erroneous view that compensation payments due to the tribe remained public money, were contrary to the Treaty of Waitangi. Government restrictions have become particularly burdensome over the last few years as the tribe pursues an ambitious programme of economic development. Ngai Tahu already own three tourism ventures and a large fishing company which has entered into joint ventures with a number of other South Island fishing concerns. With an anticipated settlement of their Waitangi Tribunal claim the tribe plans to considerably expand its tourism and fishing businesses and to increase its returns from land and forestry.

These economic developments and the structural changes to be introduced with the passing into law of the Te Runanga o Ngai Tahu Bill will mean a re-positioning of the Runanga in relation to life-world and systemic interests. As shown in Figure 5, changes currently being discussed on Ngai Tahu *marae* will entail moving the Runanga to the boundary between life-world and system as mediator between the concerns of the *papatipu runanga* and the activities of a Ngai Tahu Holding Corporation and a Ngai Tahu Development Unit.

The Holding Corporation will manage the tourism, fishing, forestry and land operations in order to provide funds for the Ngai Tahu Development Unit. It is intended that this Unit, described as a 'state within a state', will oversee the establishment and running of schools, employment training courses, together with housing, superannuation and health insurance schemes. Appointed or elected representatives of the eighteen *papatipu runanga* will debate and set general policy guidelines for tribal economic and social development at monthly Runanga meetings.

The ongoing and proposed rationalization of Ngai Tahu tribal relations has had, and will have, critical consequences for participatory-democracy within the tribe. In particular, two potentially contradictory processes have been clearly in evidence over recent years; a centralization of knowledge and expertise, and an increased politicization of tradition, especially where this relates to tribal boundaries, leadership and decision-making procedures. Bureaucratic centralization has been encouraged by the devolution proposals, the Treaty claim and subsequent negotiations, and by capitalist economic development. Politicization is the inevitable side-effect of instrumentalizing taken-for-granted traditions in bureaucratic planning. Given the potentially contradictory nature of these processes, open and effective communication between centre and periphery has become a priority for the tribe. Regular *hui* and the installation of computer and fax links between *marae* have become essential accompaniments to rationalization. Equally important in the future will be the quantity and quality of information that passes from centre to periphery enabling the Runanga to knowledgeably guide tribal development.

Ngai Tahu's structural rethinking confirms that bureaucracy and participatory democracy are not necessarily contradictory elements within postcolonial tribal formations. Indeed, if Habermas (1981) is correct, they should both be regarded as equally fundamental to modernity, postcolonial or otherwise. If the one-sided pursuit of modernity, reflected in colonial regimes of instrumental rationality, is to be redirected, postcolonial formations must include and empower arenas of communicative rationality, such as local *marae*, where bureaucratic planning is rendered continuously debatable and accountable to life-world concerns. If initiatives such as those currently being explored by Ngai Tahu go hand in hand with tribal economic development elsewhere in Aotearoa/New Zealand, then it is just possible that the Maori renaissance will retain its bicultural and emancipatory potential.

Conclusion

In this paper I have proposed that to view the Maori renaissance as an essentially cultural phenomenon is to underestimate the major transformations that have occurred in the organization of Maori political life. Instead, I have suggested that the more visible developments in 'expressive' culture, developments that have been popularly understood as heralding a transition to biculturalism, might be more usefully viewed as one aspect of a wider

social movement directed towards full economic and political inclusion. As other social movements have discovered, notably the women's movement, inclusion may be offered by capital and the state, but at a price. Throughout much of the 1980s there remained the real danger that tribal development, pursued in accordance with established bureaucratic agendas, would simply facilitate the systemic colonization of Maori tribal life-worlds. For this reason it was crucial that, as a social movement, the Maori renaissance adopted and experimented with new forms of participatory-democracy at the same time that it sought greater participation at the system level. Without such initiatives inclusion would quickly become a new path to assimilation.

Maori tribal organizations such as the Ngai Tahu Maori Trust Board clearly had a critical role to play in this regard. As we have seen, the Trust Board had a keen appreciation of its potentially contradictory position, mediating as it did between the power of the state and capital on the one hand and the aspirations of local *runanga* on the other. The Trust Board recognized the necessity of ensuring that its legitimacy and accountability were firmly grounded in local participation and debate if it was to withstand the onslaughts of those inclusive forces that would make it their instrument of administration and 'development'. All too frequently, tribal democracy has been undermined through a recognition by state officials and others of 'leaders' who are not accountable to their tribes. For participatory democracy to flourish at the tribal level, leaders, like great trees, must develop deep roots.

Acknowledgements

I would like to thank three tall trees, Tipene O'Regan, Kuao Langsbury, and Atholl Anderson for their helpful comments on earlier drafts of this paper. I am also grateful to Valda Blundell for editorial suggestions and comments.

References

Clements, Kevin (1988) *Back From the Brink: The Creation of a Nuclear-Free New Zealand*, Wellington: Allen & Unwin, Port Nicholson Press.

Dann, Christine (1985) *Up From Under: Women and Liberation in New Zealand, 1970–1985*, Wellington: Allen & Unwin, Port Nicholson Press.

Fleras, Augie (1991) 'Tuku rangatiratanga: devolution in iwi-government relations', in Spoonley, P., Pearson, D. and Macpherson, C., editors, *Nga Take: Ethnic Relations and Racism in Aotearoa/New Zealand*, Palmerston North: Dunmore Press: 171–93.

Habermas, Jurgen (1981) 'Modernity versus post-modernity', *New German Critique* 22:3–4.

—— (1987) *The Theory of Communicative Action. Volume Two, Lifeworld and System: A Critique of Functionalist Reason*, Boston: Beacon Press.

Metge, Joan (1976) *The Maoris of New Zealand: Rautahi*, London: Routledge & Kegan Paul.

Offe, Claus (1985) 'New social movements: challenging the boundaries of institutional politics', *Social Research* 25(4): 818–68.

O'Regan, Tipene (1989) 'The Ngai Tahu claim', in Kawharu, I. H., editor, *Waitangi: Maori and Pakeha Perspectives of the Treaty of Waitangi*, Auckland: Oxford University Press.

Race Relations Conciliator (1982) *Race Against Time*, Wellington: The Human Rights Commission.

Runanga Otakou (1989) Response to the Management Organization Structure for Iwi Devolution Control, 1990, unpublished ms.

Schwimmer, Erik (1968) editor, *The Maori People in the Nineteen Sixties; A Symposium*, Auckland: Longman Paul.

Scott, Alan (1990) *Ideology and the New Social Movements*, London: Unwin Hyman.

Sissons, Jeffrey (1992) 'What Did the Shark Say to the Kahawai? Metaphors of Culture within Ethnic Relations Discourse in New Zealand', *New Zealand Sociology*, 7(1): 20–36.

—— (1994) 'The systematization of tradition: Maori culture as a strategic resource', *Oceania* 64(2): 97–116.

Walker, Ranginui (1982) 'Capitalism v. Tangata Whenua', *Listener* 24 July: 62–3.

—— (1990) *Ka Whawhai Tonu Matou, Struggle Without End*, Auckland: Penguin.

GERALD R. MCMASTER

BORDER ZONES: THE 'INJUN-UITY' OF AESTHETIC TRICKS

US Public Law 101–644, November 29, 1990
Sec. 104, §1159.

Misrepresentation of Indian produced goods and products:

(a) It is unlawful to offer or display for sale or sell any good, with or without a Government trademark, in a manner that falsely suggests it is Indian produced, an Indian product, or the product of a particular Indian or Indian tribe or Indian arts and crafts organization, resident within the United States.

(b) Whoever knowingly violates subsection (a) shall –

(1) in the case of a first violation, if an individual, be fined not more than $250,000 or imprisoned not more than five years, or both, and, if a person other than an individual, be fined not more than $1,000,000; and

(2) in the case of subsequent violations, if an individual, be fined not more than $1,000,000 or imprisoned not more than fifteen years, or both, and, if a person other than an individual, be fined not more than $5,000,000.

(c) As used in this section –

(1) the term 'Indian' means any individual who is a member of an Indian tribe, or for the purposes of this section is certified as an Indian artisan by an Indian tribe;

(2) the terms 'Indian product' and 'product of a particular Indian tribe or Indian arts and crafts organization' has the meaning given such term in regulations which may be promulgated by the Secretary of the Interior;

(3) the term 'Indian tribe' means –

(A) any Indian tribe, band, nation, Alaska Native village, or other organized group or community which is recognized as eligible for the special programs and services provided by the United States to Indians because of their status as Indians; or

(B) any Indian group that has been formally recognized as an Indian tribe by a State legislature or by a State commission of similar organization legislatively vested with State tribal recognition authority; and

(4) the term 'Indian arts and crafts organization' means any legally established arts and crafts marketing organization composed of members of Indian tribes.

(d) In the event that any provision of this section is held invalid, it is the intent of Congress that the remaining provisions of this section shall continue in full force and effect.

Even Indians who are citizens are still Indians until they are fully civilized.

(Harmon, 1990: 104)

An Indian is an Indian no matter what kind of Indian he is.

(Morinis, 1982: 96)

Kill the Indian; save the man.

(Unknown)

I n September 1992 an agitated Native American artist called me regarding an exhibit of works by First Nations artists being held at the National Gallery of Canada in Ottawa. He wanted to bring to the attention of the (Native)[1] Canadian art public the US legislation PUBLIC LAW 101–644, 'Expanding the Powers of the Indian Arts and Crafts Board.' This legislation explicitly states that it is unlawful to exhibit or advertise as a 'Native American artist' individuals who are not from a 'federally recognized tribe.' At issue for the caller was the National Gallery's inclusion of a US artist – the artist was Jimmie Durham who considers himself to be of native descent though he is not from a federally recognized tribe – in their landmark exhibition 'Land Spirit Power: First Nations at the National Gallery'. The caller felt that Durham was not legitimate and should have stepped aside for an artist who was of legitimate Native American ancestry.

The issue raised by the caller indicates an ongoing tension surrounding (Native) American and Canadian identity which has now entered into the political arena of the art world.

Contemporary (Native) Canadian artists are frequently at the vortex of these socio-political and cultural struggles, sometimes within the Native (reservation), at other times in non-Native (urban), communities, and at still other times 'in between' both. In fact, in recent debates regarding (Native) identity, (Native) art communities have become the focus of attention. This comes as no surprise when we realize that (Native) art communities are loose and heterogenous, located in both rural and urban spaces, which to some degree make them ambiguous.

It is this ambiguity and indeterminancy that I wish to address in this essay. I want to argue that between the two (and more) communities – reserve and urban – there exists a socially ambiguous zone, a site of articulation for the contemporary (Native) artist that is frequently crossed, experienced, interrogated, and negotiated. This site is a perceptual space for various practices, including 'resistance' and the articulation of 'self-identity' in the postmodern and postcolonial world. That is to say this is a zone of 'in between-ness,' and as such it is a socially constructed and politically charged site where shifting allegiances criss-cross permeable grids or boundaries, and where identities are to be understood as 'nomadic subjectivities.'[2]

I will develop this argument in three parts. First, I consider questions regarding identity politics and signification, including how identity is negotiated by the self and the state. Second, I consider the dynamics of identity, including how subjects shift from one social allegiance to another, negotiating spaces in the zones of 'in-between-ness.' Finally, I raise some issues about the ethics of the current politics of identity.

The politics of signification

My first self-conscious encounter with the politics of identity was not when I was growing up experiencing it first hand. Instead, it was reading an

interesting riposte by a (Native) American who was asking (non-Native) readers, 'Why do you call us Indians?' No doubt many of them 'naturally' responded: 'Well, you are Indians.' Nevertheless, this retort brings into question notions of 'self' and 'others' and the signifying practices that construct them. The 'Indian as sign' is the site of contestation for 'Indians' and others.

As practiced by the state and its legal bodies in Canada and the United States signifying practices form the objects (Indians) of which they speak. Chris Doran (1987) would argue that for the state Indians are 'coded bodies', and in coding 'Indians' as 'bodies' the state exercises a form of state power whereby people are treated not as physical bodies but are forced upon a grid or master code. A coded body can be rendered silent, docile, and infinitely manipulable, instead of being seen as a resistant and challenging body. Later, I will consider how the resistance to the state's 'coded power' is exercised through artistic praxis.

LEGAL DEFINITIONS: CANADA AND THE USA

But first let us examine the often confusing and multifarious legal definitions by means of which states code (Native) people in Canada and the United States.

Canada

(Native) Canadians can be either Status or non-Status, although many in Canada recognize four indigenous groups: Status or registered Indians, non-Status Indians, Métis, and Inuit. Only the first group is legally defined under the Government Indian Act (1876). The remaining three groups are self-identifying, although the Constitution Act (1982) defines aboriginal people as Indian, Inuit and Métis, leaving non-Status Indians with no constitutional status.

Status Indians: According to the Indian Act a Status Indian ('legal' or 'registered') is a person registered as an Indian or entitled to be registered as an Indian. Two sub-types fall within this definition, 'Treaty Indians' and 'Reserve or non-Reserve Indians.'
Non-Status Indians: Non-Status Indians are persons who have Indian ancestry, are usually self-identifying, and yet are not considered 'Indians' by the government. Many are not 'legal' by choice, whereas others are disenfranchised Indians who lost their status by 'marrying out'. In the past, such individuals gained the federal franchise and thus the vote (it was not until 1960 that Canadian law finally allowed all Indians the federal vote). Recently the government's Bill C-31 has permitted some individuals to regain status, although there are still many who identify themselves as Indians although they remain ineligible for status, particularly individuals who live in urban areas.

Inuit: Originally Inuits were defined as Indians and consequently were not dealt with separately under the Indian Act. Today, there is an agreed-upon definition worked out with the federal government which is based on traditional land occupancy, possession of 'disk' numbers,[3] or the blood quantum.

Métis: The Métis are largely defined as 'people of mixed Indian and non-Indian ancestry.' As a result of opposition to the bi-racial connotations of this definition, however, the Métis have been redefined in terms of their socio-cultural heritage and their sense of a shared ethnicity. The 1982 Constitution Act has also legally recognized them. Two-thirds of the Métis live in the Prairie Provinces and the North-west Territories, and their provincial organizations indicate their presence and tenacity.

United States of America

According to Taylor (1983: 5) 'most of the estimated 20 million people in the [United States] with some Indian blood do not identify as Indians and are scattered throughout the land.' This creates some confusion for federal and tribal governments, especially where self-identification arises. As a result of the 1982 Indian Identification Project, which produced no consensus on the meaning of the term 'Indian', both the federal and tribal governments considered two major criteria in determining Indian identity: blood ancestry and tribal membership. Tribal governments are able to determine membership and exclude persons from their reservations. On the other hand, the federal government, represented by the Bureau of Indian Affairs, recognizes as 'Indians' individuals who are one quarter or more ancestry from a member of a 'federally recognized tribe'. There is no such notion as different kinds of aboriginality, like Métis and non-Status Indians. It's either a matter of being 'red' or 'white' or of degree of blood. In the United States the state encodes different aboriginal groups as 'federally recognized tribes', thereby empowering them to determine who is a member of their tribe. In this way, the state assumes a position of seeming neutrality and removes itself from centre stage in any controversy over individuals' tribal status.

SOME CULTURAL (SELF-IMPOSED) DEFINITIONS

> So, here we are now, translated and invented skins, separated and severed like dandelions from the sacred and caught alive in words in the cities. WE are aliens in our own traditions; the white man has settled with his estranged words right in the middle of our sacred past.
> (Gerald Vizenor, Anishinabe, quoted in Lippard, 1990: 23)

Legal definitions aside, what about the cultural questions of identity? Within those signifying practices that encode identity, the question of self-definition can be simultaneously self-empowering and open to contestation

in these late-capitalist times. The social struggle of aboriginal artists for self-definition in the face of restrictive legal and official definitions may result in deciding for 'social agency' over 'social subjectivity,' two terms used by Fiske (see note 2). As we saw in the Canadian legal context, there are more 'coded' choices than in the United States for being a subject. But what about the tactical possibility of 'nomadic subjectivity' (Fiske, 1989: 24)? Michel de Certeau provides the military metaphors of 'tactics' and 'strategy,' the latter exercised by the powerful against the fleeting, guerrilla 'tactics' of the weak (de Certeau, 1984: Chapter 2). By using these metaphors, I hope to indicate various types of negotiations of identity on the part of contemporary (Native) artists.

In *Predicament of Culture* James Clifford describes a court case undertaken by a group of Mashpee Indians in Massachusetts in order to establish their identity as an 'Indian tribe'. By seeking this explicit recognition from the state they fell into the predicament of entrenching their status as social subjects, or coded bodies. It was, however, an advantageous status they were willing to accept. However, by the time it was over, a jury denied their claim, although they have since sought an appeal. Clifford, who believes the decision should have been in favour of the Mashpees, gives a cultural argument:

> Groups negotiating their identity in contexts of domination and exchange persist, patch themselves together in ways different from a living organism. A community, unlike a body, can lose a central 'organ' and not die. All the critical elements of identity are in specific replaceable conditions: language, land, blood, leadership, religion. Recognized, viable tribes exist in which any one or even most of these elements are missing, replaced, or largely transformed.
>
> (Clifford, 1988: 338)

Meanwhile, the Mashpees have the tactical luxury of 'self-definition' against legal provisos. Conceivably, a tactical victory could be won, but perhaps only with a jury of anthropologists! Anthropological testimony in other court cases has often been denied, favouring historical or even archeological 'evidence' because of its more 'scientific' nature. Even then, would you take a chance on another 'coded power' deciding on your identity?

Presently, 50 per cent of all (Native) Americans (and Canadian (Native) people) live in urban areas where they are creating new communities and defining themselves. These urban communities entail new complexities for the politics of self-identity. Morinis provides this account of urban Indians in Vancouver's Skid Row:

> On Skid Row, there is but one category of Indians, and membership is determined on the basis of subjective and social criteria. A person is an Indian who looks like an Indian, regards him or herself as an Indian and is thought of by others as being an Indian, the legal distinction between status and non-Status Indians is of no significance here.
>
> (1982: 95)

And then there is the tactical wit of Jimmie Durham whose ruse-like demeanour to coded power, state and tribal, in reference to PL. 101–644, becomes a challenge to any definition:

> I hereby swear to the truth of the following statement: I am a full-blood contemporary artist, of the sub-group (or clan) called sculptors. I am not an American Indian, nor have I ever seen or sworn loyalty to India. I am not a Native 'American,' nor do I feel that 'America' has any right to either name me or un-name me. I have previously stated that I should be considered a mixed-blood: that is, I claim to be a male but in fact only one of my parents was male.
>
> (Churchill, 1991)

Durham is one of the new targets in the politics for self-identity, and as a result has opted for a self-imposed exile in Mexico, where no doubt he plans his next tactical maneuvers. Since the law was enacted some artists and others who did claim and advertise themselves as 'Indians' have voluntarily or were pressured to withdraw their engagement from this site.

There have always been many (Native) people whose definition of themselves and their people enabled them to meet the challenge of history. The dialectical tension between social agency and subjectivity will no doubt continue unabated. But will this have any consequence for Canadian (Native) people?

Areas of 'in-between-ness'

I got those Reservation Blues
Traded my moccasins for those
whiteman shoes
I got both feet in two canoes
I got the Reservation Blues
(Johnie, 1991: 55)

When will all this end
This senseless battle
Between my left and right foot

When will the invisible border
Cease to be
(Ipellie, 1991: 68)

G C
I'm too red to be white
G D
And I'm too white to be red
G C G
A half-breed, in-breed, no breed I'm called
(Flying Hawk d'Maine, 1991: 135)

Alternate views of 'in-between-ness' can be found. H. Brody views Vancouver's Skid Row as a community that stands 'between the limitations and constraints of a rural reserve and the rejection and alienation of white-dominated city life' (Brody, 1971). Fiske advocates de Certeau's tactical notion of 'making do', that is constructing a space within and against

that of another, and speaking the other's language, in order to 'make over' new meanings. For Fiske, the art of being in between is the art of popular culture, between production and consumption (1989: 36). On the other hand, Gerhard Hoffmann sees the spaces of 'in between' as areas of contemplation, where new strategies of negation are playful (1990a: 451). This spatialization of the 'in between' exists either at every margin, or at interfaces between different spaces, consequently its ambiguity and indeterminacy creates such interesting 'playful' possibilities.

BORDER ZONES AND LIMINAL SPACES

My own tactic is to combine two terms as one metaphor: 'zone', for it recognizes an area (in the abstract sense), and 'border' which demarcates a space, like the slash in centre/periphery or inner/outer. For my purposes, the border zone spatializes cultural possibilities.

I also want to join Arnold Van Gennep's (1909) concept of 'liminal phase or liminality' with this idea of border zone in order to argue that it is within the border zone that social spaces intersect and that this is where emergent social agents/subjects experience, interrogate, and negotiate their conditions of existence. This liminal phase (from the Latin *limen*, signifying 'threshold'), is indispensable for any 'rite of passage' as Van Gennep concluded from his study of initiation rites in certain non-Western societies. Liminality is the threshold between two states of ambiguity, a state of suspension in which the initiate loses rights and obligations. The initiate is 'betwixt and between', in an ambiguous and indeterminate phase, where the experience is one of separation or detachment from the social structure, the cultural conditions, or both. This detachment can result in the search for camaraderie to help cope with the new station in life. During this phase rank and status are no longer important. Building on Van Gennep's formulations Victor Turner calls this friendship making/seeking 'communitas,' 'society as an unstructured or rudimentarily structured and relatively undifferentiated *communitatus*, community, or even communion of equal individuals' (Turner, 1969: 96).

The struggle for land by (Native) Canadians is a struggle to create and expand space: claiming land, claiming space. A land claim is an attempt to 'reterritorialize',[4] to create in law new borders and divisions, and to mark off rights, privileges and obligations. The liminal zone, however, has no such status and is therefore socially ambiguous. Territoriality is important for (Native) Canadians, as 'Indian Reserves' are spaces that signify 'home.' Home, bell hooks says, 'is that place which enables and promotes varied and everchanging perspectives, a place where one discovers new ways of seeing reality, frontiers of difference' (1990: 148). Home is a place to which we can always return.

For many (Native) people, including me, this home is the Indian Reserve. And this return takes place daily or seasonally for social reasons: to participate in ceremonies like powwows and potlatches, or to attend

Figure 1. Gerald McMaster, *Crossfire of Identity.*

weddings or funerals and other 'rites of passage'. For many (Native) peoples
this does not mean a return to the margins, but rather a return to the centre,
thus inverting and subverting the stereotype of reserves as somehow outside
the core of the state. It is the case that reserves have always had the negative
distinction of being economically disadvantaged, but none the less they
remain home for *most* (Native) people.

So what is home away from home? I say it is that ambiguous liminal zone I
have set out above. It is, moreover, as bell hooks writes, a created space
'within that culture of domination' (1990: 148) which at the same time 'is a
radical creative space which affirms and sustains our subjectivity, which
gives us a new location from which to articulate our sense of the world'
(153). Hooks is a black feminist writer and accordingly writes from what
some consider a position of marginality. Her empowering notion of a
radically creative space, which echoes Hoffmann's contemplative playful
space for creating strategies of negation, names this a positive space of
resistance.

But we still have not answered the question of the makeup of the border
zone. I will draw from two writers (though I know there are more), who have
begun to articulate the practices of the border zone. There is, first, D. Emily
Hicks's (1988) analysis of border writers. The idea of cultural borders she
argues can be between cities, genders and economies. The dominant cultures
are seen in terms of 'inter-active' relations rather than as cultural models. She
remarks on the 'attitude' that border writers have toward more than one

culture. The subjects are bi-cultural and emphasize the difference in reference codes between two and more cultures. The writers are smugglers, *coyotes*, or tricksters. The borders are cultural not physical. At the border there is a displacement of time and space. Borders hold up a 'reflecting mirror' to the dominant society, which is to say, they can and will be subversive, particularly disrupting the one-way flow of the mass media that attempts to control images of itself. In Bakhtinian terms, the border zone is a zone for 'heteroglossia' (a multiplicity of languages within a single language), a deterritorialized and political zone. The appeal to the border zone, the space between cultures, is the access artists have to many languages (discourses) from different communities.

The second writer, Renato Rosaldo, offers these understandings of border cultures:

> More often than we usually care to think, our everyday lives are crisscrossed by border zones, pockets and eruptions of all kinds. Social borders frequently become salient around such lines as sexual orientation, gender, class, race, ethnicity, nationality, age, politics, food, or taste. Along with 'our' supposedly transparent cultural selves, such borderlands should be regarded not as analytically empty transition zones but as sites of creative cultural production that requires investigation.
>
> (Rosaldo, 1989: 208)

The border zone is a place for new cultural practices that involve improvisation and the recombination of disparate cultural elements, creating a diverse cultural repertoire. Identity becomes ever stronger, not diffused.

Briefly then, we may be able to view a border zone as indeterminate, as in the liminal zone where everyone is status-less. The border zone is free for interpretation; yet, the potential for entering into an established (determinate) territory is possible, but only if the rules and regulations are obeyed and 'illegal' conduct is restrained. Thus, in Jimmie Durham's self-imposed exile, he is able to plan and play out his tactical maneuvers from his border zone, but he also realizes that when he enters certain spaces, tensions are inevitable. This is an obvious and extreme example. Elsewhere, quieter maneuvers are routinely enacted. Durham is a maverick, and there are others. But I also want to consider the border zone as a space for 'shared experience.'

Communitas

Victor Turner (1969) also points to initiates in the liminal phase who are reduced in status, and he compares this liminality to death, invisibility, darkness, bisexuality, wilderness, the eclipse of the sun and the moon. The test of initiation by impoverishment is to enable one to cope with new realities. It is at this point that emotional bonding and friendships are made through the sharing of experience. Hence, when returning to society, the initiate is a changed person who successfully experienced the transformation. For

Figure 2. Jimmie Durham, *Self-Portrait*, 1987: courtesy of the artist and Nicole Klagsburn Gallery, New York, NY.

Turner the communitas is an unstructured community of equal individuals who submit to general authority. In 'closed' or 'structured' societies it is marginal or inferior individuals, or the outsider, who symbolizes the communitas (1969: 111). Communitas is always contemporary whereas structure is past. It is spontaneous, immediate vis-à-vis the norm-governed, institutionalized, abstract nature of social structure. Turner suggests that the products of the communitas are art and religion, rather than legal and political structures. 'Communitas trangresses or dissolves the norms that govern structured and institutionalized relationships and is accompanied by experiences of unprecedented potency' (128).

Accordingly, I would argue that contemporary (Native) artists form a communitas in the border zone, as status-less social agents whose new spatiality can be viewed as an arena for tactical creative acts. These artists now form subcultures or new 'tribes' in place of what was once referred to (often derogatorily) as 'Pan-Indian.' Syncretic/hybrid possibilities have been dismissed as being tradition-less, although so-called Pan-Indianism did involve hybridity. Today artists hybridize new cultural practices through the improvisation and recombination of disparate cultural elements, creating a diverse cultural repertoire (a process that Rosaldo refers to as 'transculturation'). Today's artists often live, create and appropriate between two and more spaces, responding, for example, to home 'markets' for ceremonial productions (on the reserve) and competing within the larger commercial art market. This is a tactical position, allowing artists to live and create new styles. As well, this position allows them to challenge deeply rooted artistic practices that are value-laden, including oppositions like art/culture, élite/popular, traditional/modern, and political/aesthetic.

In this way the border zone becomes a creative arena, a heteroglossia of languages and styles as contemporary (Native) artists maneuver to control and determine meanings. Their works are self-referential and they deploy self-parodying devices that poke fun at the clichés, stereotypes and conventions of (Native) representations. Michel de Certeau might say that (Native) artists are simply 'making do' and 'making over' the styles at hand. To be sure, these artists have assimilated the lessons of modernism, in fact their art is sometimes attacked for being too obscure. Artists in the border zone also engage in theoretical works (writing, lectures, books) that highlight social contradictions and injustices in order to advance the interests and viewpoints of the exploited. More and more, a sense of communitas, ideologically speaking, is gaining potency.

The art(istic) is the articulation, the artifice, of everyday life. As for de Certeau the individual is

> increasingly, constrained, yet less and less concerned with . . . vast frameworks, the individual detaches himself from them without being able to escape them and can henceforth only try to outwit them, to pull tricks on them, to rediscover, within an electronicized and computerized megalopolis, the 'art' of the hunters and rural folks of earlier days.
>
> (1984: xxiv)

The artist's operation is an 'aesthetic of tricks' (de Certeau, 1984: 26), as we can see in the lines of this poem by one 14-year-old (Native) girl who is answering the question: 'What is the Native experience?':

One might say that it is to have the 'Unity' that the Natives have had since the early days of this proud country, enabling them to sustain themselves with their simple, but thrifty usage of such nifty trinkets as bows and arrows, woven baskets, and soft furry blankets. Or that it is myths and fairy tales that have kept a people carefree and happy even to this day.

(Bobb, 1991: 45)

This 'Injun-uity' is the aesthetics of tricks. Contemporary (Native) literature often invokes a character that personifies artifice: s/he/it is Trickster. Michael Hurley (1991) describes Trickster as an ambiguous figure, who is currently wandering, always hungry, guided not by normal conceptions of good or evil, and is either playing tricks on people or is tricked. He is the spirit of disorder, the enemy of boundaries. Trickster is Dyonisian. Today's tricksters are artist-tricksters; they are political and activistic.

In using this metaphor of the trickster for contemporary (Native) artists, I also want to refer to Lucy Lippard's discussion of the political/activist artist. For Lippard the power of these artists is to be subversive rather than authoritarian:

'Political' art[ists] tend to be socially *concerned* and 'activist' art[ists] tend to be socially *involved* – not a value judgement so much as a personal choice. The former's work is a commentary or analysis, while the latter's art works *within* its context, *with* its audience [emphasis hers].

(1984: 349)

So far I have emphasized those (Native) artists who tend to be more consciously aware of cultural pluralism and the everyday practices of the border zone. I have concentrated on those (Native) artists who revel in these spaces, as opposed to those who simply work unconsciously within one of the many existing options. The former understands what plurality implies and that all tendencies are of equal merit and all are valid. In the mid 1970s the late (Native) American artist T. C. Cannon (Kiowa) asserted:

Art is big, and there's room for everybody. I used to argue the old arguments about the traditional painters and the modern painters . . . [But now I think] there's room for every kind of painter.

(Quoted in Hoffmann, 1986: 281)

The latter, on the other hand, pass in and out of the border zone. They are not comfortable. They require the safety of a known territory (tradition, conservatism), they are its social subjects. None the less, they are nurturers and catalysts within the community. They resist outside intervention, and often they are less critical than those in the border zone. Their sense of the

community is in helping others to improve the cultural environment by raising levels of consciousness.

The ethics of identity

We have now reached a point where it is time to look at the politics of the self/other identity, and the new conflicts that are beginning to rupture many (Native) art communities. I began this paper by referring to the US legislation which makes explicit 'who is or is not an Indian artist.' There is the cliché that governments 'ought to stay out of the bedrooms of the nation.' In the case of the (Native) American art world, the government was invited into the bedroom, so to speak, to resolve complaints by (Native) American cultural producers against 'outsiders.' Initially, craftspeople called for consumer protection legislation in the lucrative market-place for their products, because mass quantities of cheap reproductions manufactured in countries ranging from Japan to Lebanon were usurping the market from 'legitimate' (Native) American producers. In the US protecting (Native) economic interests has been the catalyst for legislation, given the history of appropriation by (non-Native) entrepreneurs. Some states have enacted laws that require truthful labeling including the specification that an object is not Native-made. The rapid rise of 'Native American art' particularly in the south-west also created international attention. With an already large population of (Native) Americans creating and selling their works as 'Native American art or craft', plus the lure of the landscape, tourists and others quickly wanted a piece of the south-west. Artists and craftspeople quickly responded, so did others who realized that 'Santa Fe-style' could make a quick and easy income. Despite their goodwill for accepting 'outsiders' over the years, the forces of popular culture to appropriate and make cheap reproductions ('making over'), (Native) Americans reacted to these new appropriations. Within the ranks of the art world certain artists gained rapid recognition as 'Native American' artists; it was, however, difficult for other artists to accept. The accusations were that some of these fast-rising Indian art stars were indeed bogus Indians. A compaign was begun by a group of artists to lobby for protection against those who were usurping a market under false pretenses. Soon after came the introduction of PL. 101–644, which was to place legitimacy of identity back in the hands of the 'federally-recognized or state-recognized' tribal governments. The new Public Law states:

> it is unlawful to offer or display for sale or sell any good, with or without a Government trademark, in a manner that falsely suggests it is Indian produced, an Indian product, or the product of a particular Indian or Indian tribe or Indian arts and crafts organization, resident within the United States.
>
> (US Department of the Interior)

Limiting the legal definition to 'who is or is not an Indian,' says Charlotte Townsend-Gault, 'perpetuates the historical tendency to remove the 'Indian

problem' by reducing the numbers of Indians' (1992: 81). Some would argue this is 'gate-keeping' and 'ghettoization' at its most perverse; yet, it could be argued that this legislation will strengthen the identities of artists who originate from these communities. In a way it is abrogating the laws which tried to tear down those gates.

Indeed, since the legislation's initial introduction in December 1990, a number of galleries and museums in the US have terminated exhibitions which featured artists of questionable heritage, out of fear of prosecution. The artist who called me was in a way not only attempting to inform the Canadian public but also giving a strong message of the unacceptability of giving or offering opportunities to those artists claiming false identities.

The law is a powerful tool; however, we recall de Certeau's notion of the 'strategy' of the powerful against the 'tactics' of the weak. The government(s) it is assumed is powerfully cumbersome, unimaginative, and over-organized. What about the tribal governments? A major question emerges: Will it be only a matter of time before tactical resistance, 'poaching' raids upon the texts and structures, begin to be made both on the outside as well as the inside by trickster artists? One senses that meaningful if not critical discussions must come from the (Native) American art community about the cultural issues of the ethics of identity against economic concerns if any legislation is to have 'validity.' On the other hand, to what extent do anomalies that confound the system partake in the dialogue? I'm thinking of those who, because of peculiarities of their individual history, are unable to prove their lineage. Or can those others who for some reason or another are disenfranchised call themselves 'Indians'? Previously, persons could be 'Indians' (Natives) either biologically, culturally or legally. What combinations and recombinations can now be called upon to determine/support one's identity as an 'Indian'? We recall the Mashpee Indians of Massachusetts and their struggle for 'legal' identity. This is the predicament facing individuals like Jimmie Durham and perhaps many others.[5] There is a sense that his refusal (disclaimer) is a guileful ruse not to acquiesce or be drawn into a state of 'ironic complicity.' The gate-keeping rationale, or negative politics, as a consequence of the legislation, potentially may turn the struggles towards the reservations rather than away.

Conclusions

The issue of (Native) identity continues to be contentious. It has its own very interesting and troubling history(ies), changing by the decade to match the times. What I've argued for here is a new awareness which moves one big step away from 'Pan-Indianism' and the view that those who live outside the reservation are 'traditionless'; conversely, I have argued that those who live on reservations are the 'gate-keepers' of a different sort. I have argued for a view of contemporary (Native) artists as not just carriers but innovators of culture, living 'betwixt and between' several cultures and communities. Contests over the representations of personal and collective identity and the categories through which identity is filtered (class, gender, ethnicity, and

nation-state) must recognize that we live in highly contestable spaces, spaces that continually collide and mix. They are spaces we continually negotiate and that the artist sees as both mental and physical.

Finally, in the July 1993 issue of *Art in America*, Jimmie Durham, writing from Cuernavaca, Mexico, had this to say:

> I am not Cherokee. I am not an American Indian. This is in concurrence with the recent U.S. legislation, because I am not enrolled on any reservation or in any American Indian community.
>
> (*Art in America*, 1993)

Acknowledgements

I would like to thank JoAllyn Archambault, Lakota, anthropologist, of the Museum of Natural History, Smithsonian, Washington DC, for information on the US Legislation and current situation. I am also grateful to Valda Blundell and Rob Shields at Carleton University, and Tony Bennett of Griffith University, for giving me insightful comments.

Notes

1 Although the term 'Native' is in common use and has been substituted for many other formal designations, like 'Indian,' 'aboriginal,' or 'indigenous,' I place it in parenthesis to indicate its tenuous application and acceptance. This statement suggests the simultaneous 'presence/absence' of identity, which is central to contemporary discourses.

2 Fiske's notion of 'nomadic subjectivities' can be understood as agents freely moving among various subject positions. However, he indicates there are contradictory situations in which the individuals can be seen as either social agents (active agency) or social subjects (subjectivity). The quest for agency is to negotiate the contradictions and to construct relevances and allegiances from among them (1989: 24).

3 James Frieders (1983: 13) notes that 'disc' numbers were originally given to each Inuk by the Canadian government as a means of establishing their numbers and enrollment. A number of contemporary Inuit art curators have frequently noticed these numbers etched on the bottoms of sculptures, primarily from the 1950s and 1960s. I am not sure if this was a parodic statement by the artists, as it was for Chipewyan artist like Alex Janvier.

4 D. Emily Hicks, whose use of the term is derived from Deleuze and Guattari, writes, 'When one leaves one's country or place of origin (deterritorialization), everyday life changes. The objects that continually reminded one of the past are gone. Now, the place of origin is a mental representation in memory. The process of reterritorialization begins' (1988: xxxi).

5 The fact sheet put out by the US Department of the Interior explains the definition of an Indian as follows:

> The definition is that an Indian is a member of a federally-recognized or state-recognized tribe, or a person who is certified as an Indian artisan by such a tribe. This definition recognizes that there are any number of reasons a person of *significant Indian heritage and upbringing* might not be a member of a tribe, and it allows them to continue to market their creative work as Indian art

provided that their tribe of ancestry will formally acknowledge them. Just as in membership criteria, the criteria for certification as an Indian artisan are entirely at the discretion of the tribe, and it is possible that some tribes will choose not to certify anyone or even adopt a certification process.

(1991: 5)

References

Art in America (1993) 'Letters: identities clarified', 81(7) July.

Bobb, Columpa (1991) 'The Native experience', in *Gatherings* (1991) II: 45.

Blundell, Valda (1992) *New Directions in the Anthropological Study of Art*, Ottawa: Carleton University.

Brody, H. (1971) *Indian Skid Row*, Ottawa: Northern Science Research Group, Department of Indian Affairs and Northern Development.

Churchill, Ward (1991) 'Nobody's pet poodle, Jimmie Durham: an artist for Native North America', unpublished.

Clifford, James (1988) *The Predicament of Culture*, Cambridge: Harvard University Press.

de Certeau, Michel (1984) *The Practice of Everyday Life*, Berkeley: University of California Press.

Doran, Chris (1987) 'Coded power today: are we trapped within its boundaries?', paper presented at the joint session of the Canadian Sociological and Anthropological Association and the Canadian Semiotic Association, Hamilton, Ontario.

Fiske, John (1989) *Understanding Popular Culture*, Boston: Unwin Hyman.

Flying Hawk d'Maine, Shirley (1991) 'Too red to be white', in *Gatherings* (1991) II: 135.

Friederes, James (1983) *Native People in Canada: Contemporary Conflicts*, Scarborough, Ont.: Prentice-Hall Canada Inc. Vol. 2, Penticton, B.C. Theytus Books.

Gatherings: The En'owkin Journal of First North American Peoples (1991).

Hicks, D. Emily (1988) 'Deterritorialization and border writing', in Merrill, Robert, editor, *Ethics/Aesthetics*, Washington, DC: Maisonneuve Press: 47–58.

Hicks, D. Emily (1991) *Border Writing: The Multidimensional Text*, Minneapolis: University of Minnesota Press.

Hoffmann, Gerhard (1986) 'Frames of reference: Native American art in the context of modern and postmodern art', in Wade, Edwin L., editor, *The Arts of the North American Indian*, New York: Hudson Hills Press and Philbrook Art Center, Tulsa: 257–82.

—— (1990a) 'The aesthetic attitude in the postideological world: history, art/literature, and the museum-mentality in the cultural environment', *German Association of American Studies* (Quarterly) 34, Munchen: Wilhelm Fink Verlag.

—— (1990b) 'Myth, nature, and aesthetics in North American Indian art and the context of Western modernism/postmodernism', *German Association of American Studies* (Quarterly) 35, Munchen: Wilhelm Fink Verlag.

hooks, bell (1990) *Yearning: Race, Gender, and Cultural Politics*, Boston: South End Press.

House of Representatives (1990) Indian Arts and Crafts Act, Public Law 101–644. 101st Congress, 2nd Session, Rept. 101–400 Part 2.

Hurley, Michael (1991) 'Wacousta as trickster: the enemy of boundaries', *Journal of Canadian Studies* 26(3): 68–79.

Ipellie, Alootook (1991) 'Walking both sides of an invisible border', *Gatherings* (1991) II: 67.

Johnie, Curtis 'Shingoose' (1991) 'Reservation blues', *Gatherings* (1991) II: 55.

Lippard, Lucy (1984). 'Trojan horses: activist art and power', in Wallis, Brian, editor, *Art After Modernism: Rethinking Representation*, New York: The New Museum of Contemporary Art and David R. Godine Publisher (Boston): 341–58.

—— (1990) *Mixed Blessings: New Art in a Multicultural America*, New York: Pantheon.

Morinis, E. Alan (1982) 'Skid Row Indians and the politics of self', *Culture* II(3).

Nagata, Shiuchi (1987) 'From ethnic bourgeoisie to organic intellectuals: speculations on North American Native leadership', *Anthropologica* XXIX: 61–75.

Rosaldo, Renato (1989) *Culture & Truth: The Remaking of Social Analysis*, Boston: Beacon Press.

Taylor, Theodore W. (1983) *American Indian Policy*, Maryland: Lamond Publishers, Inc.

Townsend-Gault, Charlotte (1992) 'Kinds of knowing', in Nemiroff, Diana *et al.*, *Land Spirit Power: First Nations at the National Gallery of Canada*, Ottawa: National Gallery of Canada: 76–101.

Turner, Victor (1969) *The Ritual Process*, Ithaca, NY: Cornell University Press.

US Department of the Interior (1991) Indian Arts and Crafts Board Fact Sheet: Questions and Answers about Title I of PL 101–644, The Indian Arts and Crafts Act of 1990. Washington DC.

TRANSLATION OR PERVERSION?: SHOWING FIRST NATIONS ART IN CANADA

nsofar as First Nations artists acknowledge and work within a culturally specific identity, cultural boundaries are at issue. Where translation is proffered, boundaries marking cultural difference are implied, but so is the idea that they can be overcome. Where translation is seen as a perversion, ('traduttore, traditore' – an Italian dictum translated, more or less, as 'translator, traitor') the suggestion is that boundaries have to be maintained and translation withheld.[1] Both positions are expressed but both positions are also being negotiated by First Nations artists. Their work, inseparable from strategies for its presentation, can very broadly be characterized as negotiating the boundaries – their existence, their significance, their permeability – around ethnicity and its expression in cultural forms. The term 'negotiation' is not intended to reassure, or to make anyone feel better, but to be a way of responding to the poly-directional complexities of the situation.

Canada's new National Gallery, a Federal institution, is a striking building of cathedral proportions, in glass and pale pink granite. It does nothing to challenge the tradition of distancing reverence as the fitting approach to art, nor do the contemporary galleries do anything to challenge the neutrality of the modernist white box as the appropriate setting. It lies, in Ottawa, about half of the well-groomed way between the Prime Minister's residence and the neo-Gothic Houses of Parliament. The Gallery's rotunda was designed to echo the neo-crocketted octagon of the Parliamentary library. Both buildings look across the Ottawa River to the rolling terrain of the Canadian Shield – Algonquin land. The Algonquin have a land claim in process which would encompass both Parliament and Gallery. It is one of many claims current between First Nations groups across the country and the federal government.[2]

Until recently the Gallery's policy for collecting and exhibiting has not included the work of artists of native ancestry, this having been, historically, the mandate of the Canadian Museum of Civilization. Canada was notoriously late to recognize the significance of the cultural expressions of its

aboriginal populations,[3] and this division of labour had maintained the separation between art and ethnography, even while much of the latter had been acknowledged to be the former by artists and *decideurs* in other parts of the world where a Euro-American aesthetic held sway. However, in 1927 a joint venture between the National Gallery and the National Museum, the 'Exhibition of Canadian West Coast Art: Native and Modern', asserted other boundaries by juxtaposing poles, masks and bowls from the Northwest Coast with work by contemporary artists such as Emily Carr.[4]

This is not the place to explore the relationship between the Gallery and other players as they formulated a climate of responsiveness, or lack of it, to the visual arts in the settler culture and the extent to which the climate was a replica of that found in 'parent culture traditions' (Williams, 1981). Suffice it to say that native production was classified apart.[5]

It was not until 1983, in an independent, commissioned 'Report on Indian and Inuit art at the National Gallery of Canada', that the Gallery was advised to change the policy that had excluded work by artists of native ancestry, although an exception had been made for Inuit art. (In 1986 the first such work, Carl Beam's *North American Iceberg*, was purchased and has been followed by many more.) The Canadian version of the realization that there were boundaries to be traversed more complex than the simple one between a diorama and a spotlit plinth came in 1988 when the Glenbow Museum mounted 'The Spirit Sings: Artistic Traditions of Canada's First Peoples'. Temporarily repatriated treasures from around the world were translated by the elegantly designed museum context into a species of contemporary lingua franca, but devoid of both the aboriginal and colonial histories that had brought these objects to that place. Among the consequences of 'The Spirit Sings' (widely known as 'the spirit sighs') was a growing popular recognition of native culture as a powerful political tool, an appreciation that the old boundaries between art and ethnography were not simply out-dated but had always been inappropriate and a joint First Peoples–Canadian Museums Association Task Force.

These few points must stand in for a long and complex historical argument, differently inflected in different parts of Canada, about art and cultural difference, the testing and contesting of the boundaries, and the need for cross-boundary translation. In 1992, when the National Gallery finally entered the fray, 'Land, Spirit, Power: First Nations at the National Gallery of Canada' represented the first move to bring artists of aboriginal ancestry into an institution which, both literally and symbolically, encapsulates the Eurocentric nature of Canada's national culture. The subtitle explicitly differentiates the nations who were here first from the nation of Canada, which had long alienated them, in more than one sense, by representing itself as the product of 'two founding nations' – the English and the French.

The exhibition opened in the rotunda with drumming by an Ojibwa-Cree group, and a sweetgrass ceremony performed by elders of the Algonquin Golden Lake band. The eighteen artists in the exhibition, from across Canada and from the United States, were formally introduced to the

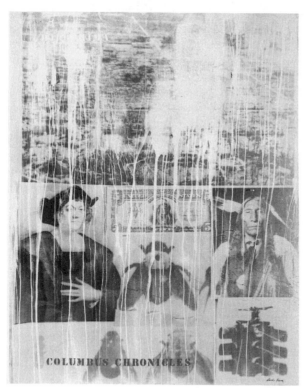

Figure 1. Carl Beam, *Columbus Chronicles*, 1992: collection of the artist; *photo* National Gallery of Canada.

unusually large opening night crowd while the setting sun filled the Gallery's great octagonal glass hall with raking light. It goes without saying that this event was variously perceived as a diplomatic *coup de théâtre*, opportunistic ploy or moment of socio-aesthetic significance, perhaps all three.[6]

The next night, the Gallery gave the first public screening of a film which included footage of Canadian army tanks crashing through the grove of sacred pine trees at Khanesetake, the Mohawk warriors in camouflage, the soldiers with machine-guns challenging Mohawk women and children, white people pelting Mohawk women and children with stones. These were the rough-cuts of *Khanesetake: 270 Years of Resistance*, the latest film by Alanis Obomsawin, on the blockade and conflicts at Oka (the Québec town which grew up interspersed with the Mohawk settlement of Khanesetake) during the spring and summer of 1990, over claims to the pines and to a Mohawk cemetery and the planned encroachment of a golf course. Rights to this land had been contested for years before the 'Summer of Oka' and the issues remain unresolved long after it. Obomsawin, a senior film-maker of Abenaki ancestry, was represented in the exhibition by her entire output over the last twenty-five years. She was one of the people who remained behind the barricades until the end. The material for the film, including

conversations, which lent depth to the images, some all too grindingly familiar from television, had been gathered at considerable risk – it was clear that few of the people there with her expected to get out alive.

'Oka', although in one sense only the latest episode in centuries of encroachment, was spectacularized by the media like no other and is central to understanding the contemporary context for the exhibition. So are the many now well-publicized land claim cases across the country; Elija Harper's 'No' to the Meech Lake Accord in the Manitoba Legislature; the prominence achieved by the native demand for self-government in the recent constitutional debates; and the response of native women who, fearing that sovereignty would erase the protections that they currently enjoy under the constitutionally entrenched Charter of Rights and Freedoms, contributed significantly to the success of the 'No' campaign in the referendum of October 1992.

It is not possible to separate the works in 'Land, Spirit, Power', from a whole ensemble that includes a National Art Gallery, the history of its policy and its mandate to shape a national culture, the roles of the curators, their research and selection processes, the manner of installation, the internal affairs of a large institution, its communications office, the fact of 'Indigena'[7] taking place simultaneously at the Museum of Civilization across the river, the reception in the native community, the press and elsewhere, and much else besides. This holds good for any art exhibition and is not to be taken as yet more sociologizing over things native, further delay in the authentication of native 'art'. The problematic of an exhibition based on ethnicity at this time in Canada can be expressed, simplistically, as a question: was a boundary being erased or maintained, by the artists involved or by the Gallery? There is no unequivocal answer. Too many political, spiritual, social and economic agendas, sometimes conflicting, underlie, or make use of, First Nations art.

'Beware the tyranny of any one discourse' the Métis performance artist Margo Kane had reminded us.[8] And there are any number of discourses. Among them, those that range between native self-recovery and cultural accommodation, if not assimilation; between avant-garde accreditation and that view of the avant-garde as a convenient funnelling-off of social protest; between the institution as legitimator, or the view of the institution as perpetuating the paternalism that systematically assimilates and de-claws successive avant-gardes. (Guilbaut, 1983; Miller, 1991).

Given the diversity of the work – in history and intent as well as appearance, native artists being confronted with as many aesthetic choices as any others – I would say that First Nations art is not an art category at all, but a shared socio-political situation, constituted by a devastating history, the powers of the Indian Act, the social geographies of the reservation system, by tribal and local politics, by the shifting demographics of the non-Native in a pluralist society, and by the worldwide ethnic revival (Townsend-Gault, 1991; 1992). By this view the often-noted diversity of work that knowingly engages with some or all of the above, that shows evidence of encounters with an assortment of socio-aesthetic strategies, is

not a terminal pluralism, squandering any hope of concerted effort. It is rather the consequence of processes of negotiation – negotiations over aesthetic strategies, the appropriation of idioms, the uses of history; negotiating, from a shared socio-political situation, with the communities of reception, the terms under which their work will be received, understood and used – conceding some things, critiquing some, battling some.

Thus Edgar Heap-of-Birds in his immense wall of words, *American Policy* (1986–9), made up of thirty-two word drawings, has produced a work of uncompromising ferocity, its critical substance injustice and amnesia. As a sample, just four drawings, devastating in any combination, read: 'uterine hats/your sport/death from the top/relocate destroy'. Thus some of the brutal facts of Cheyenne history are exposed (during the massacre at Sand Creek, Colorado, in 1864 the soldiers cut open pregnant Cheyenne women, and displayed their uteri as trophies on their cavalry hats) along with subtler forms of torment. Heap-of-Birds imbricates a declamatory style, verbal collage as found in billboard advertising, philosophical debate about the relationship between words and ideas and what happens to it when an oral culture encounters writing, an attack on linear thinking, and reading, and culturally differentiated responses to colour. There is more. It would be wrong to see his work as compromising with fashionable tropes, but he depends on their currency to translate the welter of his responses to an agonizing predicament.

In selecting the works for the exhibition we faced, and then left open for negotiation, the fact that works like the *Gagiit* mask by Robert Davidson, and a characteristic installation by Domingo Cisneros *Quebranto* (Spanish – 'loss, lamentation') grow out of irreconcilable propositions about what art is and is for. It's possible to argue that they share a certain formal intrigue, but why forego the rest? Davidson inherits the *Gagiit* from Haida tradition as a set of fully defined conventions which is yet versatile enough to accept the imprimateur of an artist who makes masks both for his own people's ceremonial use and for the market. In doing this there are accommodations to be made. *Quebranto* is a bricolage of animal bones and the archaeological remains of a settler farmstead; in its unspecified reference to ritual, if not a crucifixion, it creates its own awe, a kind of critical animism. Cisneros hears cautions from elders in the region where he lives that he may, in his quasi-ritualistic use of animal parts, be trespassing on the untranslatable.

As curators we never settled whether giving what we considered to be magnificent works by First Nations artists the opportunity to be seen to their best advantage, professionally installed, without distraction, and by a wide public, could compensate for the consequent sanitizing, (the term is Robert Houle's), and de-racination.

Such are the irreconcilables which get articulated in the work and words of artists, such as those in 'Land, Spirit, Power', who tend not to reproduce prevailing definitions but to construct them rather differently. The fact that such issues will be familiar to some from the work of Bourdieu, for instance, or that Foucault and Said and Derrida, or at least excerpts therefrom, inform the discourse on one hand; while, on the other, there is the attitude of the

bouncer outside a nightclub called Au Zone, not far from the Museum of Civilization, who shouted at Yuxweluptun, 'You f...g Indian, you don't get in here,' (Sinquin, 1992) does not solve the problem on the ground. That is to say, if the solecism be allowed, where theory meets practice. The art critic of *The Globe and Mail*, (which promotes itself as Canada's national news-paper) conceding nothing to such positional niceties, dismissed the ex-hibition as the product of 'white liberal guilt' (Mays, 1992).

This is the territory that has to be negotiated, and discrepancies of precisely this sort are the stuff of the performances and installations of the Ojibwa artist Rebecca Belmore, who at the symposium on the exhibition, spoke of her 'confusion and anger' as an artist, and in an interview on the CBC said:

> When I originally was considering, and when the National Gallery . . . curators had come to visit me, I wanted to say, no, get lost. But I rethought it. And because I went to art school and was sort of raised in the art world by a Eurocentric way of thinking of art, I have to admit that as an individual I myself am attracted to and like the art world and that means the Gallery. But at the same time I know that a lot of Native people don't go to art galleries, so I have to find other ways of working too so that they can see my work as well.[9]

Belmore's installation, '*Mawu-che-hitoowin*: A Gathering of People', grew out of this ambivalence, being both made for the Gallery and setting itself in opposition to an art institution's apparent detachment from the predicament of individual native people. She had noticed that her people, especially Ojibwa women, tended to get together in the meeting-rooms of country motels, dreary and alienating spaces, unconnected with their everyday lives and the problems and issues which, partly for that reason, they were there to discuss. She had persuaded eight women in her home community of Thunder Bay to lend her their favourite chair. Ranged in a circle they turned their backs on the equally irrelevant, but enabling, gallery space. They were set apart from it by a pool of warm light illuminating the specially constructed wooden floor on which they stood.

This floor, the literal basis for their stories, was a telling amalgam of incised Ojibwa floral motifs and the kind of floral linoleum familiar in reservation houses. Each chair was equipped with headphones so that the gallery-going audience was brought into the circle. You could sit and listen to the voice of its owner telling her story, in many cases not easy to take, and not meant to be, and become part of the circle, *Mawu-che-hitoowin* which means 'meeting', in Oji-Cree.

Ovide Mercredi, the Grand Chief of the Assembly of First Nations, had put knowledge — knowledge of First Nations' distinction, their difference, foremost on his agenda at the First Ministers Conference in February 1992. In demanding acknowledgement of a difference that the colonial relation-ship had failed to recognize, Mercredi was establishing a position from which to counteract the ignorance and prejudice that have resulted. This is

what Pierre Bourdieu would call symbolic capital, that repository of shared knowledge in which the members of a particular society have a heavy, though not necessarily equal, investment. The politics and the political discourse on difference in Canada has reached the point at which symbolic capital becomes the issue. So too its translatability.

If we can agree with Mercredi that there is a special form of knowledge here, specific to those ethnic groups whose ancestors first inhabited the continent, then it follows, if anyone else is going to get it, that some form of translation must be done, both in the work and about it. For this to take place other information from the ensemble must be introduced. Translation is also at issue because, like Mercredi's remarks, the works in the exhibition are intended, by their makers, for both native and non-native audience, with the expectation that those audiences will respond differently. Translation may seem, at first, to offer the possibility, if not of fixing the flux, then at least of tying it down here and there. It seems to offer a solution to the problem of trans-cultural incompatibilities. But it is a glib solution because it depends on language as a model for culture. Language has had its uses as a model but cannot seriously be taken as more than a metaphor – anymore than a culture can be fully described as a system, or a text – the contrivances of intellectual fashions.[10]

And yet, as a metaphor, it is worth retaining because it allows for the identification of its own limitation. Here it permits a reference to what seems very like a point of non-translatability. I think it is what Homi Bhabha means by 'limit-text, anti-West' (1984). Perhaps what Quine means by the indeterminacy of translation (1990). The struggle to maintain, and take back control over, knowledge that is specific to a culture, its mythology, history, its rules and their every nuance, implies that it can be fully knowable only to those who live it. Three very different works from the exhibition exemplify this point.

Faye HeavyShield's spare sculptures, clusters of pale, dense shapes, as though worn by time, use and weather, depend on an understanding of the significance of arrowheads for the Blood or of the sight of stockades across the formerly open grasslands for these Plains people. They owe something to minimalism but are infused with the quiet drama of their referents in ways that minimalism eschewed.

Elitekey, in Micqmaq, means 'I fashion things, these are the things that I make'. In a work of this title Teresa Marshall draws on the legends of Glooscap the Micqmaq culture hero who, at a time of dire need was to come to the aid of his people in a great stone canoe. *Elitekey* consists of a life-size cement canoe. Marshall talks of paddling it to Ottawa – her response, an oxymoron, to the obduracy of federal policies at the time of Oka while she was working on it. It is an imaginary trajectory, echoing the mythological journey of Glooscap, that animates this awkward cement vessel. Aligned with the canoe is a life-size female figure, also in cement, wearing her grandmother's Micqmaq garments. She stands as an individual implicated by the myth and by the maple leaf, the symbolic umbrella of what it means to be a Canadian. Canoe and figure are aligned with a cut-out cement flag. In

Figure 2. Faye HeavyShield, *Untitled*, 1992: collection of the artist; *photo* John D. Dean for the National Gallery of Canada.

words that suggest what it means to think of works of art as players in social transactions Marshall has said:

> I don't stand under that umbrella. It serves as an icon of oppression, assimilation, injustice and racism that intends to deny First Nations people the inherent right to self-identity and human rights. To emphasise this, I've removed the leaf from the flag. It's not a real leaf in the first place. If there is any collective meaning to identity, then it's in the individual. With a leaf-shaped void in the flag, a person can stand in its place as an autonomous being, free to celebrate their individual or collective identity.
> (Marshall, 1992)

In *Inherent Vision, Inherent Rights*, a work of computer-generated virtual reality, Yuxweluptun depends on the spirit dancing of the Coast Salish, which he has transmogrified, partly disguised, blurring its translatability in order to protect its secrets, and partly heralded with some pride as being as good a subject as any and better than most for technological transfer.

Events, objects, substances, words, hold meaning in as much as they represent, encapsulate, a system of beliefs, an ideology, symbolic capital, amassed in the past *and* the present. In Canada today such knowledges are

Figure 3. Teresa Marshall, *Elitekey*, 1990: collection of the artist; *photo* National Gallery of Canada.

being used by First Nations politicians, artists and many others to resist hegemonic knowledge and reshape their own social world. In the words of the Métis film-maker Loretta Todd: 'Cultural autonomy signifies a right to cultural specificity, a right to one's origins and histories as told from within the culture and not as mediated from without' (1992). The strategy is to find ways to translate, transform, reinvent, protect and sometimes to obscure the knowledge that is integral to the representation of a culture. Specific meanings contest the open season on all systems of signification, the patronizing permissiveness of postmodern pluralism which has replaced a patronizing primitivizing.

Taking back control takes many forms: contesting stereotypes; repossessing not just the contents but the authenticating and valorizing powers of museums; reinventing 'tradition'. For a number of First Nations artists, knowledge that defines 'difference', provides, very specifically, the substance of the work and forms its critical intent. The limit set on the translation of that knowledge is the point at which the exercise of control becomes palpable.

Although Dempsey Bob carves for his own people, he also works for a non-native audience of connoisseurs and the fascinated. One does not have to know much to know that the suave elegance of his carvings conceals as

much as it reveals – essentially unknowable to a non-Tlingit audience. Narratives recalling how the spirits were originally revealed to the clan are essential but cannot travel into a collector's home with a carving. Nor can the concept of *at-oo'w* which is fundamental to Tlingit social structure, oral literature and ceremonial life. *At-oo'w* cannot readily be translated into English, yet it remains the spiritual, social and rhetorical anchor for oratory, carving and much else.[11] The limit is set not for the sake of mystification, nor is it a hostile withholding for the sake of individual or group power, but it is set to protect a cultural power.

Given these things: that 'art' does not lie in its objects; that these artists have determined to invest their symbolic capital for the benefit of quite distinct audiences; given the boundary between art and ethnographica; the shifting temper of the art community; the shift in Gallery policy; in this context it does not seem unhelpful to think of art as a complex transaction, or series of negotiations, between individuals or between groups. They are being shaped by the reinstitution of local narratives, synthesized from the past *and* the present: Tlingit oratory, the teachings of the Ojibwe *mide-wiwin*, the revelations of the sweat lodge.

It can be said that certain conglomerations of ideas, substances, objects are transformed in the course of negotiations. They are transformed from being carriers of one type of message to carriers of another type. The subject of such transformations is persons and relations, so the messages are about relationships between persons or groups of persons, or between persons and some aspect of the external world. Marilyn Strathern has accounted for this kind of explanation as: 'theorizing things *and* persons according to a political economy model, as opposed to the neo-classical mode of "economics" which takes things as they are subjectively apprehended by Europeans, viz as inanimate "objects" or artefacts.'[12] To take instances from the exhibition, the masked figure of the Haida, Salish and Tlingit, Ojibwa floral work, the Micqmaq canoe, have been variously transformed, through a series of transactions in which makers, audience and the frame for their encounter all participate, from carriers of messages known only within a community to carriers of the type of messages classified as art in contemporary Canadian society. But there's more to this than a reclassification project.

Bob's densely carved *Raven Panel* fitted into a corner where it abutted, at right angles, a mirror of the same dimensions. His work is a negotiation between the history of Tlingit carving and the course taken by Euro-American sculpture in the twentieth century; it is a transaction between him and the followers of both, in which both are treated with the utmost respect. The carved panel itself is an extrapolation of carved settee backs and the façades of houses, and Bob has begun to incorporate mirrors into his carvings. Extending, and playing on, the bilateral symmetry that characterizes Tlingit work, mirror as an introduced material offers endless formal recombinations, even while it questions the 'truth' of what is seen. But he also uses the mirror as a way of representing reality's spiritual double, a notion always present in bilaterality.

In *Seven Ravens* by Robert Davidson and Dorothy Grant there is a fine line between promoting a culture beyond its bounds and making a travesty of it, what Bhabha would call mimicry, all the colonial discourse is capable of.[13] Davidson is an artist for whom tradition is an opportunity rather than a constraint. The collaboration with Dorothy Grant, his wife, who executes his designs in fabric, perpetuates a Haida tradition of co-operation between the roles of men and women. Their joint transactions manoeuvre the blanket from dance garment to framed two-dimensional form, for which the language of modernist formalism provides appropriate descriptives, and back again to an emblem of the continuing adaptability and development of Haida art.

To look at the meanings of the artefacts as being constructed in the course of the negotiations in which they are implicated achieves a number of things: it serves to open up the relational implications of social life and indeed of political life; it makes acknowledgement of the roles of various audiences, some of which may be non-native; it allows for the extending and pluralizing of forms of attachment to things.

To think in terms of negotiations over value, over positioning, over ownership, over interpretation, among and between groups, makes it possible to deal productively with the otherwise intractable problems of an enterprise like this exhibition: among them the reification of the category of 'First Nations art', the apparently incompatible art codes, and, again, the culturally differential attachment to 'things', a crucial matter when it comes to the objects of art.[14] Carl Beam has synopsized the disparities thus:

> Man shall have dominion over the beasts and all the little fishes, and the clams, the lobsters, water and trees; everything was made for man's usage.

In contrast:

> The Indian viewpoint is that it was made for its own sake; man has to live in accordance with that structure. One system believes that you are a part of everything, and one says that you are *on top* of everything, and everything is there for your use – everything else is *lower*. The hierarchy is already set up. You are it, man! The world is yours! You just have to go out there and harvest everything! The sheep and cows and all the good wine, the cigarettes, the real estate – all the prime waterfront footage – it'a all yours. The trees and water – if you want to dump all your chemicals in there you can just go ahead. Who else would lay claim to all of that, other than man, anyway?
>
> (Beam, 1989)

It may be objected that installations, three-dimensional work, garments, film and video, lend themselves readily enough to transactional models. But what about paintings, those icons of Western perceptualism? In works like *Scorched Earth, Clear Cut Logging on Native Sovereign Lands, Shaman Coming to Fix* and *Toxicological Encroachment of Civilization on First Nations Land*, Yuxweluptun negotiates an aesthetic between the landscape and perspectival codes of post-Renaissance Western painting, the surrealist

Figure 4. Lawrence Paul Yuxweluptun, *Scorched Earth, Clear Cut Logging on Native Sovereign Land, Shaman Coming to Fix*, 1991: collection of the artist; *photo* National Gallery of Canada.

tropes devised in Paris to break them, figures derived with greater or less precision from the spirit representations of the Cowichan, and the integration of those figures with their setting in such a way that it makes no sense to speak of figures *in* the landscape – figures *of* the land might be closer. It is tempting to see a parallel between the transformations between figure and land in the paintings, and between dancer and danced in his virtual reality work, *Inherent Rights, Vision Rights* (which allows the viewer/participant to 'be' among the dancers around the fire in a longhouse), the same exchanges of power between animals and humans, that much being vouchsafed to anyone.

Yuxweluptun paints his paintings bright to counteract the grey of reservation life and he paints them big so that they shall be too big to be filed away and forgotten. He is driven to make his huge, vivid paintings of a land animated by spirits that is being devastated by mining, clear-cut logging and other depredations, this 'schmuck' in all its 'toxicological bliss', as he puts it, not to set himself up as a new stylist for some green party but to assert his right to the land that is being destroyed. He has parlayed landscape painting into an exposure of the abuse of power that endangers the spirit of the land, revealing, at the same time, his own spirit world. Yuxwelupton calls his work 'salvation art' and that is what he means it to do.

In conclusion, a fragment of Tlingit oratory, actually meta-oratory, characteristically self-reflexive, puts succinctly what I have been trying to

say about the negotiations in which this misleadingly termed 'visual' art is implicated:

> A person will often say
> 'I am going to speak to you.'
> Public speaking
> is like a man walking up along a river
> with a gaff hook.
> He lets his gaff hook drift
> over a salmon swimming at the edge of the river.
> When he hooks on it, the salmon way over there
> becomes one with him.
> This is the way oratory is.
> Even speech delivered at a distance
> becomes one with someone.
>
> (Johnson, 1971)

Notes

1 Since presenting the paper 'Translation withheld' at a symposium, 'Threatened Identities', organized by Serge Guilbaut and John O'Brian in the Art History Department at the University of British Columbia in March 1992, I have had occasion to modify, but not jettison, my sense that this essentially paradoxical characterization is inherent in the presentation and reception of much First Nations art.

2 Seventy claims have been settled since 1973. Another sixty-nine are under active negotiation. Yet there are hundreds more that await attention, including specific claims associated with treaties the terms of which have not been fulfilled (DINA, 1993).

3 Douglas Cole (1985) has examined the racism inherent in this attitude, and its consequences specifically for the worldwide dispersal of North-west Coast art and artifacts.

4 The Gallery's Director, Eric Brown, wrote that this was 'the first time such an exhibition has been held that has been artistic first and ethnological after' (Nemiroff, 1992).

5 Shifts in the classification, always within the terms of the dominant discourse, are discussed by Diana Nemiroff (1992a). An alternative way to proceed in future is proposed by Georges Sioui Wendayete (1992).

6 Although I write as one of the curators of the exhibition, the views expressed in this paper are not necessarily shared by my colleagues, Robert Houle, a Saulteaux artist and writer, and Diana Nemiroff, Curator of Contemporary Art at the National Gallery. Where I do use a collective 'we' or 'us' it is in referring to our considerable shared experience on this two-year, and continuing project.

7 'Indigena: Contemporary Native Perspectives' was co-curated by Gerald McMaster and Lee-Ann Martin for the Canadian Museum of Civilization and ran from 15 April to 12 October 1992 in its new building, designed by Métis architect Douglas Cardinal.

8 Margo Kane in conversation with the curators, summer 1991.

9 CBC broadcast, *Morningside*, 14 September 1992.

10 For a rather different position on language as a model see Palsson (1993).

11 The concept of *at-oo'w* is discussed at length in Dauenhauer and Dauenhauer (1987). This book, with its companion volume (1990), are anthologies of the oratory, given in two languages, with glossary and commentary.
12 Strathern (forthcoming) consulted in ms.
13 See Bhabha (1984).
14 I am indebted to Marilyn Strathern for the clarity with which she both separates out and reintegrates 'things' as social markers, in a methodological caution: 'Making people's different modes of attachment "to" things do all the work of apprehending sociality is these days evidently recognisable as just exactly a historicised artifact' Strathern (forthcoming).

References

Beam, Carl (1989) *The Columbus Project*, unpublished ms: 3.
Bhabha, Homi K. (1984) 'Of mimicry and man: the ambivalence of colonial discourse', *October* 'Spring'.
Cole, Douglas (1985) *Captured Heritage: The Scramble for Northwest Coast Artifacts*, Vancouver and Toronto: Douglas & McIntyre.
Dauenhauer, Nora Marks and Dauenhauer, Richard (1987) *Haa Shuka: Our Ancestors – Tlingit Oral Narratives*, Juneau: Sealaska Heritage Foundation.
—— (1990), editors, *Haa Tuwunaagu Yis, for Healing Our Spirit: Tlingit Oratory*, Juneau: Sealaska Heritage Foundation.
Department of Indian and Northern Affairs (DINA) (1993) *Federal Policy for the Settlement of National Claims*, Ottawa. Published under the authority of Thomas Siddon Minister, DINA.
Guilbaut, Serge (1983) *How New York Stole the Idea of Modern Art: Abstract Expressionism, Freedom and the Cold War*, Chicago: University of Chicago Press.
Johnson, A. P. (1990[1971]) 'Speeches for various occasions', in Dauenhauer and Dauenhauer (1990).
McMaster, Gerald and Martin, Lee-Ann (1992) editors, *Indigena: Contemporary Native Perspectives*, Ottawa: Museum of Civilization.
Marshall, Teresa (1992) interview in Nemiroff (1992b): 197.
Mays, John Bentley (1992) 'Breaking traditions', *The Globe and Mail* 10 October.
Miller, Daniel (1991) 'Primitive art and the necessity of primitivism to art' in *The Myth of Primitivism: Perspectives on Art*, Susan Hiller, editor, London: Routledge.
Nemiroff, Diana (1992a) 'Modernism, nationalism and beyond', in Nemiroff (1992b): 21.
—— (1992b) editor, *Land, Spirit, Power: First Nations at the National Gallery of Canada*, Ottawa: National Gallery.
Palsson, Gisli (1993) 'Introduction: beyond boundaries' in Palsson, Gisli, editor, *Beyond Boundaries: Understanding, Translation and Anthropological Discourse*, Providence and Oxford: Berg.
Quine, W. V. (1990) *Pursuit of Truth*, Cambridge, Ma. and London: Harvard University Press.
Sinquin, Arlette (1992) 'Native artists greeted with racism', *Ottawa Citizen* 10 September 1992.
Strathern, Marilyn (forthcoming) 'Entangled objects: detached metaphors', a comment on Nicholas Thomas's *Entangled Objects*, in *Social Analysis* special issue.

Todd, Loretta (1992) 'What more do they want?' in McMaster and Martin (1992): 71.

Townsend-Gault, Charlotte (1991) 'Having voices and using them,' *Arts Magazine* 65(6): 65–70.

—— (1992) 'Kinds of knowing' in Nemiroff (1992b).

—— (1993) 'Impurity and danger', in *Current Anthropology* 34(1) February: 93–9.

Turning the Page: Forging New Partnerships Between Museums and First Peoples (1992) Ottawa: Assembly of First Nations and the Canadian Museums Association.

Wendayete, Georges E. Sioui (1992) '1992: The discovery of Americity', in McMaster and Martin (1992): 59–70.

Williams, Raymond (1981) *Culture*, London: Fontana.

ELAINE KEILLOR

THE EMERGENCE OF POSTCOLONIAL MUSICAL EXPRESSIONS OF ABORIGINAL PEOPLES WITHIN CANADA[1]

When 1993 was designated by the United Nations as the International Year of the World's Indigenous Peoples, Canada's aboriginal musicians formed a committee to bring about greater recognition of the burgeoning growth of activity by First Nations' musicians in the country today. The committee brought pressure on the Canadian Academy of Recording Arts and Sciences to institute a new category of Canada's national music awards, the Junos, which would recognize both popular and so-called 'traditional' aboriginal music. As a result of their efforts, one of Canada's best-known aboriginal musicians, Buffy Sainte-Marie, announced at the 1993 Juno Presentation concert that, beginning the following year, a new Juno award would be given the Best Music of Aboriginal Recording, making Canada the second country in the world, after Australia, to include this type of award in its national music industry prizes.

In this essay I will provide an overview of the kinds of music that Canada's First Peoples have heard and been involved with in the colonial period, and I will discuss how First Peoples are creating a plethora of musical expressions today.[2] Furthermore, I will comment on some examples of songs produced by First Peoples that combine elements of European music with the musical forms of their aboriginal parent cultures.[3] Some of these songs are definitely postcolonial in spirit as they reflect struggles by the First Nations Peoples to gain control over their own affairs. In fact, such songs have been a part of aboriginal heritage for over a hundred years. For example, Robert Kennicott, who traveled in the Dene areas of what is now the North-west Territories from 1861 to 1864 wrote about such songs in his Journal.

> When I try to speak French, and mix English, Slavy, Louchioux words with it, they tell me, 'that's a rubbaboo.' And when the Indians attempt to sing a voyaging song, the different keys and tunes make a 'rubbaboo'.
> (Kennicott, 1942: 86)

Given the vastness of Canada and the varied influences on First Peoples over the years, different kinds of music have been heard and used by them depending on governmental decisions, trading factors, missionary efforts, and more recently, the availability of modern media such as radio, television and recordings. Furthermore parent culture traditions have always varied across the country. The variability of aboriginal languages perhaps best underlines this fact, with approximately one and a half million Amerindians, Inuit and Métis within Canada today speaking fifty-three different languages within eleven different language families. This multiplicity of linguistic forms has been associated with major cultural, economic and governmental differences that, to varying degrees, persist today from the pre-Contact period.

In order to indicate the major policies that have affected First Peoples in Canada, and by extension have influenced the kinds of European-based music with which they have come into contact, a selective list of historical events is given in the following chronology, which covers some 450 years for which we have documentation on how First Nations' Peoples responded to these musics.

A chronological guideline

THE EMERGENCE OF POSTCOLONIAL MUSICAL EXPRESSIONS
OF ABORIGINAL PEOPLES WITHIN CANADA

3 Oct. 1535: '[Jacques Cartier] next ordered the trumpets and other musical instruments to be sounded, whereat the Indians were much delighted.' (Biggar, 1924: 24)

c. 1618: Father Gabriel Sagard-Théodat: 'Il se faut . . . chanter par fois des Hymnes, & Cantiques spirituels, tant pour sa propre consolation, le soulagement de ses peines, que pour le contentement & edification de ces Sauvages.' (Kallmann, 1960: 11)

1633: School begun at Québec in which Gregorian chant and musical notation were systematically taught to Native and French boys and by the 1640s the Ursulines were teaching Native girls church music and how to play the viols.

1640s: Fur trade between France and Huronia had developed to the point that the Hurons organized 140–150 canoes with 500–700 men annually to move some 12,000–15,000 pelts from Huronia to Québec, but epidemics such as smallpox were decimating the Native population in the eastern half of what is now Canada.

1650s: The remnant of Hurons was dispersed, their villages gone, and their corn fields reverted to forest. To continue the fur-trade French *coureurs-de-bois* fanned out from Montreal into the interior to obtain furs from the First Nations.

1670s: Hudson Bay Company established by English fur traders and granted monopoly for trading rights in those regions where the waters drained into Hudson Bay.

1685: Comprehensive system of Hudson Bay Company trading forts in place and the French *coureurs-de-bois* were setting up similar posts. Both French and English were encouraging Natives to settle around forts to assist with translating and trading. FIDDLE MUSIC BECOMES PART OF THE EXCHANGE.

1730s: Champlain had told the Hurons: 'Our young men will marry your daughters, and we shall be one people.' French expected to make them culturally French, but had discovered that Native women were vital for the success of the fur trade by dressing pelts, and selling trade goods to their people. Intermarriage had created the Métis who by the 1730s considered themselves to be a new First Nation.

1760: English abolish the annual 'gift' distributions to Amerindians that had been established by the French. Reserves that had been established to missionize the Amerindians during the French regime were confirmed by the English.

1763: English Proclamation partially acknowledged territorial rights of the Amerindians, and in 1764 land-cession treaties began to be signed in Upper Canada (now Ontario).

Late 1700s–early 1800s: Protestant missionaries working among certain Amerindian groups, adapting their hymnodies, and translating texts into newly devised syllabic renderings of Native languages.

c. 1850–1970s: The formation of Native instrumental ensembles modelled after British regimental and civilian bands flourished.

1867: Constitution Act assigned to Parliament legislative jurisdiction over 'Indians and Lands reserved for the Indians'. Parliament was to continue to make treaties where needed.

1876: First Indian Act passed. Its fundamental purpose was to assimilate Amerindians who were defined as 'Status' – 'treaty Indians who were members of groups who at some time took part in an agreement with the Crown to surrender their land rights for specified benefits', plus 'registered Indians outside treaty areas' and 'non-Status Indians' who through intermarriage had lost their legal status as 'Indians'.

1884: The elaborate feasts of the North-west Coast Amerindians, known as 'potlatch' were banned along with dances associated with religious rituals.

1895: 'Sun dances' (thirst dances) of the prairie Amerindians were banned because the government authorities did not consider their ceremonial endurance features acceptable.

1912: Canada produced its first Calgary Stampede, a rodeo and Wild West show in which Amerindians participated because they could handle horses well and had adapted themselves to the ranching economy, but the government and tourist authorities wanted to present a history in which the West had been empty before the arrival of settlers such as the cowboys, fur traders, and the North-west Mounted Police.

1914: Amendment to the Indian Act made any Amerindian participation in dances, rodeos, and public exhibitions off reserves in the Western provinces

and territories subject to the approval of local Indian agents of the Canadian government.

1920: Government declared 'compulsory enfranchisement' when an Amerindian relinquished his Indian status, and attended school to age 15. More than ever, children were taken from their communities and families at age six or earlier and placed hundreds of kilometres away in residential schools. There they were not allowed to speak 'Indian' and of course had no opportunity to hear and learn their traditional rituals including music and dance. Radio broadcasting begins in Canada.

1939–45: More Amerindians enlisted for service during the Second World War proportionately than any other segment of Canadian population even though not considered citizens.

1951: Indian Act allowed a measure of self-control in managing reserve lands and band funds. Anti-potlatch and anti-dance measures were repealed.

1960: Amerindians granted suffrage by the Canadian government without compromising their special status.

1969: National Indian Council sets up committee to study Indian Act.

1970: Blue Quills School, Alberta becomes first school controlled by an Amerindian band.

1988: Last federal residential school for Natives closed.

1990: The Meech Lake Accord which would have recognized Québec as a distinct society was defeated, in part by the refusal of the Oji-Cree chief Elijah Harper, the only Native member of the Manitoba legislature to vote. With his tactics he managed to underline the view of the First Nations that they are the original peoples of Canada and need recognition as a distinct society too.

1994: Lawrence Martin obtains the first Juno Award Best Music of Aboriginal Recording for his *Wapistan*.

European religious music

According to the historical documents, the first European musics that were heard in what is now European Canada were the Gregorian chants of the Roman Catholic Mass as it was performed in the sixteenth century along with fanfares of 'trumpets and other musical instruments' (Biggar, 1924: 24, 166). When the French decided to pursue the fur trade in Canada, an important corollary of the directives of the French Government was to convert the Amerindians to Christianity, and missionaries soon found that music was very efficacious in pursuing this goal. In 1618 Father Gabriel Sagard-Théodat wrote:

> One must . . . sing hymns . . . and spiritual songs, both for one's own comfort and relief from toil and for the edification of the savages who take

peculiar delight in hearing sung the praises of God rather than profane ditties.

<div align="right">(Translation given in Kallmann, 1960: 11)</div>

During the French regime in Canada, the Roman Catholic version of Christianity was introduced to Amerindians. That tradition continued to remain important with the missionizing efforts of the Oblate Fathers in Western and Northern Canada, and its influences are strong to the present day. After English rule became established within Canada, Protestant musical traditions began to assert an influence on various reserves.

Undoubtedly, the encounter between aboriginal cultures and Christianity has been multifarious and complex. In most Amerindian and Inuit communities the evidence now overwhelmingly indicates Christianity did not replace traditional 'religious' practices but rather merged in various ways with them. Even in priests' accounts of the early nineteenth century, various sorts of syncretic musical practices are documented, such as aboriginal tunes being adapted to Christian texts, Christian hymns being received in dreams (the traditional Algonquian Amerindian medium for the reception of song), or Christian words being composed for secular French tunes which were already popular within the Amerindian community (Cavanagh, 1987: 46).

In the 1980s ethnomusicologists were able to record Mohawk hymn-sing groups at the Six Nations Reserve in Ontario singing hymns in the same manner that was customary in Protestant singing schools some 150 years ago. In this performance practice the humns are sung by men in three parts with the tenor carrying the tune in the middle voice (Cavanagh, 1987: 47). Unfortunately, we cannot compare the sound of this hymn-sing group with that of a contemporary Euro-Canadian group because the latter have long dropped this practice of hymn-singing within Canada. However a Mi'kmaq informant (Eva Miller) tried to contrast the sound of English and Indian language hymns in this manner:

> When you sing English, the notes will float, even in Latin. But when you're singing in Indian, you have to use your voice . . . It's very hard. English, it's more light. The notes will float. It's not hard on your voice like when you sing in Indian. Some people, their voice was soft. When you're a singer like that, especially you take these here Indian hymns – will sound beautiful but some words, you wouldn't be able to say it right. If someone hears you singing the words, you have to make them clearly.

<div align="right">(Cavanagh, 1987: 51)</div>

Part of the difference that this informant seems to be indicating here is the power of 'Indian' as an oral language, which does not just connote meaning like the literate language English. Instead its words are an enactment of meaning, providing power and dramatic intensity through their utterance.

The increasing evidence from various parts of Canada regarding how First Nations' peoples use the liturgical music that they have learned from Euro-Canadians has forced scholars to re-evaluate and possibly reject Native hymnody as purely a product of missionization. Examples from

Crees using a hymn to calm turbulent waters, Mi'kmaqs and Mohawks using hymns instead of traditional dirges for wakes, Iroquois gathering to sing hymns at a house-party rather than traditional social songs, a Dene drummer performing a 'prayer song' modelled on the traditional medicine song within a Mass, or the Naskapi-Montagnais praying in a country tent by singing hymns turned outward to the tent wall beyond which the spirits are encircled, all indicate that Christian hymnody is functioning in a manner parallel to the musics of aboriginal parent cultures. Such music has come to be regarded as 'Native' by the peoples themselves as they have transformed and adapted Euro-American traditions to their own individual needs and contexts.

Fiddle music

The second type of music introduced to aboriginal peoples within Canada was instrumental music involving European-developed instruments. As noted above, Cartier had discovered that the sound of trumpets delighted the First Nation Peoples whom he encountered along the St Lawrence River. A letter written in 1640 informs us that Mother de St-Joseph taught viol to Native girls at the Ursuline school prior to 1650. According to the *Jesuit Relations* XXVII, a violin was used for the first time in the Midnight Mass of Christmas 1646 (Kallmann, 1960: 16–17). The violin became a popular instrument in Canada because the materials to make one were available here. Soon it was not only heard in church, but became the favored instrument for providing dance music as was the case in Europe.

Inuit heard these dance tunes played by fiddlers on the fishing boats that sailed up the eastern coast. European captains insisted on having a fiddler in their crew in order to keep the sailors in good physical condition throughout the long trip across the Atlantic Ocean. The Inuit made their own violins out of local materials in order to play the tunes they heard. Even today, some three hundred years later, they perform these same tunes on accordions.

These tunes comprise a largely Scots-Irish fiddle repertoire which was also well-known to many who took part in the fur trade. In fact many of the fort operators in Northern and Western Canada employed by the Hudson Bay Company were of Scottish background, evidence of which can readily be found today. When I began doing field work among the Dene of the North-west Territories a decade ago in communities along the Mackenzie River, I witnessed the performance of a whole series of Scottish dances by Amerindians in the very manner described in Scottish dance manuals of the early nineteenth century. These dances were performed to the accompaniment of a fiddle and guitar, but even though the tunes might be attributable to the Scots-Irish repertoire, the style of the tunes has been influenced by aboriginal musical traditions.

Anne Lederman has summarized such influences as follows:

– Instead of regular phrases of eight strong beats, phrases range in length between two and seven beats.

– Instead of Scots-Irish two phrases per section, there are often three or five phrases in a section.
– Sometimes instead of two sections, there is only one section plus a tag.
– Sometimes a section consists of basically only one short melody repeated several times but with slightly different endings.
– Sometimes the phrases overlap without any clear cadence resulting in a supposedly circular formation.
– Tunes often have an 'introduction' which can be just a chord but is usually a longer motif before the tune actually gets underway.
– When a cadence occurs notes are often repeated or embellished for several beats at the end of a tune.
– Tunes are often descending in nature. Scots-Irish tunes generally have a 'high' part and a 'low' part. With those tunes that have the low part preceding the high, aboriginal fiddlers will often play the high part first.
(Lederman, 1987: 12–13)

These modifications can all be related to characteristics that occur in Native musical traditions.

Figure 1a) is a transcription of '*Kagana Nishimun*' prepared by Anne Lederman. Although Western musical notation can only give a shadow of the actual performance in an orally transmitted music, the notation can confirm some of the characteristics outlined above when compared with one of the many versions followed by Euro-Canadian fiddlers, given as Figure 1b). Eight strong beats can be seen in the first phrase of Figure 1b) while in the recorded performance of Figure 1a) it fluctuates between six and seven. In other words, a Euro-Canadian fiddler groups the pitches into regular bars of two beats each while version (a) reveals groups of one, two, three, or four beats per bar. The phrases of (a) are not as clearly marked by cadences as those of (b) although both versions have two sections. The second section of version (a) is not strictly repeated as in version (b), but instead has had its contour modified so that it starts in the higher register and then descends to the lower level. This also makes it possible for version (a) to proceed in a circular-like fashion into A whereas (b) has a clear cadence at the conclusion of the second section. It can also be noted that the cadence used in (a) at the end of the second section is really an elaboration of the pitch D that is embellished through six beats. Depending on the ending used, version (b) has one or two beats devoted to the same ending. Although some repetition of small motifs occurs in version (b), certain motifs receive more repetitions in version (a).

Some of these variants between the versions of aboriginal fiddlers and those by Euro-Canadian musicians are not as evident today since First Nations' fiddlers have access to recordings by non-Native performers. Also aboriginal fiddlers can take part in fiddle competitions where more standardized renditions are expected. Nevertheless fiddle music remains a popular form among First Nations' Peoples. The Winnipeg-based record company Sunshine Records Ltd, which specializes in 'ethnic' and 'native' musics released a list of its top-selling recordings in 1993. Of these, the top twelve were releases by aboriginal fiddlers.

Figure 1. Transcription of the fiddle tune '*Kagana Nishimun*'/'*La Double Guigue*'/'Fisher's Hornpipe': (a) as performed by Albert Beaulieu; (b) as a Euro-Canadian version (Lederman, 1987).

Band music

By the 1920s, musical forms derived from aboriginal traditions were not being heard in many Native communities because of prohibitions by church and governmental authorities on the use of indigenous languages and rituals both in residential schools and on reserves. Governmental policy of the day was to assimilate Natives, and state authorities thought this would be achieved by making them speak English, encouraging them to get the vote by signing away their 'Indian' status, and generally forcing them to fit into the dominant Euro-Canadian culture around them.[4] At residential schools aboriginal students were taught to play the violin, mandolin and other instruments.

From the mid 1800s until the 1970s, Native instrumental ensembles

THE IMPERIAL NATIVE MARCH

* for *

Piano

Composed by

J. NELSON

Metlakatla B.C.
Canada

PRICE 50 CENTS

PUBLISHED FOR THE AUTHOR
BY
WHALEY, ROYCE & Co.
158 Yonge St. TORONTO.

modelled after British regimental and civilian bands flourished from British Columbia to Labrador. In outfits based on their parent-culture apparel forms or in a modification of Euro-American band uniforms they performed at parades, fairs and exhibitions. For example, Job Nelson was a Native who organized and led Nelson's Cornet Band and the Metlakatla Brass Band on the north coast of British Columbia (McIntosh 1989: 234). His composition 'The Imperial Native March', a portion of which is given in Figure 2, appears to follow the Sousa model exactly with two sixteen-bar strains, and a softer trio of sixteen bars in the subdominant. Apart from some odd harmonies

The Imperial Native March.

By J. Nelson.

PIANO.

Entered according to Act of the Parliament of Canada in the year 1907 by J. Nelson at the Department of Agriculture.

Figure 2. A portion of 'The Imperial Native March' by Job Nelson.

which I suspect are the result of printing errors and not necessarily an inadequate grasp of Western harmonic practice on the part of Nelson, I cannot find any parallels with Amerindian musical traditions in this work.

Country music

By the 1920s a number of aboriginal households were receiving radio broadcasts, and this brought to them yet other kinds of music. Canadian radio stations were in their infancy, and so many of the broadcasts that First

Nations' Peoples received originated in the United States. Native people living in the Canadian prairies, for example, received broadcasts from the American Midwest that were dominated by country-music shows featuring Hank Williams, Jimmie Rodgers, and Kittie Wells. One Native informant has described her early memories of this music as follows:

> I remember my mother used to get up early every morning to do her chores to the sound of country music which was on from five to seven every day except Saturday and Sunday. This morning ritual continued for quite a few years. I must have been pre-school age, when I first remember listening to the radio, until I was about ten or eleven years old when our radio broke down.
>
> (Whidden, 1984: 91)

Guitar is the musical instrument most often associated with country music. Because it is relatively easy to store, maintain and carry about and is also available through catalogue sales, Natives could obtain these instruments or make one with materials at hand. One northern Cree has described how her aunt learned to play the guitar:

> Learning how to play was done mostly by ear. She said she would sing one tune or note and play the chords that she thought were appropriate for the song. If they sounded like the right notes to her she would keep that in her mind and go on to another chord. Most of the notes that she knew were the chords that she had learned by watching other people play the guitar.
>
> (Whidden, 1984: 92–3)

Thus equipped with a guitar, Natives could perform country music including its sub-genres of country-western and country-rock. Its songs appealed to all age groups but they were also informal and relaxing and could be sung anywhere.

Lynn Whidden argues that country music appeals to First Nations' Peoples because its recurring themes are consistent with topics that recur in aboriginal world-views and also characterize their own lived experiences. These themes include the importance of family, the rambling man, prison, hard work, disappointed love, and religion – all prevalent aspects in the lives of Canadian aboriginal peoples. The texts of country music frequently evoke a submission to fate that echoes Native attitudes towards a tragedy. Whidden further speculates that the function of earlier Native musical traditions may have been assumed by country music, in particular its function as a vehicle for preserving, not protesting, a particular lifestyle (Whidden, 1984: 100).

Elsewhere, I have argued that there are other musical reasons as to why country-music tunes would appeal to Natives readily (Keillor, 1988–9: 68). In analysing a large number of country tunes, I discovered that a majority have a propensity for a descending melodic contour. Frequently there can be chant-like areas in the tune where one pitch is reiterated and this too

would be analogous to many Amerindian parent-culture tunes (Keillor, 1988–9).

Recent developments in Canadian aboriginal musics

I have not found any clear evidence that Native musicians prior to 1960 or so were making their own versions of country songs. It seems to me that the surge of interest on the part of Amerindians in both their aboriginal musical traditions and their efforts to consciously create new songs based on Euro-American models came along at approximately the same time that the government granted them citizenship and suffrage and began to abandon their assimilationist policy.

In the Chronology (page 154), mention is made of the major developments in enforcing the assimilationist policy, the banning of the potlatch in 1884, the thirst dance in 1895, and in 1914 the prohibition against Amerindians appearing in any type of dress for performances of traditional dances at fairs and stampedes unless the governmental Department of Indian Affairs had given prior approval in writing (Dickason, 1992: 326). An amendment of the Indian Act in 1917 did permit Amerindians living off reserves to be granted the vote without property requirements. Only 102 Amerindians had been enfranchised from 1868 to 1917, but almost 500 were enfranchised between 1918 and 1921 (Dickason, 1992: 327). The Superintendant General was empowered to enfranchise Amerindians regardless of their desires in order to carry out the policy of the Department as enunciated by Duncan Campbell Scott: it was 'to continue until there is not a single Indian in Canada that has not been absorbed into the body politic and there is no Indian question, and no Indian Department' (Dickason, 1992: 327). Although opposition across the country resulted in an amendment of 1933 that stated enfranchisement could not be imposed in violation of treaty promises, the government put barriers in the way of allowing the First Nations to form political organizations in order to better run their own affairs. When an estimated 6,000 Amerindian veterans of the Second World War returned to their reserves, they organized to remove the restrictions and inequities. A Joint Senate and House of Commons Committee sat from 1946 to 1948 to discuss the Indian Act and came up with a draft. That draft still reflected an assimilationist policy, but objections from Native leaders resulted in Indian witnesses being heard for the first time. The revised Act of 1951 allowed bands to incorporate as municipalities and allowed them a measure of control over their own affairs. Voting by secret ballot was introduced for band council elections, while the Canadian government moved in 1960 to grant suffrage regardless of the 'status' of the individual within the First Nation hierarchy of the Canadian Government's Indian Act. This gradually led to the realization that Amerindians with their distinctive heritage could add a special dimension to Canada's cultural heritage.

In a complete reversal of its policy during the previous seventy-three years, the Canadian Government requested performances by aboriginal dance groups for the centennial celebrations of 1967. Because of that request, some

groups were formed specifically to perform dances and songs derived from their parent-culture traditions. This trend is continuing today as more First Peoples have an opportunity to hear these musical forms after in some cases one or two generations of silence. Some members of First Peoples are seeking recordings of these aboriginal musics made at the turn of the century for the express purpose of learning this repertoire.

It was also in the 1960s that Native folk singers like the Mi'kmaq Willie Dunn and the Cree Buffy Sainte-Marie began to perform in coffee-houses in Toronto, Vancouver, Montreal and New York, and on the folk-music circuits. By the late 1960s Winston Wuttunee, Shingoose, and David Campbell had begun to create songs that specifically presented Native perspectives to a non-Native public. For these musicians and their successors, humour – a highly valued strategy in aboriginal cultures – can enable them to express emotionally charged issues in a way that is accessible to all audiences. One of my favorites is Shingoose singing 'Natural Tan' in which the singer relates how he sees 'white people' trying to get a tan, but then realizes he does not have to follow that example because he already has a 'natural tan'. Neuenfeldt has described the background to another wonderful Shingoose song 'Elijah' which honours the Amerindian hero Elijah Harper and his actions to defeat the Meech Lake accord in 1990. At the same time it satirizes stereotyped visions of the inscrutable 'Noble Indian' caricature (Neuenfeldt, 1991: 104–5).

In 1962 Canada launched its first communications satellite and within a decade remote communities in the far North had a television service including televised rock concerts. Soon local rock bands were being formed on every Native reserve (Cronk, 1992: 932). Their music has become known as 'pow-wow rock' because social gatherings of different Native cultural groups known as powwows have begun to include performances of this music.[5] Pow-wow rock involves the performance of standard songs from the hit parade, known in the trade as 'covers of familiar tunes'.

By the 1980s certain of these aboriginal musicians were having a decisive influence on mainstream bands. Robbie Robertson is one who did not consciously use his Native background initially; however he has said that his guitar style used in the influential group known as The Band was influenced by what he heard his uncles playing on the reserve when he visited there with his mother. More recently he has been writing songs that deal specifically with the Native culture.

While Robertson's songs are written in English, the language of the majority of Native musicians in southern Canada, other performers sing in their aboriginal language or combine indigenous languages with English or French. The Inuit singer Charlie Panigoniak began composing songs in a country-folk style around 1970. Except for a few early ones written in a TB sanitarium in Manitoba, these songs have all been written in the Inuktitut language and concern family, friends, and everday events in his life.

Panigoniak does not use Inuk musical patterns in his songs, but another performer, Philippe Mackenzie of the Amerindian Innu, has specifically modelled his songs on sounds and structures derived from aboriginal

parent-culture forms. Because the large aboriginal drum with snares is considered sacred in Innu culture, Mackenzie would not use that particular drum for his contemporary songs, but he achieved an approximation of its sound by combining maracas rattles with a drum from which the snare had been removed. He has also structured most of his contemporary songs in a manner akin to Innu hunting songs. That is, they have two sections in which the first section is largely unmetred and accompanied by a percussive roll, while the second section has a melody which is rhythmically metred and performed over a steady beat. He influenced his younger Innu contemporaries known as Kashtin who started out playing Pink Floyd and Bob Dylan songs. Their more recent original music reveals some of the rhythms of their parent-culture forms and particularly those of the Innu language. For their song 'Nikanish' the video depicts the traditional ways of the Innu. Kashtin's decision to sing in a language spoken by only 11,500 people in Northern Québec and Labrador is a great source of pride for Native communities across Canada. It also adds the appeal of the exotic for non-aboriginal urban audiences from Europe to North America.

Other Native performers have been working in the tradition of the protest song, and so it is necessary that their audience understands the words. For instance, a Slavey Dene group of the mid 1980s led by Johnny Landry produced 'We Are Standing' in which texts of both Slavey and English appear. The strophes in English stress the importance of the land to the Slavey Dene culture while the refrain underlines that this culture is distinct by having the vocables 'hi ne' which appear frequently in the songs of the aboriginal parent culture.[6] The music combines elements from Dene drum dances and popular songs and employs a synthesizer to give it a rock treatment. Willie Dunn also uses English in his version of 'O Canada' to get across his message about protecting the environment. His guitar accompaniment uses musical portions of the National Anthem, but his spoken-over presentation draws on Native traditions where there are commonly no clear markers between what is spoken and what is sung.

Conclusions

The range of musical styles employed by contemporary Native musicians depends on their musical influences from the media and from other musicians. Murray Porter of the Iroquois culture calls his particular style 'country blues'. He recalls neglecting his schoolwork to try to listen to Detroit radio stations that broadcast the blues. In 1992 he had a very popular hit with the song '1492 Who Found Who'.

What a Native musician has heard either of Euro-American styles or of his/her parent-culture musical traditions varies widely. While contemporary Inuit musicians sing almost exclusively in their own language Inuktitut, little of any influence of their parent-culture musical tradition can be heard. Probably this is due to the fact that hardly any remnants of the parent-culture musical traditions are heard in Northern Canadian communities. At gatherings such as 'Toonik tyme' in Iqaluit a few drum dances of the

parent-culture musical tradition may be performed as show-pieces (Conlon, 1992: 43). The regrouping of the Inuit by the Canadian Government radically altered their lives and the parent-culture drum-dancing communal gatherings did not transfer to the buildings provided in the government-designed communities.

On the other hand, members of the Ottawa-based group Seventh Fire deliberately choose to perform with and learn from bearers of the parent-culture musical traditions. Their stage presentations and their most recent CD, *The Cheque is in the Mail*, begin with a song of the parent-culture musical tradition. This presents a current example of Williams's definition of tradition as 'a *desired* continuity' (Williams, 1981: 187). Seventh Fire's main performers are the O'Leary brothers, but this group has included non-Native musicians who bring influences and instrumentation from reggae, blues and Afro-beat. The group's name refers to a prophecy found in some Native cultures which predicts that Euro-Canadians will make such a mess of the world that they will have to go to aboriginal peoples for guidance. The Seventh Fire song 'Colonial Attitudes' juxtaposes interviews with Canadian federal politicians and aboriginal leaders discussing Native land struggles. In one portion a recent British Columbia premier who came to Canada only in 1949 is reminded of all the Native soldiers who fought and died for the freedom of his original country, The Netherlands. The song points to his failure to see the justice of letting Natives settle their land claims and have the rights to form their own governments even though they have been in Canada for thousands of years. In 'Buffaloe Jump' Seventh Fire presents the qualities of a Native leader in contrast to white politicians while drawing upon a wide range of musical styles.

While such messages in text and music might be regarded as postcolonial, not all contemporary Native musicians are able to access these new possibilities. Some aboriginal performers feel that they have to go to Nashville or to other centres with well-known studios for back-up musicians and facilities there in order to have a chance in the music business. Because of a lack of awareness and communication, such musicians fail to realize that there are some aboriginal musicians, Randall Prescott for instance, who have sophisticated studios and are able to obtain a presentation and sound that include a Native perspective, rather than perpetuating the colonial one of the past four hundred years. As Shingoose has said:

> My influences were the Beatles and the Stones, like everybody else. When you start to get more responsible and see your people suffering, there is an awakening. What makes me different, if I am different? It leads to a mingling of traditional and contemporary. It's conceptual, rather than a sound.
>
> (Taylor, 1993: C–1).

What Shingoose is getting at, I think, is the realization that Natives have been adopting musics from outside of their parent culture traditions for hundreds of years. As a result of this process, adaptations have occurred that indicate references to their own particular approach and musical heritage, but the

adaptations have occurred in a 'colonial' way given that aboriginal cultures have been minorities within a dominant national culture. The fact that certain informants refer to some of the resultant music as being 'English' for instance, rather than 'Indian' indicates that a clear distinction is being made about how it relates to, and has become part of their Native culture.

None the less, indigenous musicians who can get across Native perspectives in a mode that appeals to a broader audience will be able to increase an awareness of postcolonial issues on a wider front. As Keeling has pointed out:

> American Indian people throughout the United States and Canada have rallied in finding new ways of adapting native traditions to economic and social patterns of the dominant society. Music has had an especially important place in this renaissance, as it offers a vehicle through which Native Americans can express their Indian-ness in spite of modern socio-economic conditions.
>
> (1992: 17)

The rapidly increasing number of recordings seems to indicate that this is happening. In the past twenty years Sunshine Records of Winnipeg has released around 150 recordings by Native performers, some of which offer innovative syncretisms of aboriginal and non-aboriginal musical traditions. In 1992 alone such albums produced by recording companies or self-produced by Natives amounted to twenty-five releases. More than double that number appeared in 1993. The fact that Kashtin's second CD, *Innu*, sold over 400,000 copies in its first six months and was nominated in both the 'roots/traditional' and 'world beat' categories of the 1992 Junos indicate that these intriguing postcolonial musical expressions are speaking to many people, both Native and non-Native in Canada and abroad.

Notes

1 This paper is an expanded version of a presentation given at the 'Post-Colonial Formations: Nations, Culture, Policy' Conference at Griffith University, Brisbane, Australia, July 1993. For this written version I am grateful to Valda Blundell for her comments.

2 Ever since Columbus labelled the inhabitants which he encountered in the Americas as 'Indians', outsiders have persisted in labelling the aboriginal populations by that term or variants thereof. Within Canada various forms such as 'status Indian', 'non-status Indian', 'registered Indian', 'treaty Indian', and 'Native Indian' have been used in an inconsistent manner in governmental acts and papers (See Chartrand, 1991). Even many of the tribal classifications are Europeanized labels. The aboriginal populations of Canada belong to three main groups, Inuit, those labelled Indian, and the Métis. Because there are distinctive differences of history and culture between these three main groups, the general terms of 'aboriginal' or 'native' are often inadequate. Thus, I have adopted the recommendation of the Métis historian Olive Patricia Dickason who uses 'First Nations' to refer generally to all aboriginal peoples within Canada, while distinguishing the so-called 'Indians' with an adaptation of the Francophone's word 'amérindian' (Dickason, 1992: 16).

3 In ethnomusicological parlance 'traditional music' refers to a musical culture which is largely conveyed from one generation to the next orally. It does not mean that the musical culture remains static as numerous ethnomusicological studies show oral tradition to have 'greater variation over time and space than music that is tied to a definitive, written musical score' (Titon, 1992: 11). In other words these studies underline Williams's definition of tradition as 'a selection and reselection of those significant received and recovered elements of the past which represent not a necessary but a *desired* continuity' (Williams, 1981: 187). In any culture decisions are being made constantly by the performers and the receivers of what elements should be retained in a musical performance.

Any adaptation of musics from a culture other than one's own raises the issue of so-called acculturation. Genuine use of Amerindian and Inuit musical material by Euro-American musicians in a non-stereotyped manner has been limited (Keillor: forthcoming), but Amerindians have resented the pseudo-Indian music of film scores. To them, this is yet another instance of the spokespersons of the dominant culture assuming 'that they are able to better understand and explain First Nations than people of the First Nations themselves' (Walkem, 1993: 33). At the same time we have to admit that there is now no culture completely void of influence from another culture (Dawes, 1993: 13). In order to go beyond the limitations of 'Other' and 'Us' in considering the musical expressions of Aboriginal peoples, it is necessary to place the micro-level of creation (the musical material and the song's poetics) into the macro-level of context (cultural, historical, and political). This will result in a multiplicity of viewpoints on the part of creators and members of the audience, which should facilitate a richer interchange of local and international meanings (Grenier and Guilbault, 1990: 393).

4 Education has played an important role in the 'civilizing' of the aboriginal peoples by Europeans in North America from the beginning of the seventeenth century. Under the British North American Act of 1867 education became a provincial responsibility, but Amerindians remained within the purview of the federal authority. Through treaties the government had committed itself to providing schools and teachers on reserves. Because of the expense involved in providing these schools the government decided to construct the schools, but allow the churches to provide teachers and look after the day-by-day operations. Residential schools were favoured because they were seen as being more efficacious in 'assimilating' aboriginal peoples into the dominant society.

School attendance was made compulsory in 1894, but because of poor administration and even abuse of students many aboriginal children did not attend. In 1920 all Amerindians between the ages of seven and fifteen were supposed to attend school, but because of the emphasis on so-called 'practical' training few Amerindians reached the level of grade five by the age of eighteen. 'As late as 1951, eight out of every twenty Amerindians over the age of five were reported to be without formal schooling, in spite of regulations for enforced attendance' (Dickason, 1992: 335). After 1951 Amerindians were gradually integrated into public schools and some bands managed to obtain input into the content of school studies. In 1984, 187 bands were fully operating their own schools. The last federal residential school was closed in 1988.

5 The powwows held throughout North America are based to a degree on parent culture traditions. Blundell's essay (1993) gives a concise overview of the powwow and its main contents as it has evolved in Ontario and the Canadian Prairie Provinces. As Valaskakis has stated, the powwow is an important means of

'being Indian' and obtaining cultural and spiritual nourishment for Amerindians coping with contemporary reality (1993: 41).

6 The characteristics of some Dene parent-culture songs and their texts are discussed in Keillor (1986).

References

Biggar, H. P. (1924) editor, *The Voyages of Cartier*, Ottawa: Publications of the Public Archives of Canada.

Blundell, Valda (1993) ' "Echoes of a proud nation": Reading Kahnawake's powwow as a post-Oka text', *Canadian Journal of Communication* 18(3) 1933: 333–50.

Burgess, Marilyn (1993) 'Canadian "range wars": struggles over Indian cowboys', *Canadian Journal of Communication* 18(3) 1993: 351–64.

Cavanagh Diamond, Beverley (1987) 'The performance of hymns in Eastern woodland Indian communities', *CanMus Documents* 1, 1987: 45–56.

Chartrand, Paul (1991) ' "Terms of division": problems of "outside-naming" for aboriginal people in Canada', *The Journal of Indigenous Studies* 2(2) 1991: 1–22.

Conlon, Paula Thistle (1992) 'Drum-dance songs of the Iglulik Inuit in the Nothern Baffin Island area: a study of their structures', Ph.D. diss. Université de Montréal.

Cronk, M. Sam (1992) 'Non-traditional music of Native North Americans in Canada', in the *Encyclopedia of Music in Canada*, Kallmann, Helmut *et al.*, editors, second edition, Toronto/Buffalo: University of Toronto Press: 931–3.

Dawes, Kwame (1993) 'Re-appropriating cultural appropriation', *Fuse Magazine* 16(5–6) 1993: 7–15.

Dickason, Olive Patricia (1992) *Canada's First Nations: A History of Founding Peoples from Earliest Times*, Toronto: McClelland & Stewart.

Grenier, Line and Guilbault, Jocelyne (1990) 'Authority revisited: the "Other" in anthropology and popular music studies', *Ethnomusicology* 34(3) 1990: 381–96.

Kallmann, Helmut (1960) *A History of Music in Canada 1534–1914*, Toronto: University of Toronto Press.

Keeling, Richard (1992) 'The sources of Indian music: an introduction and overview', *Journal of the International Institute for Traditional Music* 34(2) 1992: 3–22.

Keillor, Elaine (1986) 'The role of Dogrib youth in the continuation of their musical traditions', *Yearbook for Traditional Music* 18, 1986: 61–76.

—— (1988–9) 'La naissance d'un genre musical nouveau, fusion du traditionel et du "country" ', *Recherches amerindiennes au québec* 18(4) hiver 1988–9:65–74.

—— (forthcoming) 'Indigenous music as a compositional source: Parallels and contrasts in Canadian and American music', to appear in *Taking a Stand: A. Festschrift for John Beckwith*, McGee, Timothy, editor, University of Toronto Press.

Kennicott, Robert (1942) 'Journal', in *The First Scientific Expedition of Russian America and the Purchase of Alaska*, James, James A., editor, Evanston/Chicago: Northwestern University Press.

Lederman, Anne (1987) *Old Native and Métis Fiddling in Manitoba*, booklet with recordings, Old Native and Métis Fiddling in Manitoba, FALCON FP – 286.

McIntosh, Dale (1989) *History of Music in British Columbia, 1850–1950*, Victoria, BC: Sono Nis Press.

Neuenfeldt, Karl Wm. (1991) 'To sing a song of Otherness: Anthros, ethno-pop and the mediation of "public problems" ', *Canadian Ethnic Studies* 23(3) 1991: 92–118.

Taylor, Kate (1993) 'Native music is a hot ticket these days, a fact that's being recognized with a brand new Juno Award', *The Globe and Mail* (Toronto), 20 March 1993: C–1–2.

Titon, Jeff Todd (1992) editor, *Worlds of Music: An Introduction to the Music of the World's Peoples*, second edition, New York: Schirmer.

Valaskakis, Gail Guthrie (1993) 'Dance me inside: pow wow and being "Indian"', *Fuse Magazine* 16(5–6) 1993: 39–44.

Walkem, Ardith (1993) 'Stories and voices', *Fuse Magazine* 16(5–6) 1993: 31–8.

Whidden, Lynn (1984) '"How can you dance to Beethoven?": Native people and country music', *Canadian University Music Review* 5, 1984: 87–103.

Williams, Raymond (1981) *Culture*, Glasgow: Fontana Paperbacks.

JAMES A. MCDONALD

BUILDING A MORAL COMMUNITY: TSIMSHIAN POTLATCHING, IMPLICIT KNOWLEDGE AND EVERYDAY EXPERIENCES

Introduction

Q uestions of conciousness are fundamental to the anthropological endeavour. They take many different forms: What is the nature of social consciousness? What is class consciousness or false consciousness? How do ethnic boundaries form? The National Question. There is also a set of questions asking how the individual gains or creates consciousness and how individual consciousness is structured. And what is the relationship between individual consciousness and social consciousness?

This paper looks at consciousness in terms of ideas and how people use ideas to build a consciousness about their world and about their relationships in that world. These are anthropological matters that concern who people are as a collectivity and as individuals, and how they become that way. At issue are a people's own perceptions about their history, their place in the contemporary world, and their future. The focus of the paper is not on the psychology of ideas or the structure of collective ideas, but on the middle ground between these two fundamental anthropological concerns: the interrelationship between ideas and society and the creation of a social reality. Thus, my interest is in how ideas gain substance and meaning, and how ideas are structured into an indigenous theory of practice.

My reference material is derived from a larger study-in-progress I am doing on behalf of an aboriginal community in Canada, documenting what they call their 'cultural revival'. The term is used in the community to refer to a complex, practical process with which community members are strengthening and developing their aboriginal heritage. In terms of the interests in this paper, they are addressing issues of consciousness in the context of redefining the relationship between community structures and symbolic

structures so as to regain some of the power to control their own lives that was lost during colonization. In this regard, their struggles resonate not only with those of other aboriginal groups but also with the more general effort to decolonize and empower communities in the Canadian hinterland (Coates and Powell, 1989).

Consciousness and social reality

In the anthropological literature, understandings of the relationship between consciousness, action and symbol tend to develop one of two approaches. Some authors emphasize the ideational aspects through interpretations of the coherency of cultural phenomenon. William Roseberry's criticism of this approach is that it leads to a treatment of culture, metaphorically, as text that is *already* written (Roseberry, 1989: 24–5). His allusion is to an interpretative anthropology that is eager to explore social and cultural differentiation but hesitant to consider it as a reference to power and domination. This type of anthropology does not deal well with social processes as material processes in which culture is an act of *creation* (or production) (Roseberry, 1989: 25–6). Consciousness then becomes something individual on which the collective experience is inscribed; but to what extent does the individual consciousness mediate that of the collectivity?

The other approach to questions of consciousness is more materialist and endeavors to place ideas in the context of history and colonial capitalism. These materialist analyses treat ideology as part of a social process structured by economic and political inequality and domination, as well as by linkages between various cultural orders that exist in a global but unevenly developing and differentiated social world. Culture is text that is *being* written. Advocates of this approach (for example, see Bourdieu, 1977; Hobsbawm and Ranger, 1983; Lee, 1988) propose we look at collective expressions of ideas (culture, ideology and politics), not to try 'to understand consent but to understand struggle, the ways in which the words, images, symbols, forms, organizations, institutions, and movements used by subordinate populations to talk about, understand, confront, accommodate themselves to, or resist their domination are shaped by the process of domination itself' (Roseberry, 1989: 15–16).

The materialist tack goes a long way in examining the interrelationship between culture, history and power which is important in trying to understand postcolonial social formations undergoing decolonization. It does not, however, go very far in explicating the actual subjective agents of these relationships. People have ideas. Ideologies change. But what is the connection between the two? Pierre Bourdieu's (1977) discussion of knowledge helps with the answer to this question by defining the conceptual trilogy of *doxa*, *heterodoxy* and *orthodoxy* and combining these with the *habitus*. Bourdieu provides a theory of knowledge and consciousness that grounds cultural theory in a theory of practice and puts people squarely at the helm of culture, politics and history. The application of his views to

ideological and cultural activities has an obvious appeal if ideas are perceived to be political forums that organize internal and external relationships. Such is the perception I bring to my representation of the ethnographic ideas discussed below.

Aboriginal people in Canada

Two issues that are emerging as central to the development of aboriginal consciousness are the position aboriginal people have and should have in the Canadian confederation, and the value aboriginal culture can and should have for life in the new century. At the practical level, articulated ideas on these topics are structured into discussions of self-government, land reforms, economic development and cultural revival. These are political issues of national importance that have dominated public discussion of aboriginal issues since the late 1960s. But what meaning do they have in everyday life for Canadians, especially aboriginal Canadians? How do the ideas they represent provide an alternative way of imagining the community and individual existence? How do they become tools for resisting a century of colonial government policies, and how can they contribute to decolonizing, not only aboriginal communities but the rest of the country as well?

My focus in this paper is on a single people, the Tsimshians of north-western British Columbia, although I would argue that my comments are relevant to other First Nations[1] in Canada because they all share the common historical experience of living under the regime of the centralized government in Ottawa that represents the dominant, colonialist ideology. I do not wish to imply that a unified view exists among First Nations People regarding the federal government or aboriginal affairs, or that legislation is the only instrument of colonization. But the federal government has codified colonial ideas through the medium of statutes and policies, creating policies and a body of national law that governs aboriginal lives, for example the Indian Act. This piece of federal legislation is the central historical tool used by the government to exercise control over aboriginal lands and people.

The first comprehensive Indian Act was passed in 1876 to consolidate other pieces of legislation, some of which predated the Canadian confederation in 1867. The Act was revised a number of times, but the framework of the current Indian Act of 1951 was created in 1876. A number of other laws, such as resource laws, make special reference to aboriginal rights and are also important for fully understanding the contemporary conditions of aboriginal people in Canada and their struggle for self-government. However, the point I wish to make here is simply that to the extent the colonial power residing in Ottawa and embodied in the project of Canadian development represents a central force and a common experience for all aboriginal peoples, their various decolonization projects share a common set of objective conditions that are conducive to the development of a common consciousness. Thus it is possible to have national aboriginal organizations which, despite a number of weaknesses, exhibit considerable ability in articulating this shared experience.[2]

To illustrate this general context and to set the tone for my discussion I would like to draw upon a recently expressed view regarding the nature of cultural sovereignty. Early in May 1993, the *Globe and Mail* newspaper reported on meetings the Royal Commission on Aboriginal Peoples was holding in the village of Akwasane, an Iroquois Indian Reserve in Ontario. Staff writer Andre Picard reported that the Iroquois elders who attended the meetings argued that recognition of self-rule was long overdue, and that the wampum belts[3] were binding treaties covering land claims (*Globe and Mail*, 4 May 1993). The quoted comment comes from a presentation to the Commission by Oren Lyons who is an Iroquois faith keeper, a hereditary Onondaga chief, and a professor at Buffalo State University south of the border in New York State. He said:

> Sovereignty is in our hearts.
> Sovereignty is in our acts.

I was not at those meetings, so I do not know the full context of Lyon's statement, but I find his words particularly pertinent to my topic in this paper. In its poetic elegance this phrase summarizes the meaning structure that is called, in Canada, self-government and indicates how the meaning of sovereignty is inculcated deeply into the motivations and actions of aboriginal people.

'Sovereignty is in our hearts. Sovereignty is in our acts.' Although these words were uttered by an Iroquois intellectual living in the north-eastern region of North America, they strike a chord that harmonizes with similar sentiments on the other side of the continent in north-western British Columbia, where the Tsimshian people also are defining and building understandings about what they mean by sovereignty, including what sovereignty means in their hearts and in their acts.

The people of Kitsumkalum and colonization

The village where my work is centred, and which centres my work, is the Tsimshian community of Kitsumkalum on Canada's west coast.[4] The Tsimshian First Nation lives on the lower Skeena River in north-western British Columbia, Canada and on the adjacent islands in the North Pacific Ocean. One community lives in the Alaska panhandle, principally in the town of Metlakatla but also in nearby Ketchikan. In Canada, there are five principal reserve villages on the coast and two inland villages near the city of Terrace. Kitsumkalum is one of the inland communities. Other local north-west towns and cities, in particular Prince Rupert, Port Edward, and Terrace, also have significant, resident Tsimshian populations.

Of the approximately 450 people in the community of Kitsumkalum, over 250 people actually live (in 1993) in the village of Kitsumkalum, which is the community's central residence, and which is located on the Indian Band's principal Indian Reserve. This community has felt the impact of colonization very strongly. It is considered to be one of the most assimilated of the contemporary Tsimshian groups, and many in the community agree with

that assessment. The reasons for this assimilation are complex. Sometimes the assimilation was accepted as part of individual and group strategies for making a life in the colonial period. At other times, the changes were imposed directly or indirectly by governments, missionaries, businesses or general racism.

The people of Kitsumkalum have lived in close contact with the colonial forces for over one hundred years. They first appear in archival records as a result of their visit to the Hudson Bay Company trading post of Port Simpson on 9 August 1841 (HBCA, B. 201/a/6: fo. 13b), and again in 1852, 1857 and 1866 when their trade was singled out in the fort records (HBCA, B. 201/a/7: fo. 41; B. 201/a/8: fo. 100d; B. 201/a/9: fo. 128d). A census supposedly of Kitsumkalum and Kitselas was made in 1845 by Lieutenants Warre and Vavasour for the Hudson Bay Company (cited in Allaire, 1984: 66), but the figures available to me are only for Kitselas. Major Downie's report on his 1859 exploration of the Skeena River for the Hudson Bay Company provides the earliest historical description of the village of Kitsumkalum (Downie, 1893), although Boas (1916: 278) uses mythology to provide a description of the ancestral Robin Town which was located at Kitsumkalum Canyon, 9 miles upstream from the present village. Robin Town was abandoned in favour of the current Kitsumkalum village site in the late nineteenth century. The raising of a fireweed memorial pole in Kitselas by Kastuini (described as a Kitsumkalum Eagle chief by Barbeau) in 1860 is the earliest reference to a Kitsumkalum pole and, presumably, feast (see Barbeau, 1950: 404). After that event, radical changes induced by colonization occurred rapidly.

Fourteen years after Kastuini had his feast, community members (along with Kitselas people) at the coastal cannery town of Port Essington stopped the land surveys (Department of Indian Affairs, 1874: 282), while inland the first Christian service was held in Kitsumkalum village under the evangelical direction of the missionary Tomlinson (Tomlinson, 1875: 253). That same year, 1874, commercial interest in Kitsumkalum valley was sparked by the discovery of nearby gold, probably brought to the attention of the fur traders by a Kitsumkalum man (Department of Indian Affairs 1874: 278). Ever since, the community's association with regional economic development has been extremely intimate, affecting the lives of its members to an extent unimaginable in the more isolated communities on the coast or in other river valleys.

During the 1870s, the twin communities of Kitsumkalum and Kitselas formed a residential alliance at Port Essington where the men fished and the women and children worked in the canneries (McDonald, 1985: 25). The many Kitsumkalum people who moved to that coastal town became known as the Port Essington Indians (McDonald, 1985: 47). When the town withered and died, finally burning down in 1960, most of the Kitsumkalum families moved back to join their relatives in Terrace (McDonald, 1985: 266). Their Indian Reserve was reoccupied and the village rebuilt.

The village today is located next to the city of Terrace which services a local urbanized area with a population of over 20,000 people. Terrace

supports a logging industry and acts as the regional service centre for business and government. Beyond the city's immediate vicinity, there are a few farming settlements in the limited agricultural lands that are available. Since the territory surrounding Terrace is mountainous, little of it is settled. All of it, however, is treated as the hinterland for the city of Terrace and is organized in several ways for development and exploitation. For example, the forest part of a provincial management region called Tree Farm Licence number 1.

A significant portion of the Terrace hinterland includes the traditional land of the Kitsumkalum people and is under a land claim filed by the legal entity of the Kitsumkalum Indian Band. Aboriginal land claims can be a significant political force in Canada (the Oka crisis of 1990 is a recent, intense example involving a confrontation between Mohawks and the Canadian Army – see York and Pindera, 1991). Governments at all levels have a significant interest in resolving land claims so as to rectify injustices and also to avoid the uncertainties conflicts can introduce into development plans. None the less, despite the benefits that can be realized by settling land claims, the results of negotiations are mixed. For the Nisga'a and the Gitksans, two groups neighbouring the Kitsumkalum, the process has resulted in some remarkable co-management agreements and court cases (e.g., Cassidy, 1992; Cassidy and Dale, 1988). For the Kitsumkalum Indian Band and the Tsimshian Tribal Council the major, comprehensive land claims negotiations are still pending. In the meantime, development of Kitsumkalum territory by non-aboriginal interests proceeds unilaterally.

Notwithstanding the continuing colonization of their lands and resources, the people of Kitsumkalum have consistently defended their aboriginal rights against foreign domination, whether from other aboriginal peoples (McDonald, 1983), European settlers (e.g., Drucker, 1958; McDonald, 1990a), or industrialists (e.g., McDonald, 1990b). Even after the 1930s, when the aggressiveness of federal assimilation policies peaked and the Canadian Government effectively outlawed land claims, community members found alternative, surreptitious means to protect and advance their interests, including helping to establish the important, political vehicle called the Native Brotherhood of British Columbia (discussed in Drucker, 1958).

With the slow liberalization of the country's laws governing Indians during the past thirty years, the community quickly reverted to more overt political activities to defend their territorial and other rights. One of the more significant of these recent developments is the reinstatement of ceremonial feasting, commonly called the potlatch in the anthropological literature. This English language terminology simplifies a complex concept that involves a variety of different types of feasts used for different purposes (discussed in McDonald, 1990b: 105).

The feast or potlatch is a 'ceremonial at which the various prerogatives intimately associated with social status [are] assumed' (Drucker, 1967: 131). A feast is held to formally and publicly present an heir to a leadership position or to other privileges. The presentation is to a group of invited guests. The prerogatives and the heir's rights to those prerogatives

are publicly explained during the ceremony, in order for those rights and social positions to be publicly validated by the witnesses to the proceedings. The protocols that must be followed by both hosts and guests are very important for the successful completion of a feast. In recognition of the critical role the guests have in validating social position, the host group provides the guests with a lavish banquet and presents each person with gifts appropriate to rank. In English, people on the coast frequently refer to these ceremonies as 'feasts' because of the banquet format.

My description of the feast is brief, but two key points to keep in mind are that the feast is a focal political forum in the government of social relations and the central integrative institution of that society. The overall function of the feast ceremonial complex has been described by Jay Miller as the knot 'holding together the Tsimshian fabric' (Miller, 1984: 27–8), by John Adams as an investment in community relationships (Adams, 1973: 4), and by Margaret Anderson Seguin as the central integrative institution of that society (Seguin, 1985: 58). These and many other authors have followed Homer Barnett's classic paper on the potlatch (1938) in attributing such a key political function to the feast among all the First Nations along the coast.

Historically, Canadian Indian policy sought to undermine aboriginal cultures. Tremendous assimilation pressures were focused specifically against feast ceremonialism (LaViolette, 1973). Less officially, missionaries exerted pressure by preaching against the practice, by encouraging the burning of regalia, by publicly damning participants, and by agitating politicians to eradicate potlatching. In general, the colonial attitude was set against the potlatch and at times rose in hysteria to what were misperceived to be excessive displays of savage behaviour (Drucker and Heizer, 1967). The government outlawed the practice in a revision of the Indian Act passed in 1884. The new law was applied unevenly, but in a number of locations along the coast people actually went to jail for dancing or giving away gifts. Remarkably, despite all this pressure, potlatching survived in British Columbia, albeit often in highly modified forms (Drucker and Heizer, 1967, Seguin, 1985).

Moreover, potlatching became a symbol of the distinctiveness of aboriginal cultures, offering communities a means to continue their culture and to resist the destructively aggressive acculturation emanating from many sources in Canadian society (Drucker and Heizer, 1967). After years of protest, the law prohibiting potlatching was dropped from the revised Indian Act of 1951. Since then, especially in the past twenty years, there has been a dramatic upswing in public feast activities in British Columbia. Today, many aboriginal communities are experimenting with the feast as an institutional device to govern themselves and to govern their relations with other aboriginal First Nations and with Canadian society.

Decolonization: the Kitsumkalum cultural project

In the case of Kitsumkalum, the community returned to formal feasting in 1987, after a hiatus of more than fifty years. The exact date of the

community's last, previous feast is uncertain, however, my research suggests it took place around the turn of the century, perhaps as late as the early 1930s (McDonald, 1990b). One result of this interruption in their ceremonialism was that, in 1986, no one in the village had hosted a feast ceremony and only a few had attended one.

I must insert comments regarding two concerns members of the community expressed to me when I discussed this paper with them. The feasting I describe at Kitsumkalum represents a practice that depends on reviving existing knowledge and relearning knowledge that had been lost. First, feasting did not completely disappear in the community, although it occurred in ways that were modified to the point that practitioners did not conceptualize these events as feasting. Even though they held funeral memorials and had 'little suppers' to conduct traditional community business such as the transmission of titles, community members spoke of the feast as something of the past (see McDonald, 1990b). I interpret this as a manifestation of the assimilation pressures the community experienced. None the less, these were the activities that predisposed the people to the revival and greatly assisted the revival. Second, the more experienced potlatchers in the area, notably individual Nisga'a, state that feasting never stopped in their communities. Thus, while Kitsumkalum was returning to the feast as a form of self-government, other communities watched with an experienced eye. Historical experience varied and I am not able to document that variation in this paper.

Since the 1987 potlatch ceremony in Kitsumkalum, others have been held in the community. A second large and symbolically pivotal feast occurred here in 1992, and between these two key events, a number (2–3) of smaller feasts have also been held or are in a planning stage. All these activities represent a strong revival of the feasting practice in the community of Kitsumkalum.

Significantly, the revival has generated a community-wide discourse on feasting in which much of the discussion is about the renovation of the political and social structure of the community along lines they identify as traditional. People talk about being Indian, and about their Indian-ness. They talk about their traditions and traditional values. They talk about their social conditions and what they need to have a better, more just life, and to survive as a people. Their conversations bring to mind Peter Worsley's suggestion that culture in the colonized world is really a project that supplies answers to the important question of 'what is to be done?' (1984: 43). Worsley's notion of culture supplying a project, a design for living, characterizes a wide-spread phenomenon in Canada in which traditional ceremonies are being given more and more prominence.

Across Canada, these First Nations' cultural projects are taking many shapes and directions, according to the history of each First Nation. The Kitsumkalum people's cultural project involves their talking about how what they call their 'cultural revival' can respond to their community's needs for economic, social and cultural development, and how the potlatch can be the forum to organize that rejuvenation. This response is just another

translation of Lyons's sentence: 'Sovereignty is in our hearts. Sovereignty is in our acts.'

In 1987, for example, the first Kitsumkalum potlatch had four explicit concerns: revival of the art and ceremonialism which embodies the culture; claiming a just and meaningful place in the economic development of the region; advancing the land claim; and presenting a manifestation of self-government. This feast involved the raising of two village crest (totem) poles, a feast, the adoption and naming of a new *sm'oogyet* or chief, and a distribution of gifts to an international convention of witnesses (described in McDonald, 1990b). This feast was a community feast, sponsored by the entire community and given to people from other communities, Tsimshian communities, non-Tsimshian First Nations, and non-aboriginal governments (Canada, Province of British Columbia, City of Terrace).

The 1992 feast was a different type of feast called a 'stone raising' (in their language: a *Bax maam loop*, according to one of the spellings I was asked to use). This feast involved the raising of a memorial stone at the grave of an elder (Ed Bolton, who was important in the founding of the Native Brotherhood mentioned previously), giving a chief's name to a community leader, and the adoption and naming of two other individuals. The 1992 feast was sponsored by a single phratry, the killerwhale phratry, and given to the other phratries in the regional community, with significant leaders from other comunities and First Nations attending as witnesses (McDonald, 1993).

In 1992, the expressed concerns were just as comprehensive as in 1987, but they were contained in just two goals: reviving ceremonialism; and reviving aboriginal structures of self-government. This second goal of the 1992 potlatch encompassed the issues of their land claim and economic development. This was noteworthy evidence that a considerable evolution had occurred in the community since the 1987 potlatch. By 1992, the potlatch participants were assuming that Tsimshian self-government was the proper context for developing their land claims and for pursuing economic issues. The question was not how to establish this context but how to strengthen and deepen it. The instruments of self-government were seen to provide the means for shifting the values of the community towards indigenous Tsimshian values and to build a specifically Tsimshian moral community to take the people into the twenty-first century. As a *social institution* that can engage a world of politics and privilege, power and positioning (Roseberry, 1989: 232) and as an *instrument of knowledge* that can revive Tsimshian values, the potlatch is a principal part of the Kitsumkalum cultural project.

The potlatch as a social institution

When we think about the feast as a *social institution*, the classic definition of the potlatch as a political forum is crucial. The image is one of noble titleholders (chiefs) performing public rituals concerning some claim of social distinction, in front of a convention of invited witnesses (Barnett,

1938). We think of the potlatch as legitimizing social and political relationships and as the institutional equivalent of a parliament and a records office. By returning to the feast-as-institution formulation of the potlatch in 1987, Kitsumkalum privileged the tradition and customs of the feast *vis-à-vis* the institutions of the dominant Canadian society in order to organize an indigenous form of self-government and resolve land claims and promote economic development in the context of self-government.

Much has also been written about the symbolic power a feast has to impose a social reality by symbolically embodying that reality. Certainly, the feast generates a critical dialectic relation between the *symbolic structures* and the corresponding *action structures* but in practice the development of aboriginal self-government also implies enhancing not just the structures, but also aboriginal dispositions to government, and decolonizing the mind after a hundred years of coercive acculturation. In other words, feasting gives access to a type of knowledge, and structures certain dispositions that make possible, to use Pierre Bourdieu's (1977: 2) terminology, a certain 'native experience' and a 'native representation' of that experience.

The potlatch as an instrument of knowledge

As an instrument of knowledge, feasting can generate and propagate principles for the construction of the social reality. Feasting can generate an orthodoxy about the social world, as well as the competencies needed to live in it.

As an instrument of knowledge, feasting:

1 works to build the type of implicit consensus Bourdieu refers to as a homogenization of people's understanding and knowledge about their heritage which allows heritage practices to be immediately intelligible, foreseeable and potentially taken for granted as 'the way things are';
2 inculcates in its practitioners durable dispositions and competencies that enable them to act as Tsimshians;
3 provides principles for a practical logic that generates further appropriate practices in the same and different contexts.

I will comment briefly on each of these three points.

HOMOGENIZING KNOWLEDGE

Successful feasting requires sorting through a heterodoxy of opinions and homogenizing people's understanding and knowledge about their heritage. For example, during the planning stages for the feasts of 1987 and 1992, fundamental questions were raised about how and why to potlatch. One of the fundamental questions asked was whether or not to potlatch. One hundred and thirty years ago this question may not even have been thinkable, at least not in such a profound sense. Today, the legacy of colonialism has made it thinkable. Even in communities which have a clearly continuous history of feasting – and I want to be unequivocal in stating that

many villages do have this history — individuals have the choice to opt out of the feast system. There are consequences that must be faced by those who decide not to participate, but the consequences are not as serious today, when there are alternatives available, as they must have been prior to colonization when the feast represented greater closure. In Kitsumkalum, those alternatives had come to dominate thinking, even if they had not entirely eradicated the possibility of feasting, as 1987 demonstrated. A second set of questions addressed the meaning of 'tradition', 'aboriginal culture', 'feasting', and 'self-government' (discussed in McDonald, 1990b). Finally, there were questions (which are central to this paper) regarding how the return to feasting might counter the hegemonic influence of the state's own orthodoxy concerning self-government, land claims, aboriginal rights, criminal justice, and so on.

Discussion of these questions in 1987 and 1992 occurred during formal meetings and informal gatherings, and generated agreement as to what actions be taken. Over time, a necessary orthodoxy emerged defining the correct way to feast. This was a tentative orthodoxy as orthodoxies go because people were acutely aware of their lack of knowledge and experience and remained receptive to other ideas. As their experience with the practical logic of feasting grew, those opinions which became established as orthodox became clearer and stronger.[5]

As these discussions proceeded, a new, emergent discourse on feasting developed, and what had been consciously decided, inevitably and gradually, receded into the implicit corridors of the conversation. Matters that had needed to be explored thoroughly at the start of the process became assumptions that guided later conversations. They became a part of the culture of the unconscious 'that leaves unsaid all that goes without saying' (Bourdieu, 1977: 18). As the history of building this knowledge was forgotten in the conversation, the knowledge became naturalized. That is, the implicit knowledge or assumptions that make it seem so natural for a Tsimshian to feast in a certain way, indeed to feast at all, had been instilled in members of the community. These include the intellectual assumptions and attitudes that a mature, experienced potlatcher carries, seemingly naturally. Such mastery was demonstrated in 1992 when a titleholder from a related household in a neighbouring community, who had considerable feasting experience, came forward to support the host family's efforts and added fine ritualistic and ideological embellishments to the proceedings with that apparent spontaneity that only experience imparts.

DISPOSITIONS AND COMPETENCIES

The process I am describing involves more than the development and naturalization of ideas and ideology for feasting. Feasting requires both discussion and experience, but also entails the organization of the perception of practices and the production of practices, thereby involving a universe of discourse and a universe of practice. The aspect of these discourses that is emphasized in the literature is how feasting appropriates collective history in

the form of institutional structures and orthodoxies. Seguin's discussions (e.g., 1985) provide an excellent contemporary example from a coastal Tsimshian village. I am emphasizing another aspect as being especially important in the decolonization process.

Thus my second point regarding the feast as an instrument of knowledge: feasting inculcates in its practitioners certain dispositions and competencies enabling them to reproduce through their practices the deeply tacit values and norms that underlie the feast as an institution. For example, the 1987 ceremony involved seven months of preparation to work out the logistics of the feast. Protocols were discussed. Gifts were organized. Invitations were sent out. The service and agenda were organized and presentations were rehearsed. And so on. Decisions made in the meetings were put into practice in the days that followed with what seemed unceasing corrections, building knowledge and integrating experiences. Potlatch thinking came to govern what people did during the week. The 1992 feast involved five months of preparation, as well as preliminary discussions that began four years earlier. Those discussions involved decisions about the appropriateness of the event, the willingness of the participants, and the myriad of strategies that would need to be deployed to successfully translate the political discourse of a feast into a discourse of practice.

Such preparations build a critical relationship between the political discourse on the feast and the political practice that the discourse will embody. If this relationship is not accomplished then the feast will fail. Feasts can and do fail, usually during the preparatory period. If a proper base of support is not built, efforts to host a feast can collapse, even at the 'eleventh hour'.

In all cases, whether of failure or success, practical experience of the sort that grows into mastery is gained regarding the mechanics and practical logic of feasting. The practical processes, like the discursive processes that move toward an agreed-upon orthodoxy, also move towards habitual behaviour that is homogenized and does not demand conscious direction. The durable dispositions that result have great significance for feasting and for countering the colonization of the consciousness. This significance can be best understood if the subjectivity of the dispositions is not taken to be simply an individual subjectivity. The dispositions I am considering are sociological, with a subject that exists only in relation to the collective appreciation of the dispositions. A Tsimshian woman expressed a similar interpretation when she requested I emphasize the importance of the guests who attend a feast and validate the event.

The ethnographic literature suggests that this subject was, to some extent, bounded by the political autonomy of the villages. The Tsimshian were tolerant of variation in the intra-village interpretations of cultural practices, as long as matters concerning the ownership of rights and privileges were not violated. 'Foreigners were seen as capricious, and potentially dangerous, but never wrong in being foreign' (Seguin, 1985: 476). Thus, one could follow Bourdieu and say style is as much a part of the matter as is substance (Bourdieu, 1977: 86–7). This observation has an important implication for

the decolonization process as communities revive their traditions and customs. Such flexibility allows more experienced individuals, lineages or communities to treat shortcomings as innocent rather than compromising, and to provide support to those who are struggling to regain the cultural coherency that was distorted by colonization.

PRACTICAL LOGIC

My third point regarding the feast as an instrument of knowledge is that the forging of meanings and practices produces a relationship between collective action and event that Bourdieu calls a 'matrix of perceptions, appreciations, and actions' (Bourdieu, 1977: 82–3). This matrix internalizes the outside world and makes possible the achievement of the infinitely diverse activities to which people in Kitsumkalum refer when they speak about their cultural revival. Their current revival matrix is discussed and structured in terms of many analogous areas, including art, ceremonialism, self-government, land claims, economic development, and education. The effect is that dispositions and competencies generated by feasting also engender further feasting aspirations and practices. The practical logic of feasting is such that feasting practices tend both to develop a compatibility with the social conditions that are appropriate for feasting and to respond to the stimulus of those social conditions. Thus, the 1987 potlatch was the breeding ground for later feasting, and the 1992 potlatch can be seen as a continuation of the previous one and a prologue to the next. These two potlatches provided the practice that generated such cultural competencies in the community of Kitsumkalum. Discursive practice in 1992 began at a more sophisticated level, and took for granted much that seemed arbitrary in 1987. The 1992 potlatch modified the model of 1987 by incorporating many modifications and additional customs (or practices) and nuances (or style). Furthermore, potlatching competencies, tied as they are to other cultural domains, influence numerous other analogically related cultural activities. Given the location of the two Kitsumkalum potlatches in a process of cultural revival, this transfer effect has been especially dramatic, percolating through the community and instilling a sense of self-government in the hearts and actions of the people. Another way to describe this effect, this sense, is with the naturalizing phrase 'Tsimshian culture'.

I think, however, that it is crucial to keep in mind what the people of Kitsumkalum do *not* need to keep in mind: The matrix consists of diverse experiences, including Canadian politics as well as Tsimshian revivals. The growth of Tsimshian competencies does not so much create a new matrix defined by pure Tsimshian culture or 'tradition' as cause a shift in the existing matrix away from co-ordinates situating people in terms of the dominant society and towards perceptions related to feasting that contribute to a decolonized form of self-government. The complexity of this process was illustrated in 1987 when the same group of people simultaneously organized the pole-raising ceremony that revived the principles of the potlatch and also another ceremony in the city of Terrace to raise another

pole. This other ceremony incorporated showy references to Tsimshian feasting but avoided invoking the central governing functions of a feast that are ceremonially embodied. Appropriately, this event was called a 'dedication ceremony'. Another thing to note about the structured dispositions I am describing is that they render it difficult to think about, much less perform, incompatible actions (Bourdieu, 1977: 77). This phenomenon is part of the explanation for the source of one of the problems the feast was to resolve. Generations of official and unofficial Canadian suppression of Tsimshian cultural practices had not only undermined and damaged the knowledge possessed by people in Kitsumkalum preserving their traditions; they had also undermined and damaged the thinkability of many cultural practices. For the Kitsumkalum people, the censorship of these governmental policies rendered 'unthinkable' the idea that the community would have its own feast or that they would have a government other than some form of Indian Act government. This was true even as recently as, say, 1985. However, the unthinkable became thinkable in 1987, and again in 1992, when the change in what was thinkable was expanded.

What is to be done?

The Kitsumkalum return to feasting activities puts at stake nothing less than the task of creating a world in the Tsimshian image, a world structured in a Tsimshian way, a world that allows Tsimshian thoughts and practices. My analysis brings to mind the Tsimshian concept of *sm'oogyet* or chief. A *sm'oogyet*, literally a 'real person', is a model person who embodies Tsimshian morality and cultural values (see the discussion in Seguin, 1985: 48 ff). This ideal involves an association of several factors, including being high born, being respected as an individual, acquiring high names, distributing wealth, controlling decision-making although in consultation with appropriate others, and relationships with supernatural powers (Seguin, 1985: 48; Boas, 1916: 496). John Cove, in discussing cosmological aspects of land ownership, characterizes the 'real person' (who manages property relationships by holding titles) as someone who 'has transcended the ordinary human condition and existed in a cosmic sense, able to act with other real and supernatural beings' (1982: 7).

For real people, feasting is a collective manifestation of their individual reality. This is a reality that is consciously developed. A lifetime of participation in feasting is a lifetime spent investing in Tsimshian community relationships and developing a commitment to being a Tsimshian person. The greater the expression of this commitment, the greater the effort at developing the personal reality. So too for the modern community, where feasting is an expression of the degree to which decolonization has been achieved. To finish the Cove quote: 'In a sense, these powers did not belong to the recipient; rather [an] individual embodied them, providing an alternate form of physical existence in the world' (1982: 7).

The feast is symbolic of a way of life, infusing meaning and consciousness, generating a Tsimshian person, creating a Tsimshian reality, and defining an

answer to the question of 'what is to be done'. When seen this way, the scope of the feasting project is breathtaking, especially in a community that has suffered tremendous assimilation.

Question of interests

Before concluding, there is an important aspect to this process I should emphasize. The creation of a world in the Tsimshian image is more than a clever orchestration of the matrix and social institutions. The political and ideological discourse of feasting does not legislate a Tsimshian world into existence. When successful, feasting reflects a harmony between the subject which is the individual or the collectivity, and the objective circumstances in which the subject is located. The Tsimshian concept of a 'real person', with its rich blend of ideals and practicalities, again comes to mind. Realness is a recognition and a reconciliation of the objective and subjective conditions of a Tsimshian existence. A person cannot become a real person by simply saying so. Real-person status requires participation in Tsimshian values, commitment to those values, and the propagation of those values. This can only occur if certain conditions are met and other beings (both human and supernatural) recognize and support the practices. Like the *sm'oogyet*, the realization of decolonization or cultural revival is based on and involves the creation of a harmony between the subjective and objective conditions of the community. In producing this harmony, feasting works with Tsimshian material conditions and interests, elaborating them, bringing them into correspondence, and transforming them in various ways.

What are these interests? This is a complicated question. The short answer is that feasting focuses attention on interests that are common to the various aboriginal peoples throughout Canada (land claims, aboriginal rights, self-government) and that are identified and defined by their aboriginality. These interests exist as a result of the special history of aboriginal peoples and because of their specific struggles to ensconce these interests in the constitution and law of the country. Feasting occurs in this context. This part of the answer relates to my introductory comments about the applicability of my paper to other parts of Canada. Aboriginal interests, as such, exist throughout Canada.

Another part of the answer is that feasting places these general aboriginal interests into the context of Tsimshian values, giving them identity as being specifically Tsimshian interests and distinguishing them from aboriginal interests in other parts of the country. Thus, the history and specific circumstances of the Tsimshian or Kitsumkalum people are manifested and important to the understanding of what is to be done.

So, a quick answer to the question of interest is that, for the Tsimshians, the interests are a bundle of rights to symbolic and material property, tied together while feasting, by the threads of heritage, kinship, rank and realness.

One last point. In Canadian political discourse, aboriginal interests are

generally identified as 'aboriginal rights', a term that includes self-government, land claims, various legal rights, as well as a set of historically based rights involving the concept of aboriginality. This identification might imply a duality between what can be perceived as aboriginal and what is not. Aboriginal rights are important because they are a set of interests that make aboriginal people a distinct social class in the Canadian social formation. These rights are *not* the only material and social interests that aboriginal people have. They *are* a class of interests crucial to the meaning of the contemporary feast and to the effort of recreating the subjective life of the community in harmony with the objective conditions of the community's history. I do not want this paper to promote a conceptual dualism between traditional (that is, aboriginal) and modern. I do want to suggest that by feasting, Tsimshians support and advance those of their interests that are called aboriginal rights and, at the same time, strengthen one of the foundations they can use to pursue their other interests, including those that are linked to small business and wage labour (see McDonald, 1984, 1985, 1994). The feast is a means, and an alternative political discourse, by which all their interests are mixed into a single way of life.

Conclusion

I would like to conclude my discussion by going to the national level and making some comments on the broader practical implications an indigenous theory of practice can have beyond the local-level applications. In Canada, the multicultural situation, with its complexly differentiated politics, will probably never allow instruments of knowledge like the feast to become a natural or self-evident way to conduct political affairs, at any level, local or regional. Given the history of the struggle to rejuvenate the feast way and the reality that other options now exist, there will always be some discussion of the question 'whether or not to potlatch'. What is crucial, however, is that as the practice of feasting helps shift the perceptions and appreciations of its practitioners, the other questions concerning the alternativeness of the feast for governing the relations between people and communities will be answered with ever more profound understandings.

This cultural decolonization has consequences for all Canadians. Development of the feast, or other forms of self-government by other First Nations, as an alternative to the regularized BNA[6] Governments, breaks the hermeneutic Euro-Canadian discussion about government in Canada and opens a deeply heterodoxic discourse. The growth and spread of such heterodoxy requires and forces the review of dominant political traditions and habits. These are not speculative comments emanating from the Ivory Tower. Canadians are already slowly seeing some of the results of this review in the form of land-claims agreements that incorporate aboriginal political structures, or in broad management agreements to cover forestry and fisheries that incorporate aboriginal management structures and principles or in official bureaucratic interaction with elements of self-government, such as titleholders and aboriginal legal systems or in the

conscious assimilation of aboriginal concepts of consensual politics by national political organizations and non-governmental organizations, such as the National Action Committee on Women.[7]

Feasting, and other forms of self-government, may not entirely challenge the existence of the BNA governments. The population figures and distribution of power are too disproportionate and it would be a giddy thought, indeed, to imagine the overthrow of colonial history by the agency of feasting. None the less, the practice of feasting does challenge the orthodoxy the Canadian state hitherto imposed and misrepresented as 'the way to do things'. Undoubtedly, this challenge from the feast hall is most important within the community, where the magnitude of the experience is greatest. There, feasting obviously shakes Parliament in its lofty Victorian perch ás the epitome of man's rise to civilization and as the closest thing to truly natural government. But the importance of what is said and done in the feast is not limited to the reserve.

As the aboriginal agenda for self-government has its impact on the constitutional and political debates of Canada, practices such as feasting mean the BNA Governments, tenaciously rooted as they are in the colonial heritage, can no longer be misrecognized as natural. The hitherto naturalized Social Darwinian tradition of Euro-Canadian domination in Canada's political order becomes a rather arbitrary and unstable thought.

These types of changes have implications for all levels of government in all parts of the country, whether in the north of the province of British Columbia where First Nations are attempting to become a new level of government, or in the federally administered North-west Territories where First Nations are struggling for provincial status. Where these changes will take us is uncertain, but the theories of practice underlying self-government activities like feasting have the potential for decolonizing not only aboriginal communities but the rest of the country as well.[8]

Notes

1 The term First Nations is preferred by aboriginal peoples when referring to their 'national' political groupings. Usage depends on local definition, but generally applies to what the anthropological literature has called tribes or regional bands. In practice, a First Nation may consist of a traditional political entity (e.g., the Nisga'a Tribal Council or the Council of the Haida Nation), or an alliance of such entities (e.g., the Gitksan-Wet'suwete'en), or a fraction of such an entity (e.g., the Kitwancools), depending on negotiated arrangements between the partners. The Assembly of First Nations is a confederacy of First Nations that speaks to the federal government.

2 Conversations I have had with New Zealand Maoris, Australian Aborigines, and Fijian natives, indicate a remarkable similarity in other parts of the colonized world and Commonwealth. For a review of what is generally meant by colonialism in the Canadian context, see the discussion of the colonization of the provincial norths by Coates and Morrison (1992). This work includes a survey of the colonial experience of aboriginal people.

3 True wampum belts are made with cylindrical beads made from the round clam

shell. These beads were either white or purple in colour and were strung on thread made from elm bark. The beads were used for personal adornment, trade, religious ceremonies, as well as for official purposes by aboriginal peoples in the north-eastern area of North America. According to oral traditions, the Iroquois began using wampum strings and belts as certificates of authority and as treaty documents when the League of Five Nations was founded, prior to or during the fifteenth century.

4 I have been describing them in a series of publications (e.g., see references) as well as reports with limited distribution for the Band-sponsored Kitsumkalum Social History Research Project (reports and general information are available through the Band or this author).

5 I am not going to say more about the politics of orthodoxy surrounding these two feasts, which is obviously an important topic. There are two reasons. The minor one is that Seguin (1985) and Barnett (1942) have analyzed the process for other Tsimshian communities. More important is an ethical consideration. To publicly expose the process by discussing internal debates might, at this time, generate political difficulties from forces in the dominant society opposed to self-government. Such a discussion might become a damaging type of intervention. Therefore, I choose to only acknowledge the importance of the dynamic.

6 By BNA governments, I refer to the Provincial and Federal governments established by the British North America Act (BNA Act) of 1867, which was the Canadian Constitution until 1982 when the BNA Act was incorporated into the Constitution of 1982.

7 I am not aware of published sources on these developments, other than a popular article on the woman's organization (Collison, 1993: 62). The two bibliographic references by Cassidy provide some background information.

8 I would like to acknowledge the many-faceted support of the Kitsumkalum community and the Kitsumkalum Band Administration. The Administration initially requested I write on the topic of their revival and provided financial support that assisted the writing of this particular paper. Individual members of the community deserve special recognition for their assistance: Alex Bolton, Charlotte Guno, Larry Derrick. I thank those who commented on the manuscript and Tom Weegar for allowing me to discuss the paper with a largely aboriginal audience in his Native Social Worker class at Northwest Community College, Terrace. Their useful comments sensitized me to potential reactions from a non-anthropological audience. I apologize if I have not adequately incorporated any suggestions they offered. The Royal Ontario Museum provided financial and other forms of logistic support, including sabbatical time that allowed me to concentrate on my writing. Naturally, the opinions expressed are mine alone and responsibility for the content of the paper rests solely with me.

References

Adams, John W. (1973) *The Gitksan Potlatch, Population Flux, Resource Ownership, and Reciprocity*, Toronto: Holt, Rinehart & Winston.

Allaire, Louis (1984) 'A Native mental map of Coast Tsimshian villages', in Seguin (1984): 82–98.

Barbeau, Marius (1950) *Totem Poles*, 2 volumes, National Museum of Canada, Bulletin No. 119, Anthropological Series, No. 30, Ottawa: Department of the Secretary of State.

Barnett, Homer (1938) 'The nature of the potlatch', *American Anthropologist* 40: 349–57.
—— (1942) 'Applied anthropology in 1860', *Human Organization* 1(3): 19–32.
Boas, Franz (1916) 'Tsimshian mythology, based on texts recorded by Henry W. Tate', *Bureau of American Ethnology, 31st Annual Report, 1909–10*: 27–1037, Washington, DC: Smithsonian Institution.
Bourdieu, Pierre (1977) *Outline of a Theory of Practice*, Cambridge: Cambridge University Press.
Cassidy, Frank (1992) editor, *Aboriginal Title in British Columbia: Delgamuukw v. The Queen*, Lantzville, BC: Oolichan Books.
Cassidy, Frank and Dale, Norman (1988) *After Native Claims? The Implications of Comprehensive Claims Settlements for Natural Resources in British Columbia*, Lantzville, BC: Oolichan Books.
Coates, Kenneth and Morrison, William (1992) *The Forgotten North*: A History of Canada's *Provincial Norths*, Toronto: James Lorimer.
Coates, Kenneth and Powell, Judith (1989) *The Modern North. People, Politics and the Rejection of Colonialism*, Toronto: James Lorimer & Company.
Collinson, Robert (1993) 'Why is this woman so angry? Fiery feminist Judy Rebick', *Chatelaine* 66: 7, 47 ff.
Comaroff, Jean (1985) *Body of Spirit, Spirit of Power. The Culture and History of a South African People*, Chicago: University of Chicago Press.
Cove, John (1982) 'The Gitksan traditional concept of land ownership', *Anthropologica* XXIV: 3–17.
Department of Indian Affairs, Canada (1874) *Reports*, Ottawa: Queen's Printer.
Downie, Major William (1893) *Hunting for Gold. Reminiscences of Personal Experience and Research in the Early Days of the Pacific Coast from Alaska to Panama*, San Francisco: California Publishing Company.
Drucker, Philip (1958) 'The Native Brotherhoods: modern intertribal organizations on the North-west Coast', *Bureau of American Ethnology, Bulletin 168*, Washington, DC: Smithsonian Institution.
—— (1967) *Cultures of the North Pacific Coast*, Don Mills, Ontario: Fitzhenry & Whiteside Limited.
Drucker, Philip and Heizer, Robert F. (1967) *To Make my Name Good: A Re-examination of the Southern Kwakiutl Potlatch*, Berkeley: University of California Press.
Eagleton, Terry (1991) *Ideology. An Introduction*, London: Verso.
Foster, Stephen W. (1986) 'Reading Pierre Bourdieu', *Cultural Anthropology. Journal of the Society for Cultural Anthropology* 1(1): 103–20.
HBCA (Hudson's Bay Company Archives) (1834) Fort Simpson Journal, HBCA B. 201, Public Archives of Manitoba, Winnipeg.
Hobsbawm, Eric and Ranger, Terence (1983) editors, *The Invention of Tradition*, Cambridge: Cambridge University Press.
LaViolette, Forrest E. (1973) *The Struggle for Survival: Indian Cultures and the Protestant Ethic in British Columbia*, Toronto: University of Toronto Press.
Lee, Orville (1988) 'Observations on anthropological thinking about the culture concept: Clifford Geertz and Pierre Bourdieu', *Berkeley Journal of Sociology* 33: 115–30.
McDonald, James Andrew (1983) 'An historic event in the political economy of the Tsimshian: information on the ownership of the Zimacord district', in Paul Tennant, editor, 'British Columbia: a place for aboriginal peoples', a special issue of *B. C. Studies* 57: 24–37.

—— (1984) 'Images of the nineteenth-century economy of the Tsimshian', in Seguin (1984): 40–54.

—— (1985) *Trying to Make a Life: the Historical Political Economy of the Kitsumkalum*, Ph.D. dissertation, Department of Anthropology and Sociology, University of British Columbia.

—— (1990a) 'Bleeding day and night: the construction of the Grand Trunk Pacific Railway across Tsimshian reserve lands', *Canadian Journal of Native Studies* 10(1): 33–69.

—— (1990b) 'Poles, potlatching, and public affairs, the use of aboriginal culture in development', *Culture* X(2): 103–20.

—— (1993) The Ed Bolton Memorial Stone Raising. Kitsumkalum Social History Research Project. Report (number to be assigned), 80 pages.

—— (1994) 'Social change and the creation of underdevelopment: a North-west Coast case', *American Ethnologist* 21(1): 152–75.

Miller, Jay (1984) 'Feasting with the Southern Tsimshian', in Seguin (1984): 27–39.

Roseberry, William (1989) *Anthropologies and Histories. Essays in Culture, History, and Political Economy*, London: Rutgers University Press.

Seguin, Margaret (1984) editor, *The Tsimshian. Images of the Past; Views for the Present*, Vancouver: University of British Columbia Press.

—— (1985) 'Interpretative contexts for traditional and current Coast Tsimshian feasts', *Canadian Ethnology Service Paper No. 98*, National Museum of Man Mercury Series, Ottawa: National Museums of Canada.

Tomlinson, Rev. R. (1875) 'Journal of a tour on the Nass and Skeena rivers', *Church Missionary Intelligencer* 11(ns): 251.

Worsley, Peter (1984) *The Three Worlds: Culture and World Development*, London: Weidenfeld & Nicolson.

York, Geoff and Pindera, Loreen (1991) *People of the Pines: The Warriors and the Legacy of Oka*, Toronto: Little Brown & Company.

A POSTCOLONIAL EXPERIENCE
OF ABORIGINAL IDENTITY

In this essay I wish to discuss Aboriginal Australia and the legacy I believe the indigenous people of Australia have lived. The legacy is multifaceted and pervades Aboriginal knowledge, experience and, in fact, encompasses every aspect of life. My challenge is to take this knowledge, complex in a way that many people may know a little, but maybe nobody knows all, and to share some of this knowledge with you.

To help you to get into my line of thinking I want to tell a story about when I was still at high school and considering attending university; I went to speak to the career guidance counsellor. In reasonably brief terms I was told that it was highly probable that I would not get the scores required to enter university through mainstream entry but, as an Aborigine, there was no doubt that I would easily gain entry through a special entry programme specifically designed to encourage the participation of Aborigines. I got the idea that although I was not nearly intelligent enough to make the grade in the mainstream, for an Aborigine I was pretty bright. The guidance officer might never interpret his comments in the same light that I did, but looking back I used to wonder why he was certain that I would lead the field of Aborigines applying for special entry. Maybe it was that I had attended a school in an area that was predominantly white (at that time). Or maybe it was because I had been lucky enough to be born fair-skinned. Either way I had been saved from what appeared to be everlasting damnation.

From the start of Aboriginal Australia's relationship with the colonizers of 1788 it was apparent that Aboriginal Australia would never be the same again. Into this country came a people who had very specific ideas about who was civilized and who was not, what was the desirable way to live, and what was considered appropriate behaviour. What followed is now considered history by non-indigenous Australians, indeed long-forgotten history. But Aborigines and Torres Strait Islanders find this view contentious. The word 'history' suggests that it consists of events that took place many years ago that don't really have too much bearing on us now. In a paper entitled 'What If?' Christine Morris (1993) recounts that when Aborigines talk about our past experiences we are told that it is all history

and not relevant, but if we talk about the ANZACs or Australia's federation, history becomes incredibly important and relevant.

Eve Fesl (1993) has argued that every single Aborigine lives with stigmas and stereotypes that are a direct product of colonization, paternalism, protectionism, patronization, and Christianization. I wish to emphasize that the colonizers were not all males. As nuns, welfare workers, wives to policemen and Protectors or school teachers, white women assisted in the colonization and Christianization of Australia's indigenous people.

It is important to understand the context for these actions. Since the initial acts of British colonization, Australia has applied a number of ideologies to Aboriginal and Torres Strait Islander people. These ideologies were, in some instances, transformed into legislation or at the least remained as dominant social thought.

In the case of Queensland these periods can be briefly described as follows:

1 The period prior to 1897. This was the year that the *Queensland Aborigines Protection and Restriction of the Sale of Opium Act* (the Opium Act) was enacted. Writers have used terms such as 'dispossession' and 'extermination' to describe the dominant ideology of this period (Wearne, 1980; Anderson, 1981).
2 The period from 1897 until the 1960s was characterized by the ideology of 'protection'. The Opium Act separated Aborigines from the rest of society and saw them incarcerated on reserves to be protected from the white society so as to 'smooth the dying pillow' (Tomlinson, 1974: 8).
3 The period from 1965 when the Queensland Aborigines and Torres Strait Islanders Affairs Act provided assimilation to be the dominate social policy.

Since the early 1980s, federally the policy for Aborigines has been one of self-management. The spectrum of Aboriginal and Torres Strait Islander experience highlights the effects of these policies and ideologies.

Errol West has aptly described these effects:

I have been privileged to associate with Aborigines of all walks of life, abilities and political and religious persuasions. Resulting from those ties I have attempted to 'tell it as it is' and succinctly, it's horrifying. For some, anger towards and hatred of what has happened is impossible to control. What is even more difficult to control are the attitudes of despair, bewilderment and horror at the circumstances in which Aborigines have been placed by white people. Yet, no blame accrues to those same white people; it all falls on the shoulders of Aborigines. I am angry and disturbed about the pauperisation of Aboriginals' cultures, will, expectations, capacity and hopes. I am not fooled by or pleased with the very limited efforts by any governments of Australia, or its population, to redress the abject poverty of Aborigines. The 'sugar, flour and tea ration' mentality of ever changing political masters no longer satisfies. Aboriginal children are still dying, Aboriginal youth are still committing suicide and the aged are

still either in pain from personal oppression or numbed by the anaesthetic oppression which attempted to force the discarding of their self-respect and confidence in their culture. All of this is the cumulative effect of two hundred years of racism, hatred and white arrogance.

Aborigines must be freed from the designations of the past. Aborigines suffer the effects of the whites' practice. It is to no avail that any intellectualising of the problems faced by Aborigines will solve or resolve any issue. Nothing will prevent Aboriginal deaths in custody until racism, entrenched in the practice of, and the letter of the law, is subdued to the point of non-existence, and the list is endless.

(West, 1990: 10)

To me this speaks of pain, deeply entrenched pain, a pain that is borne by all Aborigines. The pain is about being Aboriginal.

It is also important to understand that since the initial colonization of Australia there have been ongoing attempts by governments through legislation to remove any sense of group identity shared by Aboriginal people. However these efforts have failed because people have been bound together by the very actions that were designed to separate them.

Aboriginal people have retained a strong identification with their Aboriginality, in light of powerful political and social pressures not to do so. When mixed heritage children were removed from their families or mixed heritage people were forced to move off reserves, they either illegally returned or they got together creating new communities on the outskirts of country towns or in one or two particular suburbs of the capital cities. There was a very strong reliance on community support and co-operation because many could not get work or they were underpaid for work they did. Their sticking together was about survival and resistance against the people who were, through legal and social policies, trying to annihilate and separate Aboriginal society.

A word that seems to crop up in discussions about Aborigines is 'guilt'. Most Aborigines will say that we do not want non-Indigenous people to feel guilty. What Aborigines really want is people to understand what has happened to them and their ancestors and take it into account when they are considering their situation. It seems that the 'Aboriginal problem' has been shelved away in the too-hard basket or at least not been considered fully. Now Aborigines are saying that this is not good enough, the response from non-Indigenous Australia is that they are being unfairly accused. There are concrete ways to deal with the Aboriginal plight and claiming undeserved guilt or anxiety isn't one of them.

Australian Aborigines are a colonized people and share the experiences of the continuing effects of colonization with colonized peoples worldwide. Most Australian people are ignorant of the war between the colonizers and Aborigines, of the stealing of Aboriginal women and children at the whim of the aggressors, and of the unnecessary incarceration of Aboriginal men, women and children with the aim of annihilating Aboriginal society.

Australia's history has been about controlling Aboriginal populations (Anderson, 1981: 54). Some of these control mechanisms were, and still are, influenced by:

1 An inherent belief in the absolute moral, technical and cultural superiority of European society. This justifies land dispossession based on the view that Aborigines never 'developed' the land, reflecting a nineteenth-century social evolutionist framework wherein human societies exhibit 'development' and 'progress'.

2 The influence and dominance of powerful lobbying concerns, such as pastoral or mining companies, with entrenched financial interests in land and resource exploitation.

(Anderson, 1981)

The ongoing colonization of Aborigines and the disenfranchisement of Aboriginal experiences and knowledge continue and are perhaps most in evidence in academia. The perfect example is a researcher going into a captured community such as Palm Island or one of the Torres Strait Islander communities. The researcher collects data on certain issues and leaves the community, often never to return. This is a familiar experience for many Aboriginal communities. This knowledge then becomes the property of the researcher who becomes an 'expert' on that issue. The Aboriginal people who live that knowledge may not get a mention or a higher degree to show for the knowledge they have freely imparted. They lose control of that knowledge. This is academic colonization and it's happening all the time. Why? As one academic said to me, 'my supervisor said it would be a good idea and it would complement the research he is doing there.' What is the value of that?

So what does this mean? Where to now? It is apparent that for Aboriginal people there is no hiding from these issues for too long. Aboriginality stays with you all day every day. We can't go home at the end of the day and leave it at work. The racism Aboriginality attracts occurs every day. Academic and other forms of colonization exist and continue every day in Australia. Strength for Aboriginal people comes from the knowledge that we are not alone in our struggle. All Australians are in just as deep. The feelings of many Aborigines are best understood by reading their poems, such as those by Nicole Williams (1993). These are extracts from her poem 'The politics of a racist game':

> We're reeling from the side effects
> of a not too pleasant time,
> where your well-meaning attitudes
> equate to an atrocious crime
>
> My family remains silent
> afraid to speak aloud.
> Worried about your answer
> because you see they're not feeling so proud.
>
> It's all about empowerment
> about setting our people free.
> We're learning your terminology
> and someday you will see.

References

Anderson, Christopher (1981) 'Queensland. [Aboriginal land rights]', in Peterson, N. (1981) editor, *Aboriginal Land Rights: A Handbook*, Canberra: Australian Institute Of Aboriginal Studies: 53–114.

Fesl, Eve (1993) 'Colonisation and Mabo', paper presented to Post-Colonial Formations Conference.

Morris, Christine (1993) 'What if?' Paper presented to 'Post-Colonial Formations' Conference, Griffith University, Brisbane, Queensland (July 1993).

Tomlinson, John (1974) *Institutionalization: A way of life in Aboriginal Australia*, Brisbane: Amnesty International Australian Section.

Wearne, Heather (1980) *A Clash of Cultures: Queensland Aboriginal Policy 1824–1980*, Brisbane: The Division of World Mission of the Uniting Church in Australia.

West, Errol (1990) 'Towards a bran nue day: a discussion about the present and the past for the future', unpublished thesis.

Williams, Nicole (1993) 'The politics of a racist game', *Inside My World*, unpublished poetry collection.

KEN GELDER AND

JANE M. JACOBS

'TALKING OUT OF PLACE': AUTHORIZING THE ABORIGINAL SACRED IN POSTCOLONIAL AUSTRALIA

T he phrase from our title, 'talking out of place', comes from an account of sacred country given by an Aboriginal man, Paddy Roe (1988; Muecke, 1992), from the Kimberleys in north-west Western Australia – an account to which we shall return towards the end of the paper. We use the phrase self-consciously in order to suggest that by talking about the Aboriginal sacred we, as non-Aboriginal Australians, are in some senses (e.g., if one thinks about questions of protocol) 'talking out of place'. But the other meaning of this phrase is important, too. We are also talking out of *a* place – contemporary Australia – where the Aboriginal sacred figures certainly as something with unspeakable dimensions, but also as something which arguably is spoken about these days only too often. It is not that the Aboriginal sacred is (still) marginal to the nation – quite the opposite: it would be difficult now, even for non-Aboriginal Australians, to conceive of the one without the other. Nevertheless, there are important issues of speaking rights which we cannot and do not wish to ignore. In fact, our interest is not in the content of the Aboriginal sacred, much of which may well be unspeakable or secret, but rather in how the Aboriginal sacred is negotiated outside of itself in the public domain – which may, of course, entail a consideration of what happens when secrecy and publicity intersect. In other words, our interest is not in what is being said about sacredness so much as what is being said *about* what is being said. Such a study might consider a range of Aboriginal involvements in the sacred (at various levels of officiality); it could also focus on particular judicial decisions and governmental policy (where Aboriginal involvement *is* official); and it may well address more general levels of non-Aboriginal participation, too.

We have written this paper in a national context designated as 'after

Cultural Studies 9(1) 1995: 150–60

Mabo'. In 1992 the High Court of Australia found in favour of Eddie Mabo's claim that the 1879 annexation of the Torres Strait was unlawful and in no way extinguished his customary ownership. This decision legitimated Aboriginal prior occupation in Australian Common Law and laid to rest the concept of *terra nullius*, a founding myth of Australian nationhood. Land-rights claims, which until this moment had operated within the limits of piecemeal legislation, were now possible across the nation.

This 'after Mabo' moment is not only about Aboriginal claims on land, but also Aboriginal claims on non-Aboriginal self-consciousness (notably, our historical self, our national self). It is true that this moment has mobilized residual racisms. We can note, however, that it can also mobilize romantic or sympathetic alignments on the part of non-Aborigines, and we shall return to such possibilities later in the paper. It is often claimed that the Mabo case – and the moment 'after Mabo' – has 'divided' Australia, a media-driven generalization which is difficult to verify. Nevertheless, it seems fair to say that Australian law has manufactured a decision which has 'shaken' the nation in certain ways. The divisive or destabilizing effects of the 'after Mabo' moment have worked most spectacularly at the institutional level of government – producing disagreements between the federal government and the states, new divisions within party ranks, disagreements (and distrust) between government and business interests, and so on. We can note that the topic of sacredness has not figured largely in this institutional shake-down. But it is likely that land claims will once again be adjudicated – to some degree at least, if not primarily – in terms of Aboriginal relations to their sacred sites.

This has in fact been a familiar pattern of land-rights arbitration, available since the early 1970s, which has consistently disadvantaged those Aborigines who will not or cannot present their land interests in this way. The requirement of channelling a land claim through sacredness, to make it depend upon the provable absence or presence of sacred sites, has in the past worked severely to constrain land claims. It is worth noting, however, that in spite of a long history of such constraint, a certain kind of non-Aboriginal 'panic' has arisen in response to what is perceived as a current 'liberation' of the Aboriginal sacred in Australia. Mining companies have often complained of being under threat from (claims about) sacred sites; the colonizers luxuriate here in a self-representation usually associated with the colonized. The federal government's somewhat fragile decision to disallow large-scale mining at Coronation Hill in the Northern Territory, because of the presence of a Jawoyn dreaming figure, Bula, produced many examples of this kind of rhetoric. Mining interests spoke of themselves and (since the one was always incorporated into the other) the nation as endangered, peripheral to what was seen as other, more privileged agendas. Western Mining head Hugh Morgan (1991) likened the decision to the threat to nationhood posed by the fall of Singapore in 1942, and conceived of Aboriginal sacredness as a 'plague' which was spreading rapidly across (secular) Australia, speculating that other parts of the nation ear-marked for mining ventures might well find

themselves designated by hopeful claimants as 'Bula II', 'Bula III', and so on. Aboriginal claims which are in fact subject to a range of rigid controls are here the means by which the nation is imagined – not altogether untypically – as *out* of control.

Anthropology and the sacred

The representation of the sacred as unmanageable can also be found elsewhere, in a context less prone to hysterics. We can trace a version of this trajectory – a version not unrelated to the comments above – by turning to the anthropologist Ken Maddock's (1991) recent paper, 'Metamorphosing the sacred in Australia'. Maddock gives a certain kind of institutional history to the Aboriginal sacred, taking anthropology's interest in sacredness as a point of origin for non-Aboriginal constructions of it. In this sense, the Aboriginal sacred is 'original' to anthropology. The discipline began by polarizing the sacred and the profane, as in Emile Durkheim's (1915) account of the Aboriginal sacred where '[t]he sacred thing is par excellence that which the profane should not touch, and cannot touch with impunity' (cited in Maddock, 1991: 215). This polarization was gendered, with early anthropological accounts regarding the sacred as the domain of men and the profane as the domain of women, and where to bring them together was, in Durkheim's words, 'promiscuous'.

This polarization began to fall apart when anthropology came into the service of the law, through land-rights procedures – that is, where, to quote Maddock, 'sacred sites entered the language of the law from the language of anthropology' (1991: 223). The law, more directly aligned to government policy at this time, sought to capitalize on anthropology's containment of the sacred. Maddock goes on to trace the fortunes of the sacred under this new institutional regime. On the one hand, by turning the sacred into a subject for discussion and elaboration, the law sent the sacred into the public domain as something increasingly familiar to it – that is, it rendered the sacred profane, domesticated, even ordinary. On the other hand, however, the law may have also amplified the mystery of the sacred by manufacturing prohibitions around it to produce a certain kind of (non-)recognition, for non-Aborigines especially, mediated through the legally ratified practices of 'care and circumspection with which [the sacred] is approached and treated' (Maddock, 1991: 215).

It would be possible to read the law's interest in sacredness as consistent with the history of colonialism. But Maddock's article sees the law's appropriation of the Aboriginal sacred from anthropology as amounting to another kind of institutional shake-down. Indeed, for Maddock – although he does not express it in this way – the slippage of the sacred from anthropology to the law, from one institution to another, is in effect symptomatic of the movement from colonialism to *post*colonialism. We can glimpse this in the conclusion to one section of his article, which emphasizes the progressive inability to contain – or control – the sacred:

The story does not end there. If we look back we can see that the concept of a sacred site passed out of anthropological control once lawyers took it up. So, too, if we look around we can see that the concept is escaping from legal control.

(Maddock, 1991: 226)

It may be that Maddock has a nostalgia here for his own discipline's 'original' investment in the sacred. Nevertheless, his remark that 'the concept is escaping from legal control' offers possibilities for a contemporary reading of sacredness – which sees the constraints outlined above as by no means totalizing and which would therefore position it in a postcolonial rather than colonial paradigm. The implication here is, however, ambivalent. Do the constraints of law – or, indeed, anthropology – themselves paradoxically work to produce the sacred as a non-fixable surplus? As something which, not so much in spite of the law as *because* of it, is (still) a mystery? Or is there something not necessarily intrinsic to sacredness but rather about its actual *performance* – the way it is spoken about, the way it is unspoken about – which is capable (and is perhaps increasingly capable) of 'soliciting' those constraints? And in this context we are drawing on Derrida's (1982) use of the word, deriving from 'an Old Latin expression meaning to shake the whole, to make something tremble in its entirety'.

The recent (although '*before* Mabo') contestations between the Jawoyn people and mining interests over Coronation Hill in the Northern Territory have brought these issues into the foreground. These contestations in part centred around fixing the geography of the sacred in attempts to determine the spatial limits of the area of land the Jawoyn people called 'sickness country'. The question, 'where *is* the sacred?' – especially important for mining companies to determine – involved a whole range of authorizations, not only from the Jawoyn people themselves. Non-Aboriginal modes of authorization were highly visible here – from mining and government representatives, as well as those academics who lent (or in some cases, refused) them support. Constraints were placed in particular upon claims over the locality and ownership of sacred sites. An example of academic work here would include Stephen Davis and Victor Prescott's (1992) recent book, *Aboriginal Frontiers and Boundaries* – which attempts restrictively to arbitrate on the geography of Jawoyn land interests. They argue that the Jawoyn were not traditionally associated with the area containing Coronation Hill itself, mapping their pre-contact presence conveniently to the south of the mining site. Contemporary Jawoyn claims about Coronation Hill's sacredness are interpreted as illegitimate, the product of a post-contact 'expansion' and 'elaboration of traditions' (Davis and Prescott, 1992: 76). This would seem, however, to be one place where – again – imposed constraints do not hold. Indeed, official site registration procedures designed to offer the Aboriginal sacred 'protection' and legal status have gestured towards the *unbinding* of sacredness here. Coronation Hill was not registered as a sacred site with fixed boundaries, as was the usual translation of the spatiality of the Aboriginal sacred into policy. Rather, the site

recording authority controversially registered it as a networked zone of influence – an expansive, geographically flexible area which rested uncomfortably (and somewhat unstably) with the organized knowledges of the state.

What was solicited in this arrangement were conventional distinctions between the local and the regional (where a 'site' diffuses into a 'zone'); but since the outcome of contestations over Coronation Hill was directly related to the national interest and to Australia's fortunes in the world, the local and the regional also reached into the national and the global – and, of course, vice versa. The Jawoyn 'expansion' at work here, then, might rather be seen as an engagement with traversals across the Coronation Hill site which modernity has already installed. And it would be possible to read this engagement – which is itself modern – positively, rather than negatively. We can appreciate the reach of the local into the global, for example, in Francesca Merlan's account of Jawoyn commentators observing that, if Coronation Hill is disturbed, 'earthquake, fire and flood will affect "Sydney, Melbourne, overseas"' (1991: 340–1). The local, the national and the global – as otherwise discrete categories – are quite literally solicited through this remark.

Sacredness, sympathy and secrecy

We can open up the question of the sacred in performance – where non-Aboriginal and Aboriginal negotiations over the sacred are acted out in the public domain – by looking at some other recent examples. The political problem of fixing the terms of reference for the Aboriginal sacred, involving as it does the nationalizing and even globalizing of local interests, is well illustrated by the controversy which developed around the Northern Territory government's attempt to build a dam near landlocked Alice Springs, in central Australia. The proposed dam encroached upon the Two Women Dreaming of the Arrernte; that is, it encroached upon a sacred site for Arrernte women.

This case involves the problematic of disclosure and the reach of disclosure into the public domain. In the first stage of the dam controversy in the early 1980s, Arrernte women confined disclosure of the site's content to official site-recording authorities; some disclosure was necessary to ensure that the sites were recorded by the state and afforded 'legal' protection, but the amount of information shared was kept to a minimum. As the prospect of dam development consolidated, however, the Arrernte women decided to disclose the content of the site more widely. Journalists were invited to the site and were told some things about its content, suggesting, now, a strategic approach to disclosure. These same journalists were also told that there were things they, and their reading public, could *not* see and know. The journalists told readers what had been revealed about the site, but went on to note that there were things which must remain unseen and unknown. This case thus came to involve a negotiation between what could be spoken and

what should remain unspeakable — a negotiation which then itself became the means by which the public could come to 'know' the sacred.

In speaking of their sites, the Arrernte women were not insensitive to the resonance of their struggle with that of women elsewhere. An Arrernte woman characterized the sacred objects stored at one site in this way:

> They are a vital part of being a woman. Like you've got women's liberation, for hundreds of years we've had ceremonies which control our conduct, how we behave and act and how we control our sexual lives. . . . They give spiritual and emotional health to Aboriginal women.
> (Welatye Therre Defence Committee, 1983; cited in *Sun*, 9 May 1983: 13)

Destruction of the site, an Arrernte spokeswoman was quoted as saying, would 'bring a curse on all women. . . . Not just Aboriginal or local women, but all Australian women' (*Age*, 20 March 1992: 9). The possible destruction of the Two Women Dreaming site did indeed become an issue for all women. Support and donations were received from Women's Action Against Global Violence, the Feminist Antinuclear Group, Women's Health Centres (Adelaide and Sydney), the Feminist Bookshop (Sydney), a Sydney women's refuge, Women for Life, and the Women's International League for Peace and Freedom (Lloyd, Gale and Sitzler, 1984: 7–8). Arrernte women were keen to advertise this wider support for their cause, and a newsletter was released which listed and quoted many non-Aboriginal supporters (Welatye Therre Defence Committee, 1983).

Alliances were also formed with groups committed to global environmental projects which had begun to turn towards indigenous knowledges in their quest for ecological salvation (see, for example, Knudston and Suzuki, 1992; Lawlor, 1991; Merchant, 1989). The London-based Aboriginal Support Group made clear their sense of supporting the Arrernte as part of the environmental imperative to protect the 'wisdom of the elders':

> We have all come to admire and respect the deep feeling Aboriginal people hold for their land and feel that we in Europe and people all over the world have much to learn from you in caring for the earth.
> (Cited in Welatye Therre Defence Committee, 1983)

The Arrernte struggle resonated with the concerns of global environmentalisms and feminisms. In this particular case, then, it was the manufacture of sympathetic and no doubt nostalgic alliances — rather than, say, the modernizing forces of capitalism — which amplified the Aboriginal sacred and rendered it global in its reach.

But at the moment at which the sacred spiralled out of its locality through the manufacture of sympathy, the Arrernte women began to take a more cautious approach to disclosure. When a second dam site was proposed, one Arrernte woman explained her concerns to the second inquiry established to arbitrate on the deadlock:

> Only the Traditional owners used to hear these stories that their grandparents told them. Now they are going to hear this story all over the place. This dam has made the story really come out into the open; the

story that used to be really secret. Now other tribes are going to hear about it . . . now everybody is going to learn, and the white people as well are going to learn about it. . . . Now they know about that place all over the world. . . . We are giving away all our secrets now, and it will be heard all over the world.

<div align="right">(Wootton, 1992: 74)</div>

So far, then, we have a movement from the local to the global, and a pulling back into the local again – a movement driven by negotiations around the need for disclosure (to ensure legal protection of the sacred) and the need for secrecy (in accordance with Aboriginal law). Our point would be, however, that the *performance* of secrecy can itself have a global reach just as much as the act of disclosure. In the case of the Arrernte women, secrecy hints at an unknowable dimension to their concern for their sites. The performance of this unknowability, in a paradoxical sense, authenticated the Aboriginal sacred for sympathizers elsewhere and positively amplified the significance of those sites. That is, secrecy itself may have mobilized the politics of sympathizers, providing an unknowable space into which their imaginative desires – their knowledges – about Aboriginality can be projected. Of course, when one outcome of non-Aboriginal imaginative projections grounded in global environmentalisms or feminisms is a political alliance which desires and does not discredit secrecy and may even assist in the acknowledgement of Aboriginal rights, then narrow adjudications of 'predatory appropriation' by non-Aborigines are problematized – although not, however, eliminated. (For a discussion of 'appropriation' and the predatory gaze, see Morris, 1988: 256–69). So the most positive reading of this is that the local and the global can co-exist in a kind of mutual intensification. But a more negative reading would see secrecy in its local manifestations as always already compromised – opening, as it does, the Aboriginal sacred to the various agendas of non-Aboriginal environmentalists and women's groups.

Performing the sacred

Our final example returns us to the account of sacredness by Paddy Roe, told to, and transcribed by, Stephen Muecke – made in relation to a land claim in the Kimberleys. Muecke (1992) titles this text 'The children's country' and provides a reading of it which is included (along with the text itself) in his recent book, *Textual Spaces*. We can note several things about Muecke's reading which are pertinent to our discussion. It is concerned primarily with the means by which Paddy Roe achieves authorization – to enable him actually to say the things he says. The text is taken as ethical or pedagogical, in that it works to 'orient the subject [the listening subject as well as the speaking subject] in discourse' (Muecke, 1992: 116). Muecke achieves this, however, by playing out a split between ethics and information, where the way a text directs the subjectivity of its listeners in particular is sheared away from the information that text conveys. He says, 'I have subsumed the referential or informative function of language under the instructional,

because information is indifferent to subject positions, at least when it is idle' (116). We may note here that information is never 'idle': it is only when information is distinguished from ethical directives in this way that such a claim could be made. Elsewhere in his reading, in fact, Muecke raises an *informational* problem when he says (almost in passing) that Paddy Roe's text 'takes up the issue of land rights, but skirts around it in an indirect manner' (108). So a contradiction of sorts is produced through Muecke's reading which, in some senses, he seems to recognize: Paddy Roe's text is rendered ethically directive, but informationally *indirect*. Our own reading would want to problematize this polarity of ethics and information, particularly in the context of our earlier discussion about secrecy and disclosure where (as we have seen with the Arrernte women's site) the conveying of information always involves ethical decisions, and where offering directives about the sacred may very well involve 'skirt[ing] around it in an indirect manner'.

The second point to make about Muecke's reading relates to the reach of Paddy Roe's text into various kinds of audiences. For Muecke, the audience is divided into immediate listeners (Paddy Roe's children and, we could presume, Muecke himself) and a generalized 'white Australia' (to which Muecke, of course, is also attached). That is, a local and national, even global, polarity is at work here. Indeed, Muecke's book, which reproduces Paddy Roe's local text, seems itself to be written for an internationalized audience – it is endorsed on the back cover by the American academic Lawrence Grossberg. This again brings us back to the issue of direction and indirection. For Muecke, there is no problem concerning direction in the immediate sense, since he suggests that the text 'provides points of insertion for listening subjects [i.e., Paddy Roe's children] who may want to take up his story and tell it again' (Muecke, 1992: 102). But as well as ethically directing its immediate listening subjects, this text may also be available for the *less* immediate 'predatory appropriations' and sympathetic alignments we have outlined above. We may wish to ask: are we to take this as an *indirect* consequence of this text? We can only do this if the local and the global – the direct or immediate, and the indirect or less immediate – remain polarized, as they do in Muecke's reading.

In fact, Paddy Roe's text addresses this problem. His country – around Broome in north-west Western Australia – is traversed by the national and the global, most recently as a highly publicized tourist destination. So part of the problem involves trying to negotiate the local in *relation* to the national/global. Paddy Roe begins by noting that for his generation localness was a given:

we never say, 'You come from that part of the country, you come from
that part of the country', no, we never say those sorta things –
all the people is all same to us –
because they know their boundary, they go back –
we know –

we know our old people's boundary too they all go back to each
boundary –

(Muecke, 1992: 103)

Everybody knew their location, and at the end of the day they went back to
it. For Paddy Roe, this is the way the 'old people' used to live. And it was
never necessary to say – in 'language' (i.e., in the language of the local
Aboriginal community) – where those localities were. He underscores the
point:

but language got nothing to do –
no, language got NOTHING to do –
with the country –

(Muecke, 1992: 104)

This insistence, however, is made in the context of some remarks about what
conditions are like now rather than then. The point seems to be that
language is still not necessary in relation to localities, not because everybody
knows where their own locations are and 'go[es] back' to them at the end of
the day, but rather because, now, the local is always more than just local.
This local space – what was once the country of the 'old people' – is now also
a national space and a global space, where the connections between
language and locality, or even identity and locality, have been unbound:

ANY language can live –
today –
English, Japanese, Chinese, we all friend –
we can't say where they come from –
and now people just the same

(Muecke, 1992: 104)

The earlier remark about how it was then – when 'we never say', that is, we
never *needed* to say, where one's own locality was – now changes to become
'we can't say'. In other words, what once was simply unsaid now becomes
something that is impossible to say. There may be too many voices now, too
many unbound voices, for the local and the global to be properly
distinguished.

But all this takes place in the context of making a land claim, where one
must gesture towards the locality of sites and country: *something* must be
said. So Paddy Roe's account seems to enact a strategic shift. Since the
surface of the country is now traversed by so many voices from so many
places, the sacred is duly located underground:

but the top soil is belongs to ANYbody can walk –
walk around, camp, ANYwhere, we can't tell-im he got no right to be
there –
if he got right to camp because the top soil is belongs to him –

but the bottom, the bottom soil, the bottom soil that's belongs to my
family, family trustees, family group –
family trustees –

<div align="right">(Muecke, 1992: 109)</div>

This distinction between the top soil and the bottom soil produces a renewed
authorization of the sacred in contemporary Australia. It is a means by
which the localness of the Aboriginal sacred can be recovered from the
wanderlust of globalization. It may be true that the sacred eludes globaliz-
ation here in a manner not unlike Maddock's account of the sacred 'escaping
from legal control' – even as it further authorizes itself through the language
of the law by drawing on the legal terminology of 'trustee'. But it may also be
true that locating it underground, rather than speaking the country, may
well provide one of those 'points of insertion for listening subjects' that
Muecke had described in his commentary. To locate the sacred underground
as Paddy Roe does in his text returns to the discourse of secrecy, but in order,
it seems, to render the sacred hidden for all to see. Even here, there still
remains an indirect direction towards 'predatory appropriation' or, indeed,
sympathetic alignment from 'listening subjects' elsewhere. And this is one
problematic which seems to inhabit the location of the Aboriginal sacred –
wherever it might be – in postcolonial Australia.

References

Davis, Stephen and Prescott, Victor (1992) *Aboriginal Frontiers and Boundaries in Australia*, Melbourne: Melbourne University Press.
Derrida, Jacques (1982) *Margins of Philosophy*, Hertfordshire: Harvester Wheatsheaf.
Durkheim, Emile (1915) *The Elementary Forms of the Religious Life*, London: George Allen & Unwin.
Knudston, Peter and Suzuki, David (1992) *Wisdom of the Elders*, Toronto: Allen & Unwin.
Lawlor, Robert (1991) *Voices of the First Australians: Awakenings in the Aboriginal Dreamtime*, Rochester, Vermont: Inner Traditions.
Lloyd, Robert, Gale, Fay and Sitzler, Minna (1984) *Report, Alice Springs Recreation Lake* Vol. 1, Alice Springs, Australia: Board of Inquiry into Alice Springs Recreation Lake.
Maddock, Kenneth (1991) 'Metamorphosing the Sacred in Australia', *The Australian Journal of Anthropology* 2(2): 213–32.
Merchant, Carolyn (1989) *Ecological Revolutions: Nature, Gender and Science in New England*, Chapel Hill: University of North Carolina Press.
Merlan, Francesca (1991) 'The Limits of Cultural Constructionism: The Case of Coronation Hill', *Oceania* 61: 341–52.
Morgan, Hugh (1991) 'Reflections on Coronation Hill', transcript of a speech to the Adam Smith Club, Melbourne, 9 July 1991.
Morris, Meaghan (1988) *The Pirate's Fiancée*, London: Verso.
Muecke, Stephen (1992) *Textual Spaces*, Kensington, New South Wales: New South Wales University Press.
Roe, Paddy (1988) 'The children's country', *Meanjin* 47(1): 11–20.

Welatye Therre Defence Committee (1983) *Voices from Mparntwe* (Newsletter), Alice Springs, Australia: Welatye Therre Defence Committee.

Wootton, Justice Hal (1992) *Significant Aboriginal Sites in Areas of Proposed Junction Waterhole Dam, Alice Springs. Report to the Minister for Aboriginal Affairs*, Canberra, Aboriginal and Torres Strait Islander Commission.

SIMON DURING

BROACHING FICTION: A SHORT THEORETICAL APPRECIATION OF WILLIAM FERGUSON'S *NANYA*

I n 1990, the anthology *Paperback: A Collection of Black Australian Writing* appeared. It was a noteworthy event in Aboriginal writing, among much else because it threw open an important, if narrow (I'd say only apparently narrow) question that has been neglected by postcolonial critique and theory. This question concerns what I'll call the conditions of emergence of Aboriginal fictionality. One story in particular, William Ferguson's *Nanya*, first published in the anthology, triggered my inquiry because, as far as I know, it now stands as the first piece of Aboriginal literary prose in print which is not a transcription of a traditional narrative. That is to say, *Nanya* broaches Western fictionality. Broaches – because, like many a bush yarn, *Nanya* is based on an actual event. Let me begin by telling the story as Ferguson presents it.

Nanya was a young man of the Barkindji people living along the Darling River, a major waterway in south-eastern Australia. In the days before contact, he fell in love with Mimi, a girl of his own meat or *gingue* as the text calls their skin (or section) names: they are both Kangaroos. After Nanya's initiation, he elopes with Mimi into the desert. According to the customs of the Barkindji, this transgression, we are told, means certain death: Nanya's elders give chase, but as they pursue him they encounter, for the first time, white men whom they believe to be spirits of the dead. Frightened, they turn back. Nanya also sees the whites but he regards them as spirits he has invoked to aid his escape. So for the first time in Barkindji memory, the narrator tells us, defiance of the law (or *Bora*) goes unpunished and Nanya and Mimi escape. For the next forty years, they live in the desert, helped by their meat kin, the Kangaroo. They have children; Nanya fathers more children from these children. Most of the resulting family have misshapen bodies; they lose their law (anyone can have sex with anyone) and, more radically, they lose their language (no one even has a name). However, when

Nanya is an old man, the family is captured and brought into what the narrator calls 'civilization'. Almost immediately, Nanya dies and is transformed into two kangaroos who, so trappers say, magically defy bullets. Only one of Nanya's family survives in settler society – Ada, a beautiful young woman who marries a man of 'her own colour' but whose children forget the old ways (Ferguson, 1990: 196).

Let us consider the conceptual frame of this extraordinary allegory of colonial contact and destruction. It transforms certain traditional indigenous narratives of romantic transgression, in particular as they were recycled (by both blacks and whites) as 'Aboriginal legends'. These legends were presented in texts inspired by the (pre-ethnographic) folklore movement which dates back at least to the brothers Grimm and whose most imortant exemplar in the late nineteenth century was perhaps the prolific Andrew Lang, an author both of fairy-story collections and of academic works of 'comparative mythology'. There are, for instance, narrative analogies between *Nanya* and the Dreaming story of Purleemil and Tirtla as told by K. Langloh Parker (1898) in a popular Australian collection of such 'folklore' Aboriginal legends. But in *Nanya* the unchangeable order of 'myth' is inserted into secular Western history. The story is also set in Western space: its division between the desert and the civil being defined by the limits of settler agriculture. Certainly it is not placed in a geography organized through what are now called Dreaming tracks or songlines. And the story fuses Barkindji custom with white science: the breaking of the *Bora* is punished by the generation of monstrous bodies – as social Darwinism would predict. From the Aboriginal side, though, the coming of 'civilization' is itself a punishment for transgressing the law or *Bora*, 'civilization' being a word that is coded increasingly negatively as the story progresses. By necessity, Ferguson's text itself breaks the old law: the true meat or skin names of the Barkindji are forgotten (Kangaroo was never one) and the story violates prohibitions on mentioning the dead. In sum, Nanya's story is transformed into a quasi-fiction by grafting white on to traditional Barkindji concepts.

What conditions enabled this borderline fiction to be written? Let us begin with the largest horizon that question gestures to – fiction itself. Fiction needs to be distinguished not just from so-called 'truth' (and especially historico-scientific truth such as that produced by social Darwinism) but from 'sacred' discursive forms such as myth, Scripture or Dreaming-narratives. Although I cannot fully argue the case here, it was no accident that it was during the European Enlightenment that fictions became a dominant Western cultural form. In this context, it is important to bear in mind some particular features of Enlightenment fiction. Its characters belong to the same world as its readers and potentially at least they possess selves open to transformation, largely through the power of sexual desire both to break through social hierarchies and to found nuclear families. Such fictions which, at least in their most popular form, celebrate class exogamy against patriarchal caste endogamy – I am thinking of works like Samuel Richardson's *Pamela* or Jean-Jacques Rousseau's *Julie* where the passion of

lovers from different classes is affirmed against marriage practices designed to maintain class filiation (and the property transmissions secured by such filiation). In their transgressiveness and realism, such fictions engage their readers in a contract to identify with unreal situations and characters with new intensity: the implicit contract, 'I know this is not true, but,' (as the Lacanians famously put it) works more powerfully in Richardson than in his conservative rivals – Henry Fielding or Tobias Smollett say. These enlightened fictions are read for entertainment, and are available to any one with access to print. At a more abstract level, they are also almost always deterritorialized in the sense that their geographical setting is either vague and symbolic (as in Richardson and Jane Austen) or, if more particularized, exists as a stage for the teleological and ethical narrative which is of primary importance (as in Fanny Burney and Daniel Defoe). They are also historicized in the sense that they happen in a temporal order over whose direction human agents have control. And, last, they are desacralized: they happen in a world in which God does not intervene except as 'Providence', and which, except in genre-fiction, lacks magic.

That fictionality is a crucial component of Western Enlightenment is borne out by the way the West has represented so-called primitive societies as having no fictions. We can take two contemporary examples: Fred Myers writes: 'there is no category of fictional narrative in Pintupi' (1991: 49), a statement Eric Michaels echoes: 'Desert Aborigines have no category of fiction' (1987: 32). It seems likely that these statements are too absolute, taking post-Enlightenment forms of fictionality too much for granted. After all, some pre-contact Aboriginal communities had about five hundred narratives in circulation, some secret, most not, and many were, like Western novels, told for entertainment and instruction. Early accounts of Aboriginal peoples emphasize the importance of entertainment in their gatherings now called corroborees – including, after contact, performances in which narratives of struggles between blacks and whites were represented. In the very earliest days, these performances were popular among both black and white, and seem to have possessed at least some of the distinguishing features of fictionality. Furthermore, an important element of modern fictionality, the individual's capacity to dissimulate and to change or exchange identity (think of the plotline of Fenimore Cooper's *The Last of the Mohicans*, for instance) was not just a commonplace of songline narratives but an aboriginal life-practice, especially as a tactic in inter-communal warfare.

None the less, let us provisionally accept that Aboriginal culture as preserved in the archives seems to lack narrative fictions of the kind associated with the short-story or novel – until *Nanya*. I want now to think more carefully about its conditions of emergence. We cannot simply consider the story as marking the moment at which fictionality is appropriated for Aboriginal discursive practices, as its writing and publication belongs, in fact, to three separate moments: the period in which the story was set (that is, from about 1860 to 1893 when Nanya's group were in the desert); the time when Ferguson wrote his manuscript (probably the 1930s)

and, finally, 1990 when the story was published for the first time in the effort to circulate and anthologize black writing with all the losses and gains that such production of cultural capital in settler terms entails. I want here to deal briefly only with the first two of these three moments.

Despite Ferguson's presentation of Nanya's story, the actual events it is based on happened about thirty years after whites entered Barkindji territory. This is the time when initial Aboriginal strategies for dealing with whites – maintaining their old ways around the stations and transport routes – became very difficult, especially once the introduction of galvanized fencing allowed settler property to be enclosed, and indigenous species to be crowded out by (privately owned) cattle and, later, sheep. In this situation, disease, overgrazing and appalling settler indifference and violence increasingly depopulated local peoples. In the light of *Nanya* two signs of this breakdown are particularly worth noting: it was during the 1860s that the indigenous communities no longer killed infants whose fathers were white. It was then too that some young Barkindji began to take advantage of white institutions to break out of their communities' generational hierarchies – so that, for instance, in an 1867 case white authorities permitted a young Barkindji woman to marry a man of her own skin.[1] During the years that Nanya was in the desert such tactical co-operation with white ways became common. Indeed, he was captured by his own people who seem to have been both responding to what they thought was best for him and to have expected a reward from the state's Aborigine Protection Board, established in the early 1880s. The reward never materialized but personal gains could still be made. Harry Mitchell, the Aborigine who organized Nanya's capture and who told the story to Ferguson or perhaps to Ferguson's brother who lived on the Menindee mission where Nanya's family ended up, became an overseer at the Nulla station, a powerful position in the settler community. But it is important to note that if *Nanya* reads, at least on one level, as a fictional allegory of the destruction of indigenous culture at the moment of contact – one written between two cultures – that effect is only achieved by omitting this more ambiguous web of events in which both sides make use of each other.

The events which the story fictionalizes and simplifies belong to the violent borders of empire but the story itself is written when resistance to Aboriginal subordination was becoming politicized. Its author, William Ferguson, a shearer and son of a shearer, was not brought up in indigenous traditions, entering politics as a labour organizer closely connected to the Australian Labour Party and with strong Christian affiliations. He became a Koori activist in the 1930s as a leading figure in the Aborigines' Progressive Association and, with John Patten and William Cooper, was responsible for the 1938 'Aborigines Claim Citizen Rights' Manifesto and Day of Mourning organized against the official celebrations of the hundred and fiftieth anniversary of the colony's founding.[2] He put special effort into trying to stop a re-enactment of the first landing in which people from the Menindee mision were to play the indigenous people 'put to flight' by Governor Phillip's arrival. That was all the more ironic a performance considering that

Menindee was the home of many Barkindji, presumably including Nanya's family, whose local culture was just then under great stress.[3] (Later he became a bureaucrat, a member of the New South Wales Welfare Board, established in 1943 after amendments to the 1909 Protection Act.)

Ferguson's politics in the 1930s were supported by some whites: he was, for instance, encouraged to print his Manifesto by P. R. Stephensen and Xavier Herbert who had together just finished *Capricornia*, the novel, controversial at the time, in which the damage sustained by Northern Territory indigenous peoples from (relatively recent) white settlement was foregrounded. Indeed Ferguson's political standpoint, though complex and shifting, was, like Herbert's, basically assimilationist. Ferguson argued for his people's right to citizenship, education and self-formation as modern subjects of the nation-state, against Protectionist policies which segregated most so-called 'full-bloods' on reserves in the expectation that their kind would die out – a politics which would become official governmental policy under the name 'assimilation' only as late as 1953, and would lead to the granting of citizenship to Aboriginal peoples in 1961 (see Rowley, 1972: 239). *Nanya* enacts this politics much more adventurously and successfully than any white text (including *Capricornia*) in the skill and power with which it fuses black and white cultural forms and concepts in the manner I have outlined. Yet it also enacts the logic of assimilation by acceding to the destruction of traditional practices while affirming the ongoing reproduction of people of 'the same colour'. Its implicit logic is that, since Aboriginal peoples are *not* going to die out even though pre-contact traditions are disappearing (at least in the south-eastern edges of the continent), Kooris should not be treated as absolutely subordinate 'others' requiring 'protection'. To this end, the narrative replaces traditional forms of exogamy across different sections by endogamous marriages of people with the same skin-colour. In doing so it again ignores certain conditions, this time internal to the Barkindji. For their marriage laws remained in force at least until the First World War, and, throughout the continent, the larger structure of those laws, in particular skin names, have remained intact and in a few situations are in fact being revived.

We can further explain the manner in which the story strips away the complexity of post-contact colonial relations by considering its relation to another form of white knowledge. Probably non-intentionally, it inverts the so-called Murdu legend upon which the first Australian anthropological work, Fison and Howitt's 1880 *Kamilaroi and Kurnai*, is based. (This ethnographic text was destined to have a major impact on Western social science from Freud and Durkheim and Mauss to Lévi-Strauss). As Fison and Howitt present it, the Murdu legend, supposedly produced by the Dieri people, narrates how Dieri marriage laws emerged from a period of total promiscuity (1880: 25). *Nanya* inverts this narrative: it tells a story in which the law breaks down, incest becomes rampant, but, crucially, the narrative ends in signalling the possibility of Aboriginal regeneration. Two points need to be made about this inversion of what was a key myth for late nineteenth-century anthropology. First, Ferguson's politics in the 1930s

involved criticizing anthropologists for representing his people as 'scientific curiosities' and for helping make those he called 'wild bush natives' a synecdoche of Aborigines as a whole. At this stage of his career (if not so much later), his assimilationism required him to exclude those of his people who lived on or beyond the colonial frontier, as well as academic representations of them. His inversion of the anthropological paradigm, which drove him into fiction, was thus part of a larger political gesture. Second, although to all intents and purposes constructed by whites, the Murdu myth is not a fiction (in the way a novel is for instance) but a scientific falsehood telling anthropologists of the time what they wanted to hear. For them, Aboriginal society lay at the furthest point from their own on the evolutionary scale, and the Murdu story appealed to them so powerfully because it indicated to them that Aboriginal culture is primitive enough to retain living memories of a primal state when marriages were non-existent and sexual relations were simply promiscuous (the state that Lewis Morgan, Fison and Howitt's influential scientific patron, called the 'consanguine family').

In fact *Nanya* enters into relations with the anthropologists' myth because Western and Aboriginal societies had one important feature in common: the need for more or less arbitrarily structured social institutions for organizing sexual relations. Why was this common feature chosen rather than, say, language or practices dealing with death? Mainly, I'd suggest, because of *Western* interests: relations between socio-cultural and sexual reproduction in the West, organized around the affective, nuclear family, were unstable and had long been critiqued by calling upon cross-cultural comparisons (perhaps the most famous example being Diderot's essay on Bougainville's Tahiti). And social reproduction through what Lawrence Stone famously called the affective nuclear family was precisely what Western fiction, especially romantic fiction, was designed to support at the period when such fiction became an important cultural form. So it was no accident that an inversion of self-serving anthropological knowledge and fictionality could be harnessed for Ferguson's purposes around the question of the social organization of sexuality.

Yet, as we have seen, Ferguson draws on Aboriginal traditions too. On the Aboriginal side, certain Dreaming stories figure the land as the trace of narratives of sexual transgression so as to build the law into the structures of communal existence (rather than, as was the case in the West, into the subjectivity of individuals and their ethical choices). Also, more secular and ethical narratives, as Ronald Berndt has pointed out, were designed to show that flouting traditions – especially traditions determining the choice of marriage partners – will bring 'social condemnation and death' (Berndt and Berndt, 1964: 846). I'd argue that it is because early Western ethnographical science, modern romantic fiction and some traditional Aboriginal orature are all designed to stabilize the socialization of sexuality that *Nanya* can become a fiction – pass the threshold of fictionality – in the form that it does. To be more specific, and remembering that the story ends when Nanya's incestuous daughter Ada, at home with white ways, marries a man of her own colour, we can say that *Nanya*, in attacking false white science which

preserves old black knowledge rather than supporting contemporary life-practices, takes on the ethical function shared by both Western fiction and indigenous trickster narratives but this time to urge skin-colour endogamy in the interests of assimilation and the colonial state.

So *Nanya* is directed towards a readership for whom Dreaming narratives are no longer true (they have become fictionalized) and for whom skin names are lost – though skin-colour differences remain. As the story bypasses older traditions and presses towards assimilation, it does not, however, drive Aboriginal difference out. Difference between Aborigines and gubbas (white Australians) continues to exist but only through the Aborigines' cultural loss – whose traces remain only in what, by the story's own logic and also Ferguson's early assimilationist politics, now has no meaning: the colour of one's skin. In a magnificent paradox, skin colour becomes a signifier worth preserving through endogamous marriages because it no longer means being different, being other; it just reminds of a lost past. This rather risky affirmation of skin colour as a signifier of no living difference had become impossible at the time of the story's publication in 1990 when autonomy rather than assimilation had become the primary aim of Koori politics – for very good reasons. Indeed it is possible to read Ferguson's refusal to have Ada marry a white man as proleptic of a politics that he was himself unable fully to institutionalize and articulate, the politics of Aboriginal cultural and political autonomy. Yet now that a politics expressed and enacted in these terms does exist, we can think about the story in larger as well as more local terms. By fusing three registers – which we can call the magical (that transformation into a kangaroo), the falsely scientific (that punishment for transgression of the incest taboo) and romantic fiction – and by presupposing a readership which no longer believes in the traditional narratives, *Nanya* is no longer just a local story. It fits into narrative practices associated with contemporary cultural globalization. It enters into relation with postcolonial 'magic realism' but it also anticipates those globally popular genres in which apocalyptic ruptures in, or leaps out of, history trigger narratives in which boundaries between humans and other species as well as the animate and the inanimate are remarkably fluid. I'm thinking of stories like *Batman Returns* or *Jurassic Park*. Which is worth saying, even in this very truncated form, because it is important to insist that writing like *Nanya* need not simply belong to the nation-state which has treated the first inhabitants of its territory so inhumanly.

Notes

1 See Hardy (1976) for material on the Barkindji.
2 The best published source of information about Ferguson is in Horner (1974), to which I am endebted. The term 'Koori' is the name adopted by urban Aboriginal peoples from Australia's South East.
3 See Carmichael (1993) for an insight into contemporary Barkindji life.

References

Berndt, Ronald M. and Berndt, Catherine H. (1964) *The world of the first Australians*, Sydney: Ure Smith.

Carmichael, Aunty Beryl (1993) 'A New Partnership in Education', *Meanjin*, 52(4): 697–702.

Ferguson, William (1990) '*Nanya*', in Davis, Jack, Muecke, Stephen, Narogin, Mudrooroo and Shoemaker, Adam (1990) editors, *Paperbark: A Collection of Black Australian Writings*, Brisbane: University of Queensland Press: 175–97.

Fison, Lorimer and Howitt, A. W. (1880) *Kamilaroi and Kurnai: Group-marriage and Relationship, and Marriage by Elopement, Drawn chiefly from the usage of the Australian Aborigines*, Sydney: George Robertson.

Hardy, Bobbie (1976) *Lament for the Barkindji*, Adelaide: Rigby.

Horner, Jack (1974) *Vote Ferguson for Aboriginal Freedom*, Sydney: Australia and New Zealand Book Company.

Michaels, Eric (1987) *For A Cultural Future: Francis Jupurrurla Makes TV at Yendumu*, Sydney: Artspace.

Myers, Fred (1991) *Pintupi Country, Pintupi Self: Sentiment, Place, and Politics Among Western Desert Aborigines*, Berkeley, Ca.: University of California Press.

Parker, K. Langloh (1898) 'Purleemil and Tirtla', in *More Australian Legendary Tales*, London: Macmillan 1898: 105–24.

Rowley, C. D. (1972) *The Destruction of Aboriginal Society*, New York: Penguin.

HELEN MOLNAR

INDIGENOUS MEDIA DEVELOPMENT IN AUSTRALIA: A PRODUCT OF STRUGGLE AND OPPOSITION

> What we want to do is show our people from our view of people. We know that white people are misrepresenting us. They have been for almost 200 years. We need our information. We need to control our own information. We need to put out the messages that the community needs to hear.
>
> (Aboriginal broadcaster quoted in Quigley, 1987: 2)

T his paper examines the growth of Aboriginal and Torres Strait Islander community media in Australia over the past twenty years. It argues that there is an urgent need for indigenous broadcasting policy and funding to reflect how central broadcasting has become to Aboriginal and Islander culture, and is critical of federal government departments for their inadequate response to this issue.

Introduction

The 1991 census estimated that there were 257,333 Aborigines and Torres Strait Islanders out of a total Australian population of seventeen million. This figure is considered approximate because it is difficult to make an accurate assessment in remote areas. Aborigines and Islanders live in urban and rural areas, but it is only in remote Australia that they form a significant part of the population. Despite their small numbers, Aboriginal and Islander communities are very diverse and have distinct language and cultural differences. This diversity extends to all areas of Aboriginal and Islander life including religion, political beliefs, ideals and history. Pan-Aboriginal and Islander approaches to indigenous issues are therefore inappropriate as they fail to take this diversity into account.

Since the 1970s, aided by the Whitlam Labor Government's commitment to indigenous self-determination and the cessation of previous assimilationist policies, Aborigines and Torres Strait islanders have sought to control more of their own affairs so that they are not always in the position of being objects of governments and welfare agencies. A crucial part of this

© 1995 Routledge 0950-2386

control is a new sense of indigenous identity. Aboriginal- and Islander-produced media content has an important role to play in this process as it can promote indigenous languages and culture, and indigenous social and political agendas.

Indigenous media development 1970–94

Aboriginal and Torres Strait Islander media began to develop in Australia in the 1970s and grew rapidly in the 1980s. Most of the growth has been in community radio, but community video and television production is gaining momentum. A significant feature of the indigenous media industry has been the formation of indigenous media associations throughout Australia. The link between these associations and the community is very important, and is often misunderstood by government departments. Many of the media associations have grown out of existing indigenous community organizations, because these organizations feel that the electronic media can be used to provide information on a range of social, cultural, economic and political issues in a form and language that is relevant to the needs of Aborigines and Torres Strait Islanders. There are now an estimated 150 media associations, and they range in size from the Central Australian Aboriginal Media Association (CAAMA) employing over seventy people, to associations which are run by one person – usually on a voluntary basis. In 1992 the Aboriginal and Torres Strait Islander Commission (ATSIC) acknowledged the extent and influence of the media associations by making funding available for the establishment of the National Indigenous Media Association of Australia (NIMAA) to represent the hundreds of Aboriginal and Torres Strait Islander broadcasters working in radio, video and television.

The rapid development of the indigenous media sector is quite extraordinary if one considers that as recently as 1980 a small number of non-indigenous controlled community radio stations were the main outlet for Aboriginal and Islander media production. Today, Aborigines and Islanders are involved in almost every sector of the media.

In 1994, Aborigines and Islanders are producing programs on thirty non-indigenous community radio stations (urban and rural), five Aboriginal community radio stations (two in Queensland, one in the Northern Territory and two in Western Australia), eighty Broadcasting for Remote Aboriginal Communities Scheme (BRACS) television and radio stations in remote communities, Australian Broadcasting Corporation (ABC) regional radio (Western Australia, the Northern Territory, South Australia, Queensland, and the Torres Strait Islands), ABC and Special Broadcasting Service (SBS) metropolitan radio and television, two HF shower shortwave radio services (Northern Territory), and remote commercial television services (the Golden West Network (GWN) covering Western Australia, and Imparja transmitting to the Northern Territory, South Australia, New South Wales and Victoria). In addition to this, Aborigines own a remote commercial television station (Imparja), and Aboriginal and Torres Strait Islander video-makers in each state are producing community videos and

video programs commissioned by corporations and government departments. This wide-ranging involvement has strengthened the overall impact of the indigenous media industry. It has also put pressure on the federal government to design policies and funding mechanisms that address the multifaceted nature of the industry.

Electronic media and indigenous cultural expression

The concentration on the electronic media, rather than the printed media, has not been accidental. The key advantage offered by radio and video is that they are oral media, and as such they have enabled Aborigines and Torres Strait Islanders to skip the print generation, because the oral qualities of radio and video are ideally suited to oral cultures and for indigenous cultural expression. The printed media, on the other hand, have not been major vehicles for indigenous communication in Australia. One of the more obvious reasons for this is their use of the written English language, but equally important is the fact that the printed media have largely maintained their hierarchical work practices and European forms. Radio and video technologies, in comparison, have become increasingly user-friendly, community oriented and affordable since the 1970s, and can easily be adapted to a range of uses. This adaptability has allowed Aboriginal and Torres Strait Islander broadcasters to create their own forms of communication. It has also encouraged community involvement. Everyone in a community, from young children to elders, can participate in radio or television programs, increasing the community feeling of these media. This community perspective is very much a feature of indigenous radio and video programs in urban, rural and remote areas. In one production at Ernabella, a remote community in South Australia, the video-makers were accompanied by up to thirty custodians who would 'tell and re-enact Dreaming Stories and perform the song and dance for each successive site on video' (Turner 1990: 44). Each person was directly accountable, in terms of Aboriginal reckoning, for some aspect of the story being told, and the video could not be made without them. Aborigines and Islanders have, in this way, adapted the smaller technologies of radio and video to their cultural requirements and forms of expression.

The accessibility of radio and video, combined with their relative cheapness, has also meant that Aborigines and Islanders can own and control their own radio, video and television technology and thus determine their information agendas. This is crucial for indigenous cultural and political self-determination, for regardless of how sympathetic some of the mainstream media may be to indigenous issues, indigenous control is essential for self-determination.

To date, community radio and video and low-power television have offered the most potential for indigenous control. The channel-sharing arrangements indigenous media associations have with ABC radio in remote areas (the Kimberleys and the Torres Strait Islands) have also given Aboriginal and Torres Strait Islander broadcasters a level of control not possible on the mainstream media. The media associations in these regions

use an ABC transmitter to broadcast their programs for up to fifteen hours a week. They do this from their own studio, at set times, by switching off the regional ABC signal. The programs feature current affairs, community news, music and story telling, and are produced in a number of indigenous languages. This, along with the community orientation of much of the content, sets the programs apart from the more tightly structured and faster paced ABC formats.

The ABC committed itself to channel-sharing arrangements in remote areas because of the large number of Aborigines and Torres Strait Islanders living in these regions. In doing this, the ABC acknowledged that, as the national broadcaster, it had a responsibility to Aborigines and Islanders. At the same time, it realized that it would be inappropriate for the ABC to produce programs for Aborigines and Islanders as this would continue a mainstream media tradition of speaking on behalf of indigenous people. Instead, the ABC encouraged indigenous media associations to produce programs in indigenous languages, in a form that they considered relevant. This is very important in remote areas, because it is in these regions that indigenous languages are still strong. Of the estimated 350 indigenous languages that existed at the time of European colonization (1788), only 100 are still spoken today. Aborigines and Islanders in remote areas feel that the electronic media can play a major role in the maintenance of these languages.

In order to assist the associations, the ABC has provided training and equipment, as well as administrative help with applications to government departments to fund training wages, salaries and other associated costs. This is essential because it allows the media associations to operate independently of the ABC, which is important if they are to determine their own program forms and content.

Aboriginal and Islander media associations have taken up opportunities like those offered by the ABC, because they feel that the power and prominence of the electronic media increases the impact of indigenous media content. This is important, because in many instances, Aborigines and Torres Strait Islanders are using indigenous produced radio and video programs to resist the imposition of Western media and culture. Radio and television are effective vehicles for this resistance as they can 'authorize' indigenous languages and cultures by making them part of the public agenda, thus signalling their significance. A vital aspect of this is the way in which indigenous media content demonstrates that indigenous culture, far from being consigned to a museum, is alive and relevant to our times. How this is achieved is illustrated in the following description of one of the leading video-makers at Yuendumu, Francis Jupurrurla Kelly, by Eric Michaels:

Jupurrurla, in his Bob Marley T-shirt and Adidas runners, armed with his video portapak, resists identification as a savage updating some archaic technology to produce curiosities of a primitive tradition for the jaded modern gaze. Jupurrurla is indisputably a sophisticated cultural broker who employs videotape and modern technology to express and

resolve political, theological, and aesthetic contradictions that arise in uniquely contemporary circumstances.

(Michaels, 1987: 26)

Fry and Willis argue that radio and video are the significant media in this cultural strategy because these media allow indigenous producers to 'break the circuit of producing products for circulation and consumption within the culture of dominance'. Aboriginal and Islander radio and video producers can do this by determining the content and shape of their own programs, and by 'producing ideas and images that circulate in their own cultures'. Radio and video in this way offer potential forms of resistance to imposed national and transnational cultures as they 'occupy a cultural space from which the right to speak is asserted' (Fry and Willis, 1989: 160).

Just as significantly, Aborigines and Islanders are using the electronic media to create new means of distribution, and to restore the communication links destroyed by European colonization. Indigenous broadcasting, while largely community based, can potentially be transmitted locally, regionally and nationally, informing Aborigines and Islanders about each other, thus strengthening indigenous self-identity. In remote communities without access to telephones, this networking function is very obvious. Community radio has become a 'community telephone', passing on messages and news to the community.

The Tanami network is another example of community networking, and at present is the only network of its type. In July 1992, four remote communities in Central Australia (Yuendumu, Kintore, Willowra and Lajamanu) set up a video conferencing network using compressed digital audio-video technology, because they wanted to 'work out family things and keep the traditions and Aboriginal law strong' (Toyne, 1992: 2). The primary purpose of the Tanami network from the communities' point of view, is to re-establish the earlier traditional communication network which had been disrupted by forced resettlement and European contact, in order to provide community members with 'direct and accessible ceremonial and family links' (1992: 2). The communities opted for this solution because Telecom's terrestrial system has been inadequate, and has only offered them very limited telephone, fax and computer facilities.

The network is owned by the four BRACS communities, who have contributed substantially to its cost. To date, the uses of the network have been varied, and have included broadcasting meetings involving older men so that they do not have to travel long distances, art auctions, health workers giving advice, and sessional contacts between teachers and secondary students. One of the network's more unusual uses is to confirm the presence of people on the community detention program, thus helping them avoid prison sentences for minor crimes (see Toyne, 1992).

Building bridges between indigenous and non-indigenous Australians is another major function of indigenous-produced media content, because this content gives non-indigenous Australians an insight into the diversity of indigenous culture and lifestyles missing in the mainstream media.

Indigenous media development is also encouraging other forms of reconciliation between indigenous and non-indigenous Australians at a community level. Aboriginal and Islander communities have led the way in establishing community radio in areas which had no other community radio service. One consequence of this has been that non-indigenous Australians are approaching indigenous media associations and asking for access. This has happened in the Torres Strait Islands and the Kimberleys (WA). The significant factor here is that the non-indigenous Australians are working within an indigenous determined framework, rather than vice versa.

The Tanami network, referred to earlier, also offers the potential for reconciliation between indigenous and non-indigenous Australians. Government departments have found that their communication with remote communities has not been very successful, so they are buying time on the network to discuss government policy issues of significance to remote communities (Toyne, 1992). The video conferencing facilities mean that the communities can talk back, and this is encouraging a dialogue between them and government officials.

Indigenous initiative versus inadequate government policies

The extent and significance of the indigenous media industry, however, is poorly understood by the federal government. One suggested reason for this is that the development of the indigenous media happened so quickly that it took the government by surprise. This may help explain the lack of policy in the 1980s, but it cannot be used to justify the absence of definite policies in 1994. It also needs to be remembered that the first Aboriginal public radio program went to air on 5UV in Adelaide in 1972, and twenty years later there are still no comprehensive policies for the development and funding of indigenous media.

When examining the growth of the indigenous media industry, it becomes clear that it has developed in a policy vacuum, with varying levels of support from the relevant federal government departments. Freda Glynn, the former manager of CAAMA, once said 'policy is something that happens behind us' (Glynn quoted in McCarthy, 1989: 24). The Australian Broadcasting Tribunal (ABT, now the Australian Broadcasting Authority) also referred to this during the remote commercial television service inquiries and noted that:

> A fundamental difficulty has been to strike a balance between Aboriginal self-initiative and the setting of Government goals in respect of Aboriginal broadcasting. The emphasis on self-initiative can too often be used as an excuse for Government and Government agencies for doing nothing.
>
> (ABT, 1985: 42)

More tellingly, Glynn said that 'Aboriginal broadcasting is the product of struggle and opposition' and this is still the case today (quoted in ABT, 1986).

The underlying problem facing Aborigines and Islanders is that all the indigenous media are heavily dependent on government funds. In a

broadcasting era that favours deregulation and privatization, the reality is that only some of the larger indigenous media associations can generate a reasonable level of revenue. But this amount is nowhere near enough to allow them to operate independently of government. Aboriginal and Torres Strait Islander media associations therefore require clear guidelines and assurances from government about the level and type of funding they can receive. To date, however, this has not happened.

One of the main reasons for this is the number of government departments and agencies involved in indigenous broadcasting – the Department of Communications and the Arts (prior to 1994, the Department of Transport and Communications, DOTAC), the Department of Employment, Education and Training (DEET), ATSIC (formerly the Department of Aboriginal Affairs, DAA), the Australian Broadcasting Authority (ABA, prior to October 1992 the ABT), the ABC and SBS. Of these, Department of Communications and the Arts, DEET, and ATSIC are the main points of contact for Aboriginal Torres Strait Islander broadcasters.

The Department of Communications and the Arts is responsible for broadcast policy and the licensing schedule. It also provides very limited funding to the Community Broadcasting Foundation (CBF) to subsidize programs produced by Aborigines and Torres Strait Islanders on non-indigenous community radio stations in urban and rural areas. DEET has been primarily responsible for training and the allocation of funds in this area. Until mid 1992, DEET's responsibilities included community training and major initiatives such as the Aboriginal employment program at the ABC. In July 1992, ATSIC took over the administration of the Training for Aboriginals Program (TAP) community training funds from DEET. The Broadcasting and Policy section of ATSIC has overall responsibility for indigenous media policy, and directly funds a number of indigenous media associations, providing money for wages and capital costs, and community training initiatives. These divisions mean that Aboriginal and Islander broadcasters are often involved in time-consuming applications and consultations with all three departments. Complicating this further is the fact that each department has a vested interest in indigenous broadcasting, and can appear more concerned with its own departmental agenda, rather than addressing the more significant issue of policies for indigenous broadcasting.

The present lack of comprehensive policies covering all sectors of indigenous media is impacting directly on resources for staff, equipment and training. There is an urgent need for definite funding guidelines for each indigenous media sector (radio and video, in urban, rural and remote areas). At present, funding is administered on an *ad hoc* basis, which creates considerable instability and great frustration.

Much of the blame for this inaction must go to DAA, the department responsible for Aboriginal and Torres Strait Islander affairs before 1990. In 1983–4, DAA undertook a major study on Aboriginal communication requirements. The Willmot Task Force's recommendations were published in 1984 (*Out of a Silent Land*), and after this DAA officially took on the responsibility for indigenous media policy. *Out of a Silent Land* has shaped

indigenous media policy up to now, yet it has been the subject of much criticism which will be referred to shortly. The Willmot Task Force did, however, refer to the inadequacy of the policies in this area, and called for a 'completely new approach which includes an integrated policy of national, regional and local elements' (Willmot, 1984: 125). But DAA's apparent lack of interest in broadcasting meant that indigenous media growth in the 1980s happened in a piecemeal way (Michaels, 1986: 95). During these years, indigenous broadcasters repeatedly asked for policy guidelines for the emerging indigenous media but their requests rarely resulted in positive responses. Usually after lengthy delays, and often conflicting information, no action was taken (Michaels, 1986: 50–2, 80–91; ABT, 1986: 13).

In 1989, Sue Paton, then in charge of DAA's Aboriginal broadcasting section, wrote a report reviewing the developments in indigenous broadcasting and included recommendations for government action. This report, which acknowledged the lack of satisfactory government action in the past, argued for indigenous broadcasting to be set up as a separate sector and funded along the lines of the ABC and SBS. The ABC and SBS are statutory institutions which receive funds every three years from the Department of Communication and the Arts. The ABC and SBS then determine how this funding will be used.

Paton's paper was one of the first official acknowledgements that indigenous broadcasting should be established as a sector by itself, rather than being divided up among government departments. Moreover, if indigenous broadcasting was directly funded in this way every three years, rather than annually by three government departments, the sector would be much more stable and be able to develop with more confidence. Paton was also very much in favour of more resources for BRACS and indigenous community radio, and argued for the creation of Aboriginal community radio licences.

Paton's review was to have been published in conjunction with DOTAC, but officials in that department did not like the strong line it took and said:

> In summary we believe any problems that Aboriginal broadcasters may experience as a group are better addressed within the existing framework, and do not warrant the kinds of initiatives that are flagged in the paper.
> (Ellis, 1989)

By opposing the draft policy, DOTAC appeared to be ignoring the argument for a broadcast sector 'designed to allow Aboriginal and Islander commuinity groups to determine their own broadcasting priorities and structures' (Fell, 1990: 14). It was reported that DOTAC was particularly 'nervous' about any suggestion that the funding responsibilities for indigenous media devolve to them (*Communications Update*, 1991: 6). DOTAC's approach to broadcasting was market driven. One consequence of this was that the department felt that Aborigines and Islanders did not constitute a significant enough percentage of the population to warrant separate sector broadcast funding. Moreover, DOTAC's insistence that Aborigines and Islanders

work within the existing structures meant that the department had rejected a policy of self-determination, and had instead favoured one of assimilation.

Paton left the broadcasting section in 1990, and in August 1991, ATSIC and DOTAC eventually published the *Aboriginal and Torres Strait Islander Discussion Paper* which was extremely short on policy, and essentially descriptive. The paper summed up indigenous broadcasting developments over the last decade, and added little that was not already known. Moroever, unlike Paton's paper, there were no specific policy and funding suggestions. Missing also was the very strong theme in Paton's paper that the government had not performed well in this area.

In November 1991 at Batchelor (NT), and in May 1992 in Canberra, national conferences were organized between Aboriginal and Torres Strait Islander broadcasters and representatives from DOTAC, DEET and ATSIC to discuss the draft policy paper (see ATSIC 1992a, 1992b, 1992c, 1992d). The broadcasters raised their concerns about the lack of cohesive policies for indigenous broadcasting, funding and training They were extremely critical of the ATSIC/DOTAC draft paper, saying that they had heard all this before. The gap between the broadcasters and their aspirations, and the Canberra bureaucrats who determine indigenous media policy, was very obvious at both conferences as the departmental representatives made it clear that there was a long way to go before indigenous broadcasting would be recognized as a sector in its own right. They reinforced the view that their preference was for Aboriginal and Islander media to feed into other broadcast sectors such as community radio, and commercial, ABC and SBS radio and television, rather than being funded as a separate sector. Their responses were particularly frustrating for the broadcasters, because they appeared to continually 'pass the buck' from one department to the other.

However, not all Canberra bureaucrats are insensitive to the needs of indigenous broadcasting. A few have given crucial support to indigenous media developments. Nevertheless it would appear that some still feel that they need to 'control' indigenous broadcasting. Government departments may no longer be pursuing policies of assimilation, but officials in certain departments are attempting to control the agenda for self-determination. They see themselves as service providers and feel that their expertise allows them to decide what is in the best interests of Aborigines and Islanders. This attitude was also clear in the views expressed by the departmental representatives at the conferences referred to above, as they attempted to 'keep the lid' on indigenous broadcasting. The most obvious manifestation of this is their determination to view the major indigenous media sectors, community radio, BRACS and community video, as 'marginal', existing outside the other media. Such a view ignores the extensive developments in Aboriginal and Torres Strait Islander media over the past decade. It also fails to respect the argument put forward by Aborigines and Islanders that they cannot remain on the 'fringes of communication', outside a national communications network in which their interests are only 'incidental' (Bellamy, 1987: 1). Moreover, while non-indigenous Australians may regard community media as alternatives to the mainstream media, for

Aborigines and Islanders, community media are the mainstream indigenous media because they offer Aborigines and Islanders control as well as access.

Culture, technology and economic rationalism

The marginalization of the indigenous media is further exacerbated by the narrow perspective many government officials have of the media's roles. Government departments, driven by economic concerns and a kind of technological determinism, see broadcasting as technology-centred, and have little or no understanding of what is entailed in program production. As a result, they regard broadcasting as a costly and difficult area, and are reluctant to make commitments that would raise expectations of continuing support (ABT, 1985: 42). Therefore when Aboriginal and Islander broadcasters seek funding for more equipment, training and salaries, this can result in the accusation that they want the very best of everything, and that they are somehow being 'greedy'. Another common response to extra equipment requests is 'but look what we have given them'. In fact these requests are rarely extravagant and have to be expected as Aboriginal and Torres Strait Islander broadcasting develops and expands. Moreover, this attitude which shapes much of the government responses to indigenous broadcasting, is clearly patronizing. Implicit in it is the view that Aborigines and Islanders should be pleased with what they get, because after all, indigenous broadcasting does not need to be a 'Rolls-Royce service'.

Of equal concern is the fact that these responses suggest that government feels that it can meet indigenous broadcasting needs simply by funding technology (BRACS, RCTS (Remote Commercial Television Services)). Such funding is preferable from the government's point of view because it is a tangible political reminder of government support. However, the concentration on technology obscures the harder questions that need to be asked about the policies and resources required to make the technology effective. Technology is after all inanimate, it cannot function if broadcasters are not trained and resourced to operate it.

This technologically and economically determined mindset also means that while some government officials talk about the importance of the indigenous media for maintaining indigenous culture and languages, they realy do not understand that media content is a cultural product. From their narrow technological perspective, they see broadcasting simply as a means of transmission of entertainment and news, a 'luxury', which is extrinsic to society. When Aboriginal and Islander broadcasters talk about using the media for cultural and political expression and for community interaction, government officials have difficulty understanding how central broadcasting has become to indigenous community life. One consequence of this is that government departments do not give broadcasting the priority it deserves when allocating indigenous funding.

It is for these reasons that much Aboriginal and Islander media growth (community radio and video, remote low power television stations) has occurred outside government control, and some government initiatives

(BRACS) have resulted in the development of a completely new area of indigenous media which has taken these departments by surprise. One government official at the Batchelor meeting said that when BRACS was established, his department had not realized this would lead to 'broadcasting'. He just thought they were putting some audio and video equipment into remote communities to help preserve remote Aboriginal and Islander culture. A number of Aborigines and Islanders, however, see BRACS as a vehicle for cultural assertion and political self-determination, and have actively sought to use BRACS for these purposes.

The low-power television stations set up at Yuendumu (NT) and Ernabella (SA) in 1985, which broadcast illegally because the then Department of Communication (DOC) would not give them licences, were one of the earliest examples of Aborigines determining how they would use communications technology for their own purposes in the absence of government policies and assistance (Toyne, 1984, 1986; Michaels, 1986; Turner, 1990). Aborigines from both communities had told the federal government on numerous occasions that they wanted to be broadcasting their own programs before the launch of Australia's first series of domestic satellites (Aussat) in 1985. One of Aussat's major roles was the delivery of ABC and commercial television programs to many remote areas that previously had received no television (*Aboriginal News*, 1985; Michaels, 1985c). The Hawke Labor Government, convinced of its own political rhetoric about the Aussat satellites uniting the nation and bringing services to the outback, did not examine alternative technological options which could have facilitated community media involvement in remote areas (See White 1985; Paltridge 1989; White and Fisher 1990). When it did consider this, a few years later in 1987, it belatedly imposed BRACS technology on remote areas assuming that this was the answer.

The policy and funding vacuum

However, while acknowledging that this range of indigenous media initiatives have taken place, overall the government's reluctance to formulate appropriate policy and funding mechanisms for each indigenous media sector has restricted the growth of the industry. The inability of ATSIC to determine funding criteria has been particularly serious. This problem is exacerbated by the fact that some funding is allocated from Canberra under a national program, while other funds are disbursed by regional ATSIC offices. DEET funding is allocated in a similar way. The regional offices, however, have widely differing views on broadcasting and its priority for funding. As a result, some indigenous media associations have benefited from being in regions where there are sympathetic regional ATSIC or DEET offices, while others have suffered because their regional ATSIC or DEET office has little interest in broadcasting. One consequence of this for BRACS communities has been that some regional ATSIC offices have withheld the already meagre BRACS allowance of $16,000 (for a part-time operator's wage, operation, repair and maintenance costs), and allocated this to

non-broadcast areas they feel are more important. This will always be a problem for indigenous broadcasting while the funds remain with ATSIC, as broadcasting has to compete with major funding areas such as education and health.

The need for funding guidelines becomes even more apparent when ATSIC's broadcasting budget is taken into account. The total budget is very small. In 1992/3, ATSIC only allocated $9.765 million to broadcasting out of the total ATSIC budget of $836 million (ATSIC, 1993: 38). The bulk of this, $3.4 million, went to CAAMA and Imparja to subsidize the lease of the satellite transponder for Imparja's remote television service. Regional resource associations like CAAMA received the next largest sum, followed by BRACS. Aboriginal and Islander broadcasters in urban and rural areas fared the worst. Their allocation of only $66,000 is supposed to act as seeding money to help indigenous media associations get started.

To put the paucity of this budget into perspective, it should be noted that in 1992/3 the federal government provided $12.221 million to SBS, to run two ethnic radio stations, 3EA in Melbourne and 2EA in Sydney. At a political level the reasons for this vast difference are obvious. The ethnic communities in Australia are much better resourced than Aborigines and Islanders and have a stronger political base from which to influence government policy.

An examination of the broadcasting budget reveals that ATSIC does have two preferred funding categories – remote and regional. These categories are, however, loosely defined, and the available funding is not allocated uniformly across remote or regional indigenous broadcasting. DEET has been less interested in remote broadcasting, and focused mainly on regional associations and mainstream media initiatives such as the Aboriginal employment and training programs at the ABC and SBS. There are a number of problems with these approaches. Firstly, ATSIC has continued to support DAA's view that Aborigines and Torres Strait Islanders in remote areas are more disadvantaged in terms of access to the media than Aborigines and Islanders living in rural and urban areas. Implicit in this is the assumption that Aborigines and Islanders in remote areas also have more to lose culturally and linguistically. Aborigines and Islanders in major rural and urban areas, on the other hand, have been categorized as more 'Westernized' and DAA, in particular, felt that they would be better served by gaining access to existing non-indigenous community radio and, if possible, the mainstream media, because DAA felt they needed to live within the dominant framework of a European society.

These misleading views were first endorsed by the Willmot Task Force in 1984, and, as noted, have formed the basis of indigenous media policy ever since, even though they have been soundly criticized for ignoring the special needs of Aborigines and Islanders in urban and rural areas (Shimpo, 1984; Michaels, 1985b). The Task Force worked on the false premise that Aborigines and Islanders in towns and cities had sufficient access and encouragement to be involved with public radio (Powis, 1985: 30). In coming to this conclusion, the Task Force misunderstood the communications

environment in which urban and rural Aborigines and Islanders existed, and the fact that the mere existence of more media outlets in urban and rural areas does not guarantee Aborigines and Islanders access to the media, let alone control. At present, there are very few Aborigines and Islanders working in commercial radio or television. The ABC and SBS do have Aboriginal training and employment programs in place, but the number of Aborigines and Islanders to be employed (2 per cent of the total workforce) will not make a significant impact on these organizations overall. Moreover, Aborigines and Islanders working within the ABC have to adhere to ABC program forms and standards, and do not have the same freedom that indigenous media associations transmitting via the ABC in remote areas have to determine their own programs.

Non-indigenous community radio, particularly in city areas, has offered a reasonable level of access. In Sydney, for example, Radio Redfern broadcasts for up to thirty hours a week via a community station. But some of the community stations in country towns (NSW and Victoria) are very conservative and have made access difficult for Aborigines and Islanders.

Despite the obvious difficulties Aborigines and Islanders face in gaining access to the existing media in rural and urban areas, the latest version of ATSIC's Aboriginal and Torres Strait Islander broadcasting policy paper, published in January 1993, reinforces the emphasis on remote and regional indigenous media. ATSIC is therefore continuing to ignore the communications requirements of Aborigines and Islanders in urban and rural areas by not providing them with adequate resources to produce culturally appropriate community radio and video. The Commission also appears to be saying, unwisely, that the 'real' indigenous culture is in remote areas, and that this needs to be protected. Such a view is clearly inaccurate, because indigenous culture exists in many forms throughout Australia. Moreover, as noted in the discussion on BRACS, this view is paternalistic, as the emphasis on 'protection' suggests that indigenous culture is static, like a relic from the past.

As a result of the two preferred funding categories, from the mid 1980s to 1994 DAA, and now ATSIC's main focus has been on BRACS and the regional resource broadcasters serving regional and remote areas. BRACS was established in 1987, and the installation of the BRACS units in eighty remote communities was completed in 1992. BRACS allows remote communities to receive mainstream (ABC and commercial) television and radio via satellite, and to produce their own radio and video to transmit locally. However, BRACS from the very start was a 'cheap fix'. By 1992, just over $3 million had been spent on the project, with the BRACS units costing only $40,000 to $45,000 to build and install. Aborigines and Islanders wanted a system like BRACS so that they could counter what they felt was the potentially damaging one-way flow of mainstream media content being transmitted by Aussat. The federal government, however, ignored the complex social, economic and political context in which the technology was to be used, and essentially 'dumped' equipment on the communities (See Molnar, 1993a).

The nine regional resource broadcasters have fared better than BRACS. These associations, which include CAAMA, the Townsville Aboriginal and Islander Media Association (TAIMA), Waringarri Media in Kununurra, the Top End Aboriginal Bush Broadcasting Association (TEABBA), the Western Australian Aboriginal Media Association (WAAMA), Umeewarra Media (SA), and the Torres Strait Islander Media Association (TSIMA), receive ATSIC and DEET funds for salaries, capital costs, trainers and training wages. This funding allows these associations to operate at a reasonable level in comparison to BRACS broadcasters and Aborigines and Islanders working in community radio in urban and rural areas, whose funding amounts to 'petty cash'. The only source of funds available to Aborigines and Islanders in urban and rural areas is a program subsidy administered by the CBF (funded by the Department of Communications and the Arts and ATSIC). This amount remained at $301,000 for a number of years, but was increased in 1993 to $530,000. The subsidy, which starts at $55 for the first hour of broadcasting, is used to buy tapes, records, and for small equipment outlays. The hourly subsidy is now being reviewed and it may increase to $100 for the first hour. However, it is still inadequate, as it assumes that the broadcasters will always 'work' as volunteers. In comparison, in 1992, CAAMA received $798,000 and TAIMA $449,249.

This is not an argument for less funding to the regional resource associations. It is vital that they receive these funds because they are involved in many activities (radio, video, newsletters, training), and four now have their own community radio station. However, ATSIC and DEET's preference for funding regional associations reflects the limited way in which Canberra bureaucrats allocate funds.

ATSIC and DEET prefer to deal with 'representative' associations which they can deem as 'accountable', rather than smaller groups and individual Aboriginal and Torres Strait Islander broadcasters. This distinction fails to recognize that a large number of Aborigines and Torres Strait Islanders involved in community radio and video are part of small groups or work as individuals. At a more fundamental level, regional resource broadcasters have another advantage. They have the expertise and the resources necessary to lobby for funds, a difficult and time-consuming process, while the smaller media associations lack this advantage.

DAA's, ATSIC's and DEET's concentration on regional associations has also been contentious as the government departments have determined that one indigenous media association as opposed to another is more 'representative' of indigenous broadcasting, and has funded it accordingly. Over the last decade, this distinction has caused conflict among indigenous media groups. Even worse, for a number of years in the 1980s, DAA would only fund indigenous media associations which were producing programs for the ABC because it felt that the ABC, as the national broadcaster, should take the responsibility for indigenous broadcasting. Neither the ABC nor indigenous media associations were happy with this arrangement, and argued that Aborigines and Islanders should be able to determine their own broadcasting.

DEET's concentration on 'representative' broadcasters, the ABC, SBS and the regional resource broadcasters, during the period that it administered community training has had serious consequences for community radio, BRACS and community video – sectors which DEET found much harder to categorize. DEET's failure to fund adequate training programs for these sectors has placed a considerable constraint on indigenous broadcasting, in some instances marginalizing Aboriginal and Islander broadcasters, leaving them open to criticism which they do not need. Most significantly, the lack of reasonable training programs has meant that a number of Aborigines and Islanders are not participating in the media as effectively as they could be. And while ATSIC now administers the community training funds, it has still not devised training programs for community radio, video and BRACS.

Another serious concern with the lack of training programs which is often overlooked, is that Aborigines and Islanders are not being equipped with the skills necessary for long-term employment. Aborigines and Islanders have the highest rate of unemployment in Australia. In remote communities, their job prospects are particularly limited. A very important feature of the indigenous media, which tends to be overlooked, is the fact that these media offer paid employment and career paths for Aborigines and Islanders. The Aboriginal community radio stations, for example, employ a core staff of fourteen to twenty people. Glynn stressed the significance of this when talking about CAAMA. The association is one of the largest employers of Aborigines in Alice Springs.

> In Alice Springs there is very little employment for Aborigines . . . and CAAMA sees itself as building up whole new areas of employment – a new industry for Aboriginal people – art, drama, music, script writing, and all the television technical and lighting, and all that sort of thing . . . We want the kids to see that at the end of finishing school, there's going to be something for them to go forward to.
>
> (Glynn quoted in ABC, 1986)

Ideally, the BRACS stations could employ four to six people, and indigenous media associations working as part of a consortium on a community radio station need at least one paid co-ordinator's position, and wages for a small number of core staff. The same applies to indigenous community video groups.

Neither ATSIC nor DEET, however, have addressed the issue of salaries or training wages properly. While some media associations do receive funds for salaries and training, the situation, as noted earlier, is very *ad hoc* and there are few guidelines to indicate who will be funded, at what level and why. The non-indigenous mainstream media always train and pay their broadcasters, and the same principle should apply to the indigenous broadcast industry, especially as this industry now offers real opportunities for long-term employment. It is time that ATSIC and DEET stopped categorizing the indigenous media as 'just community media' and started to regard these media in the same way they do the ABC and SBS.

In 1993, the Minister for Aboriginal Affairs, Robert Tickner, announced

that his department was giving DEET $750,000 to fund indigenous training projects in the mainstream media. A national training program for indigenous community media could have been set up with this amount of money. Instead, in the Year of Indigenous People, the Minister decided to provide funds to the mainstream media who should not have to be subsidized to employ Aborigines and Islanders. Moreover, Aborigines and Islanders working in these media can only hope to have a marginal impact, if any, on the dominant Anglo-Saxon forms and content features on these media.

Consultation: the missing factor

The absence of adequate policies and funding guidelines are clearly an obstacle, but before these can be tackled, a much more fundamental problem has to be overcome. One of the most obvious features of indigenous media development to date, has been the government's lack of consultation with Aborigines and Torres Strait Islanders. Consequently, any government claims about consultation with Aborigines and Islanders need to be examined closely. The Willmot Task Force, for example, essentially 'consulted' with the ABC and CAAMA, which DAA deemed 'representative' of all indigenous media interests regardless of the fact that CAAMA can only speak for Aborigines in Central Australia.

The lack of comprehensive consultation has meant that in a number of instances, the most appropriate policies are not in place. This can be seen with major broadcasting initiatives (Aussat, the RCTS, the Remote Commercial Radio Services (RCRS) and BRACS), all of which have occurred with minimal input from Aborigines and Torres Strait Islanders, despite the fact that they were one of the stated beneficiaries of these initiatives, and in the case of BRACS, the major beneficiary. Consequently, technology (Aussat, BRACS) has been imposed on Aboriginal and Islander communities, along with broadcast models (RCTS, RCRS) which have failed to take into account the special needs of Aborigines and Torres Strait Islanders. The government, having invested a considerable amount in these technological initiatives, then feels that it has 'served' the needs of Aborigines and Islanders, and fails to recognize the range of indigenous media activities that exist outside its imposed models which are in need of government funding.

Aussat did conduct an investigation, through consultant Brian Walsh, into the Aboriginal and Torres Strait Islander 'fears, perceptions, and expectations of satellite communication' (Meadows, 1992: 46). The report recommended that Aussat provide support for independent indigenous media production centres, and that particular attention be given to the design and development of the second generation of Aussat satellites due in 1993 to facilitate indigenous production (1992: 46). However, Aussat did not act on these recommendations. For the most part, during the Aussat debate, Aborigines and Islanders had little choice 'but to sit back and watch the technocratic rivalry and political expediency that drove the satellite debate' (Michaels, 1986: ix).

After the launch of Aussat, the federal government instructed the ABT to hold licence hearings for Remote Commercial Television Services (see ABT, 1985, 1986; DOTAC, 1990). However, the three RCTS, (each of which has a monopoly in a defined regional area), have not served the interests of Aborigines and Torres Strait Islanders well. The stations, GWN, Imparja and QSTV, have failed to make a reasonable commitment to indigenous employment and program content, even though Aborigines and Torres Strait Islanders were defined as one of the key target audiences for these services. The ABT did set conditions for indigenous content on RCTS in an attempt to add a service element to the remote commercial television ser-vices, but to a large degree the stations have been able to circumvent these requirements.

The commercial imperative to make a profit by attracting the most profitable audiences has meant that these stations mainly program non-indigenous material from Australia and overseas which, they claim, is essential to attract advertisers. Indigenous content, on the other hand, is seen as having minority appeal, and is more expensive to produce than programs purchased from overseas and from Australian networks. A half hour locally produced language program on Imparja can cost at least $15,000, whereas an American series such as *Star Trek: the Next Generation* can be purchased for $70, and old American series like *Bonanza* for only $17. RCTS stations can also purchase current Australian series produced by the networks at very low prices because audience size is taken into account when the selling price is calculated. For $120, the RCTS can buy a one-hour episode of the top rating prime-time Australian series.

In their first years of operation, the RCTS stations were saddled with a large fee for the lease of the satellite transponder ($4.2 million). However, all three services are now receiving a federal government subsidy to cover this cost (which is now under $3 million), but they have not used their extra funds to increase the production of indigenous content.

The key problem with RCTS will always be the cost of the satellite technology to service small remote audiences, and the adoption of commer-cial media as 'service' models. If the government had been seriously inter-ested in remote audiences it should have considered offering commercial incentives to TV operators to program Aboriginal and Islander material, along with considerably tighter licence conditions which involved the stations' performances being evaluated on at least a two-yearly basis. It could also have encouraged the ABT (and now the ABA) to set a specific quota for indigenous programming, similar to the one that exists for Aus-tralian content. Given the size of the Aboriginal and Islander audiences, and taking into account the other audiences to be serviced, such a quota would be under the 50 per cent target for Australian content. A definite percentage, however, is useful as this is not open to negotiation. The ABC, SBS, BRACS and community access television all offer better possibilities for Aboriginal and Islander access and control of content and production, because these sectors, to varying degrees, are more committed to indigenous broadcasting, as indigenous programming is part of their mandate. However, it is very

important to have Aboriginal and Islander content for indigenous and non-indigenous audiences on commercial television as these channels are more widely watched than the ABC and SBS. This is particularly important for young Aborigines and Islanders seeking some sense of self-identity from the media, as they prefer commercial channels to the ABC which they refer to as 'talk, talk television'.

The Broadcasting for Remote Aboriginal Communities Scheme

BRACS, like the RCTS, came into existence because of Aussat, and was established after minimal consultation with remote indigenous communities. In 1984, with the imminent launch of the first satellite, the Willmot Task Force recommended the co-ordinated introduction of satellite radio and television reception and re-broadcasting facilities to remote Aboriginal and Islander communities. Most significantly, it said that these remote communities should be provided with the facilities to allow Aboriginal and Islander people to control programs broadcast in their communities (see Willmot, 1984: vi–xiii).

BRACS, as noted earlier, is a clear example of the problems that occur when a technological model is imposed without the proper resources – training, training wages, salaries for operators, adequate funds for software and upgrading of equipment (see Corker 1989; Molnar, 1993b). In some BRACS communities, the units are still inoperational because no one has been trained to operate them. Moreover, because of the initial lack of consultation by DAA, the potential of BRACS is poorly understood in some areas, with the result that the BRACS unit simply operates as a replay unit for the mainstream media, and there is no local content.

ATSIC is now talking about a BRACS revitalization plan, but given its budgetary constraints it is very unlikely that it will have the resources to comprehensively overhaul the eighty existing units, and provide the necessary training and operators' wages.

The real shame about BRACS is that the ideal behind it is a good one, and where it is working, there is some local, indigenous content and this is very much appreciated (Molnar, 1993a, 1993b). BRACS radio and video content is varied and includes songs, stories, oral histories, music, reports on sporting events, and special information days on issues such as health and education. In addition to these programs, some BRACS communities now make an interview a requirement of entry to the community.

One of the most interesting aspects of BRACS, is that the prospect of 'doing it for the camera' has lead to the revival of songs and dances. An example of this was seen at Ernabella, where a media association was invited by a nearby community to record the Seven Sisters Dreaming on video. The community wanted the dances recorded and broadcast so that people could see them and say 'it is true'. In this way, video enabled 'them to do the same sort of thing they used to do traditionally. That is to visit sites and to re-empower those sites through performance and to keep them alive as a thing of great cultural significance' (Turner in *Satellite Dreaming*, 1991).

The custodians of the site were so happy with the recording that they sang a song they had not sung for years, and included this in the broadcast thus revealing the 'old song especially for the TV' (*Satellite Dreaming*, 1991).

The significance of BRACS at a community level is obvious in other ways as well. In some communities, for example, where BRACS is working, the community has raised money to upgrade equipment and add extra studio space.

Properly resourced, BRACS could provide the basis of regional and national networks. The Tanami network, with its satellite links between four BRACS communities, is also an interesting indication of future directions BRACS could take if these resources were available.

However, for the moment, the main 'achievement' of a number of BRACS TV stations, (as opposed to BRACS radio which does feature local content), and the three RCTS, has been the delivery of mainstream television to remote areas (Spurgeon, 1989; Meadows, 1992). The government's policies on remote media have therefore been essentially integrationalist and had little to do with public service. They have also contradicted other policies supporting Aboriginal and Torres Islander self-determination and self-management. Eric Michaels claimed that this was not unique to Australia, and said that other indigenous people had been similarly disadvantaged. He pointed to a common pattern in the establishment of new media:

> New media are enlisted to serve more deep-rooted government and institutional social policy (even where it is not expressly formulated). Where governments intend disruption or 'national integration' of Aboriginal cultures, media are designed to be hierarchically structured, emanating from urban centre to remote periphery and transmitting culturally homogeneous, state approved messages in the official state language.
>
> (Michaels, 1985a: 24)

The exception to this is the development of Aboriginal community radio licences. From the late 1980s, DOTAC made it easier for indigenous media associations to gain Aboriginal community radio licences, and thus determine their own radio content. Prior to October 1992, a community licence which encouraged the widest public participation was generally awarded in an area where there was no other community radio station. But DOTAC decided that this was only a guideline, and that it could be ignored on social justice grounds. Therefore where ATSIC had said that an indigenous media association was able to start broadcasting quickly, and there was a significant Aboriginal or Torres Strait Islander population, DOTAC specified that the licence be an Aboriginal one rather than general access. DOTAC's decision was important because it recognized the problems facing Aboriginal and Islander groups applying for community licences as part of a consortium in which they may have only a minor voice.

The growth of the Aboriginal community stations since 1991 has been a significant development. Aboriginal stations, managed and staffed by Aborigines and Torres Strait Islanders, producing their own forms and

content, without any pressure to adhere to mainstream media standards or work practices, offer a level of indigenous participation and control not possible in any other sector of radio. Some of the programs may at times sound European in form, but in Aboriginal stations the broadcasters will be able to make choices about whether to continue these forms or to develop new ones. The establishment of more Aboriginal stations will also increase the likelihood of an indigenous community radio network. There have been link-ups between the existing stations, most notably for the Bicentenary protest march in Sydney when eleven stations across the country contributed to programming on 26 January 1988. More recently, the four Kimberley stations broadcasting on ABC radio have networked programs regionally, strengthening and extending their influence. With five Aboriginal community stations now operating, and at least another five yet to be licensed, a national indigenous radio network will soon be possible. The eighty BRACS stations could potentially be part of this network when they are better resourced.

A national indigenous radio network will in turn further stimulate the growth of other indigenous industries such as contemporary indigenous music. This industry has grown enormously over the last decade because of the prominence of indigenous music in Aboriginal and Islander programs. The network would also provide outlets for a range of other indigenous arts and cultural events, thus increasing their economic viability. This would lead to more employment opportunities for Aborigines and Islanders which is vital for indigenous self-determination.

Future directions

While it is true that there has been enormous growth in all indigenous media sectors since 1980, it is also clear that this industry would have developed even more quickly, and be on a much more stable footing than it is today, if it had received adequate government support. The lack of policy and funding guidelines for each sector will continue to restrict indigenous media growth and create more instability in the industry. The possibility of this situation being addressed while indigenous broadcasting remains divided up among government departments, however, appears limited.

The need for indigenous broadcasters to control and administer their own funds is very important, because at a time when Aborigines and Torres Strait Islanders are increasingly getting the opportunity to operate their own media, ATSIC, DEET and the Department of Communications and the Arts are undermining their attempts to do this effectively. This situation is all the more absurd when one considers that non-indigenous Australians have two specially funded government services – the ABC and SBS – yet the demand by indigenous Australians for a similar service to meet their communication requirements continues to be ignored.

References

Australian Broadcasting Tribunal (ABT) (1985) *REMOTE COMMERCIAL TELEVISION SERVICES*, First Report, Canberra: AGPS.

—— (1986) *REMOTE COMMERCIAL TELEVISION SERVICES*, Second Report, Canberra: AGPS.

Aboriginal News (1985) 'Aussat brings TV to the bush', 1(3) March: 5–7.

Aboriginal and Torres Strait Islander Commission (ATSIC) & Department of Communication and Transport (1991) *Aboriginal and Torres Strait Islander Discussion Paper*, Canberra.

Aboriginal and Torres Strait Islander Commission (ATSIC) (1992a), papers submitted to the Aboriginal and Torres Strait Islander Commission (ATSIC) in response to the *Aboriginal and Torres Strait Islander Broadcasting Policy Discussion Paper*, May, Canberra.

—— (1992b) *Report on Aboriginal and Torres Strait Islander Broadcasting Policy Development*, including outcomes of the 5–7 May 1992 Policy Development Workshop, the 12–13 May Training Needs Conference and the 14–15 May National Conference, Canberra.

—— (1992c) 'Recommendations on the establishment of a National Indigenous Media Council (working title), Aboriginal and Torres Strait Islander Broadcasting Policy Workshop, Canberra 5–7 May 1992.

—— (1992d) *Interim Report Evaluation of Broadcasting and Communications Sub-Program* June, Canberra: Aboriginal and Torres Strait Islander Commission.

—— (1993) *Aboriginal and Torres Strait Islander Broadcasting Policy*, Review Report and Draft Policy Statement, January, Canberra.

Background Briefing (1986) Prod. Cheryl Rose, 21 September, 3AR.

Bellamy, Louise (1987) 'Black & white TV from the heart', *Age Green Guide* 22 October: 1, 22.

Communications Update (1991) 'Aboriginal and Islander broadcasting: laundered paper released', October: pp. 6–7.

Corker, John (1989) 'BRACS: destined to fail?', *Media Information Australia* 51: 43–4.

Department of Transport and Communication (DOTAC) (1990) *Review of Remote Area Television Services Discussion Paper*, Communications Policy and Planning Division, DOTAC, August, Canberra: AGPS.

Ellis, W. R. (1989) Letter to Rod Christopher, Secretary, DAA, re. Draft Aboriginal Broadcasting Review, 5 December.

Fell, Liz (1990) 'Aboriginal air rights: Snowden moves into debate', *Communications Update* December: 14.

Fry, Tony and Willis, Anne-Marie (1989) 'Aboriginal art: symptom or success?', *Art in America* 77(7): 108–17, 160, 163.

Ginsberg, Faye (1991) 'Indigenous media: Faustian contract or global village?', *Cultural Anthropology* 6(1): 92–112.

McCarthy, Mark (1989) *Prime Time Dreamtime: the Future of Indigenous Broadcasting in Australia*, MA thesis unpublished, Brisbane: Queensland University of Technology.

Meadows, Michael (1992) *A Watering Can in the Desert: the Australian Government Response to Claims for Indigenous Broadcasting Rights*, Queensland: Institute of Cultural Policy Studies, Griffith University.

Michaels, Eric (1985a) *Working Papers in Aboriginal Telecommunications 1984–85*, February, Canberra: Australian Institute of Aboriginal Studies.

—— (1985b) 'A preliminary review of the report on Aboriginal and Islander broadcasting and communications: *Out of the Silent Land*', in *Working Papers in Aboriginal Telecommunications 1984–85*, Canberra: Australian Institute of Aboriginal Studies.

—— (1985c) 'New Technologies in the Outback and their Implications,' *Media Information Australia* 38: 69–72.

—— (1986) *The Aboriginal Invention of Television In Central Australia 1982–86*, Canberra: Australian Institute of Aboriginal Studies.

—— (1987) *For a Cultural Future: Francis Jupurrurla Makes TV at Yuendumu*, Melbourne: Art and Criticism Monography Series.

Molnar, Helen (1993a) 'Remote Aboriginal community broadcasting (Australia)', Lewis, Peter (1993) editor, *Alternative Media: Linking Global and Local*, Paris: UNESCO: 29–39.

—— (1993b) *The Democratisation of Communications Technology in Australia and the South Pacific: Media Participation by Indigenous Peoples, 1970–1992*, unpublished Ph.D. thesis, Clayton: Monash University.

Paltridge, Sam (1989) 'Australian satellites: promises, performance and the next generation', *CIRCIT Policy Research Paper No. 1*, Melbourne: Centre for International Research on Communication and Information Technologies.

Paton, Sue (1989) *Aboriginal and Torres Strait Islander Broadcasting Policy Review Draft Report*, November, Canberra: DAA.

Powis, Tina (1985) 'Black radio signals ward against whitewash', *New Journalist*, December: 30–2.

Quigley, Bryon (1987) 'Aboriginal broadcasting development 1979–86', unpublished Masters thesis, Sydney: Macquarie University.

Satellite Dreaming (1991) Dir. CAAMA Productions, ABC TV, 12 December.

Shimpo, Mitsuru (1984) *A Critical Appraisal of* Out of the Silent Land: *Report on the Task Force on Aboriginal and Islander Broadcasting and Communications* January, Darwin.

Spurgeon, Christina (1989) 'Challenging technological determinism: Aborigines, Aussat and remote Australia', in Wilson, Helen editor, *Australian Communications and the Public Sphere: Essays in Memory of Bill Bonney*, South Melbourne: Macmillan.

Toyne, Peter (1984) 'Yuendumu and Aussat', *Junga Yimi* 5(1): 1–4.

—— (1986) 'The development of local television broadcasting units in central Australia', in Foran, B. D. and Walker, B. W., editors, *Science and Technology for Aboriginal Development*, CSIRO and Centre for Appropriate Technology.

—— (1992) 'The Tanami network: new uses for communications in support of social links and service delivery in the remote Aboriginal communities of the Tanami', a paper presented to the Service Delivery and Communications in the 1990s Conference, 17–19 March, Darwin.

Turner, Neil (1990) 'Pitchat and beyond', *Artlink* 10(1 & 2): 43–5.

Walsh, Brian and associates (1984) *Aboriginal Use of Aussat: a Feasibility Study for Aussat Pty Ltd* vols 1 and 2, Melbourne.

White, Peter (1985) editor, 'AUSSAT and AFTER', *Media Information Australia* 38, special edition.

White, Peter and Fisher, Dominique (1990) editors, 'AUSSAT culture policy & technology', *Media Information Australia* 58, special edition.

Willmot, Eric (1984) *Out of the Silent Land*, report of the Task Force on Aboriginal and Islander Broadcasting and Communications, August, Canberra: DAA.

▪ REVIEWS ▪

ANNETTE HAMILTON

AFTER MABO

■ Tim Rowse, *After Mabo: Interpreting Indigenous Traditions* (Melbourne: Melbourne University Press, 1993) 168pp + Bibliography and Index. n.p.

T his is a puzzling and finally frustrating book. Published as part of the 'Interpretations' series under the general editorship of Ken Ruthven (which aims to provide introductions to 'recent theories and critical practices'), the title would seem to suggest an analysis and critique of dominant and emergent approaches to the interpretation of 'tradition' in the context of a restructured relation between indigenous and other Australians consequent on the 'Mabo' decision. This philosophically and legally remarkable decision by the High Court of Australia has reversed the doctrine that Australia was legally an unoccupied or 'waste' land (*terra nullius*) at the time of British occupation, and has found that the indigenous inhabitants, or at least certain of them, have rights in common law as land owners. Their dispossession by successive waves of 'settlement', under the conditions of British colonialism cannot be regarded as justified and thus the entire basis of the relation between indigenous people and the Australian state comes into question. This does not of course mean that all indigenous Australians have rights to all of Australia; it is not necessary here to describe the probably tortuous processes by which some will be found to be land owners and others will not in the claims yet to begin. However, it would be reasonable to suppose that this book would set out some of the key issues surrounding the rhetoric and discursive construction of 'tradition' in a context where this will constitute one of the principal 'tests' of legitimate claims. But this does not seem to be the intention of the book.

The clearest and most lucid section is the first chapter, 'Mabo and moral anxiety', which suggests the necessity of a new moral and practical reason in

relation to the future coexistence of 'settler and indigenous cultures'. This chapter sets the issue interestingly with reference to the saga of Captain Cook, a series of narratives with wide currency in Aboriginal Australia which interpret the actions and behaviours of the famous navigator as the source of moral impropriety in the relations between indigenous and non-indigenous peoples.

From this powerful and intelligent beginning (most of which was also published in *Meanjin* in 1993) the intention is to 'review books and articles', including academic history, anthropology, and other writing by Aboriginal and non-Aboriginal people, in order to 'give a critical account of the kinds of thinking about Australia that are now possible'. Perhaps it is simply far too vast a task to encompass in a brief work; perhaps it is impossible to sustain a clear approach, lodged within a question of 'moral community', as the first chapter proposes, across such a wide field of different sources. But the problems seem to be more than those of an over-ambitious project. The text wavers and slithers across other writers' writings, sometimes perceptively, often superficially; while the term 'representation' appears here and there, the real issues underlying this concern are not given any sustained consideration, and come into focus only in an Afterword which tries to engage with critiques by certain 'cultural studies' writers of 'Aboriginalism' (of Said's 'Orientalism'). But the brief four or so pages can only nod, perhaps apologetically, in this direction. The reason for even including this material would seem to be the heavy reliance on anthropological writing in the preceding chapters. While many anthropologists have been irritated by the treatment of anthropology by the 'cultural studies' writers mentioned by Rowse, a genuine engagement with the issues raised would have been welcome.

However, the chapters move across several themes without any strongly coherent focus. In the loosest sense, they seem to be concerned with the question of 'culture', specifically the question of how Aboriginal Australians have managed in spite of the realities of colonialism to continue some form of cultural reproduction which has permitted survival and sometimes resistance. This theme in turn bears on the question of 'tradition'. But the links are not clearly articulated or explored; the references to source works are extremely dense and, to those unfamiliar with them, probably mystifying; and the final effect is one of uncertainty. What is the writer asking the reader to think about all of this? Are there as many conclusions as there are approaches? Did Aboriginal Australians reproduce 'their' culture, or is there a new and different culture being reproduced? If so, how is this to be identified? And in what way do the various knowledges and understandings alluded to here contribute to a new moral community between, or around, Aboriginal and non-Aboriginal Australians in the post-Mabo environment? Or are these not really the author's primary questions after all?

The second chapter, 'Lives in custody', is in its own terms a vivid discussion of another implicit question: should the lives of Aboriginal people on settlements and missions be seen as those solely of 'inmates', 'incarcerated people', or is there a deeper level of cultural identity beneath this which

marks their Aboriginality? Rowse examines the extensive and influential work of Charles Rowley, published in the 1970s, and work by Jeremy Long specifically on Aboriginal settlements, to question the Goffman-esque assumptions which inform these studies. He seems to be questioning the notion that 'institutionalization' should be seen as the decisive Aboriginal experience of the colonial encounter across the country, and to suggest that the perspectives arising from this approach are complicit with assimilationism. There are many issues which might be raised here. It has been common in certain circles to denounce Jeremy Long for his alleged role in subjecting desert-dwelling Aborigines to a new settlement regime in the 1960s, when he was employed as a patrol officer, an archetypal functionary of colonial rule. Fortunately, this fatuous charge is not levelled here; but a rather odder one is: that Rowley and Long 'preferred the insights of the liberal sociology of Erving Goffman to those of Australian anthropology' (p. 28). Given the period at which they were writing, it is arguable how much the insights of Australian anthropology could have actually contributed. Most of the decisive anthropological work which has redrawn the lineaments of Aboriginal Australia has been carried out and published since the 1970s (as is made clear elsewhere in the book). Certainly, a finely modulated analysis of social, cultural, and ritual life based on the earlier works of Strehlow, Berndt, Stanner and others could have been brought to bear on their analyses; but this would necessarily have been based on assumptions and implications, since most of this work was firmly located in the timeless anthropology of 'traditional life' which, as Rowse himself notes, was not in any sense concerned with the conditions of social and cultural reproduction of virtually all Aboriginal people in the mid twentieth century. In a very important way, the focus on institutionalization and its consequences in the work of Rowley (and others) opened up a new awareness of the 'real conditions of Aboriginal life' among many of the younger anthropologists struggling against the traditions of their elders. I include myself here: an untold part of this story is the difficulty of placing these issues onto the central anthropological agenda, in terms of the conventions of Ph.D. construction and disciplinary legitimation, throughout the 1970s and into the 1980s.

There seems to be a suggestion that a settlement is a settlement, irrespective of time and phase of development of the frontier; thus, when Hausfeld found a 'dissembled culture' at Woodenbong in 1956–60, and experienced a form of 'researcher control', Rowse remarks that this was a problem of 'field method' which apparently did not affect other anthropologists. There are two problems with this conclusion: Hausfeld was the resident manager of the settlement, hence in a specific relation of power and authority over the residents. And Woodenbong in the 1950s was a very different environment to, say, Papunya in the 1970s, simply because the people of Woodenbong had already experienced a century or so of intensive colonial disruption whereas the people of Papunya (and most other Central and Northern settlements where anthropologists worked) had had a far briefer and less penetrative connection with a 'settlement environment' (and

everything that goes with it). What Rowley was anxious to overcome was a racist tendency to explain Aboriginal peoples' 'lacks' with reference to their 'culture', understood as a kind of biological limitation. Of course the latter view was almost universal in Australia until very recently, and indeed may still be heard, *sotto voce*, in remote area pubs and townships. Rowse's critique of the limitations of the Goffman model is important and telling: in particular, the reproduction of kinship relations, and relations to country, were possible in Aboriginal settlements in contrast to other total institutions. Certainly the tendency to see Aboriginal people primarily as 'inmates' can be taken too far, and it is also true that Rowley did not understand the Aboriginal concern with land as a transcendent social and cultural value. However, if Rowley and Long believed 'that Aboriginal people would evolve towards bourgeois modernity', they were doing so in response to the wider Australian perceptions of the time – that Aborigines were inherently incapable of doing this.

Later in this chapter Rowse uses the memoirs of several Aboriginal writers to examine the experiences of life under various incarceral regimes. He then continues to examine the way in which families themselves became 'prisons' of a sort for many of the Aboriginal children removed forcibly from their own families in the name of 'improvement'. Finally, he discusses the problems of Aboriginal parents today where the young people in various ways refuse the authority of their elders. The linking together of these very different themes is insightful and interesting, but the conclusion, that 'we should be sensitive to the variations' of these institutional orders, (p. 53) hardly seems to relate to the basic theme of the chapter, or perhaps could have been its starting point.

The third chapter approaches the question of Aboriginal politics by considering a wide variety of manifestations of 'Aboriginality'. This discussion also has many positive features, but traverses so many issues (the meaning of terms such as 'tribes' and 'clans', the concept of community, factionalism, problems of national representation, gender issues) that it seems to fall into incoherence. Again, the conclusion is puzzling: 'positions' made available by a colonizing liberalism must be taken up within 'what we might call an Aboriginal politics of "tradition"'. What does this mean? Who must take up these positions? Who is 'we'? Does an awareness of Aboriginal difference, glossed in some contexts to 'tradition', exist only as an artefact of 'colonizing liberalism'? And, after all, what is that?

The sense of odd conjunctions is even stronger in Chapter Four, 'Art and identity'. Here the question of a 'subculture' of the dispossessed southern peoples, now identified by their preferred terms as Kooris, Nungas, Murris and Nyungars (rather than as Aboriginal, or indigenous, people) is presented through a discussion of an autobiographical book by Ruby Langford, *Don't Take Your Love to Town*. The discussion then switches briefly to the Aboriginal art market and the different roles for Aboriginal artists within its framework, then back to autobiographical writings to interrogate the notion that the maintenance of 'kinship' is unproblematic for many Aboriginal people. This chapter really has no conclusion, ending instead on the

subjecthood of the Aboriginal writer and the 'gendered contingencies of Koori experience'.

The final chapter seems to be concerned with the widespread Australian idea that Aboriginal people are inherent conservationists and natural allies of 'green' politics. This is an important issue, one which has received scattered but superficial coverage in contemporary writing (no doubt because it raises deep fissures within movements often taken to be coterminous). Again, this chapter touches on many interesting and important themes, from the career of H. C. Coombs (whose biographer Rowse has now become), to the role of aesthetics in totemism and Aboriginal fire-using practices. There is no space here to offer a detailed critique of this chapter, but it seems to me the least successful of those included, and the most confused. To give a brief example, Rowse draws up a table of oppositions between positive and negative conditions of country, which appears to counterpose Aboriginal understandings of 'wild' as a negative value with the positive non-Aboriginal evaluation of 'wilderness', among other apparent oppositions (p. 126). But the word 'wild' in Aboriginal languages generally doesn't exist at all as an equivalent to the Western concept. 'Wild' means something like 'angry', 'disordered', or, in the common Kriol equivalent, 'cheeky', as used for a person who is aggressive or a creature which is poisonous. Obviously, this range of meanings has little in common with the Western conception, which simply contrasts landscape which has been brought under direct human control for the purposes of production with that which has not. It is labouring a point to see what Aboriginal people want to do with landscape as 'humanizing' it: what they seek is to bring it into the relation of order which it is believed was its inaugural state, and thus its 'natural' state. The optimist rhetorical flourish at the end of the chapter brings the book to its conclusion, and then comes the Afterword, mentioned above, and the question of an ethical case against 'Aboriginalism'.

Even the most sympathetic reader would find it difficult to state clearly, by the end of this work, what it has been 'about'. In another case this might be a positive virtue, an example of the effects of a postmodern consciousness on a not-quite-postcolonial social order. But it is hard to see this work in that light. If the problem is 'to rethink Australia as a colonial nation with a postcolonial future' as the back-cover blurb proposes, we are already in the realms of confusion and intellectual disarray. Perhaps these are not Rowse's terms, and not his intention. The issues are extremely important, but need to begin with much more careful attention to just what 'colonialism' actually is and was, how it has operated to maintain and reinforce a certain form of control and suppression of Aboriginal people in Australia, and how this in turn will come into rhetorical play and finally discursive reality through the operations of a post-Mabo politics which seems likely to remain at best postcolonial, and almost certainly not, in Marcia Langton's terms, anti-colonial. Rowse seems to be reaching towards some of these issues, but this is not the work in which to find them articulated, let alone brought into the kind of scrutiny they so urgently deserve. Disappointing.

Notes on the contributors

LEONARD BELL is a Senior Lecturer in Art History at the University of Auckland, New Zealand. His *Colonial Constructs: European Images of Maori 1840–1914* was published by Auckland and Melbourne University Presses in 1992 . . . TONY BENNETT is Professor of Cultural Studies and Founding Director of the Institute for Cultural Policy Studies at Griffith University in Brisbane, Australia . . . VALDA BLUNDELL teaches in the Department of Sociology and Anthropology at Carleton University in Ottawa, Canada . . . SIMON DURING teaches English and Cultural Studies at the University of Melbourne, Australia . . . KEN GELDER is Principal Lecturer in English, Media, and Cultural Studies at De Montfort University in Leicester, England, and is on leave of absence from the University of Melbourne, Australia. He is currently working on a reader in 'subcultural studies'. His book on vampire film and fiction was published by Routledge in September 1994 . . . STEPHANIE GILBERT is an indigenous Australian who lectures at the Centre for Aboriginal and Torres Strait Islander Participation, Research and Development, James Cook University of Northern Queensland, Townsville, Australia. Her interests include the participation of indigenous people in higher education, the issues of Aboriginality and Aboriginal terms of reference. Her publications include 'The Effects of Colonisation On Aboriginal Families' in J. Mason, ed., *Australian Child Welfare Policy* . . . JANE M. JACOBS is a Research Fellow in the Department of Geography, University of Melbourne, Australia. Her research interests include the politics of cultural property and identity in Australian and British settings. She is currently writing a book on space and the 'post'-colonial . . . ELAINE KEILLOR, Assistant Director of Music at Carleton University in Ottawa, Canada, is the principal investigator for the Canadian Musical Heritage Society, which has published fifteen volumes of pre-1950 notated Canadian music to date. Among her latest publications is the book *John Weinzweig and His Music*, published by Scarecrow Press in 1994 . . . JAMES McDONALD is Associate Professor and Acting Chair of the First Nations Studies Programme and the Anthropology Programme at the University of Northern British Columbia in Prince George, B.C., Canada. His interests include the political economy of colonization and the decolonization of the contemporary world . . . GERALD R. McMASTER is Curator of Contemporary Indian Art at the Canadian Museum of Civilization in Ottawa, Hull, Québec, Canada. He curated and edited *INDIGENA: Perspectives of Indigenous Peoples on Five Hundred Years* in 1992 and was recently selected to be the Canadian Commissioner to the XLVI Venice Biennale . . . HELEN MOLNAR is a Senior Lecturer in Media, Literature, and Film at Swinburne University of Technology, Hawthorn, Victoria, Australia . . . RANGIHIROA PANOHO is Lecturer in the School of Design, Wellington Polytechnic, New Zealand . . . JEFFREY SISSONS is a Senior Lecturer in the Department of Social Anthropology at Massey University in Palmerston North, New Zealand. His book, *Te Waimana/The Spring of Mana: Tuhoe History and the Colonial Encounter*, was published

by University of Otago Press. His current research interests include tourism and national identity in the Cook Islands . . . ANN SULLIVAN is from the Nga Puhi tribe in New Zealand and is a Lecturer in Public Policy and Administration at the University of Waikato in Hamilton, New Zealand. Her research interests include comparative indigenous and ethnic politics . . . CHARLOTTE TOWNSEND-GAULT is a Curator in the new National Gallery in Ottawa, Canada.

Books Received from Publishers
Spring 1994 (through 1 July 1994)

Allison, Anne (1994) *Nightwork: Sexuality, Pleasure, and Corporate Masculinity in a Tokyo Hostess Club*, Chicago: University of Chicago Press, $14.95 Pbk, $37 Hbk.

Arebi, Saddeka (1994) *Women and Words in Saudi Arabia: The Politics of Literary Discourse*, New York: Columbia University Press, $17.50 Pbk, $49.50 Hbk.

Bell, Michael Mayerfeld (1994) *Childerley: Nature and Morality in a Country Village*, Chicago: University of Chicago Press, $32.50 Hbk.

Bohrer, Karl Heinz (1994) *Suddeness: On the Moment of Aesthetic Appearance*, New York: Columbia University Press, $55 Hbk.

Bourdieu, Pierre (1994) edited by Randal Johnson, *The Field of Cultural Production: Essays on Art and Literature*, New York: Columbia University Press, $15.50 Pbk.

Brooks, Peter (1994) *Psychoanalysis and Storytelling*, Oxford and Cambridge: Blackwell, $15.95 Pbk, $39.95 Hbk.

Butalia, Urvashi and Ritu Menon (1994) editors, *In Other Words: New Writing by Indian Women*, Boulder, CO: Westview, $14.94 Pbk, $49.95 Hbk.

Crissman, James K. (1994) *Death and Dying in Central Appalachia: Changing Attitudes and Practices*, Champaign: University of Illinois Press, $13.95 Pbk, $39.95 Hbk.

Dienst, Richard (1994) *Still Life in Real Time: Theory After Television*, Durham, NC: Duke University Press, $16.95 Pbk, $49.95 Hbk.

Doan, Laura (1994) editor, *The Lesbian Postmodern*, New York: Columbia University Press, $16.50 Pbk, $49.50 Hbk.

Ellis, David (1994) editor, *Imitating Art: Essays in Biography*, Boulder, CO: Westview Press, $22.95 Pbk, $66.50 Hbk.

Frow, John and Meaghan Morris (1993) editors, *Australian Cultural Studies: A Reader*, Champaign, University of Illinois Press, $17.50 Pbk.

Geyer-Ryan, Helga (1994) *Fables of Desire*, Oxford and Cambridge: Blackwell, $19.95 Pbk, $49.95 Hbk.

Grimm, Reinhold and Jost Hermand (1994) *High and Low Cultures: German Attempts at Mediation*, Madison: University of Wisconsin, $25 Hbk.

Guback, Thomas (editor), Dallas Smyth (author) (1994) *Counterclockwise: Perspectives on Communication*, Boulder, CO: Westview, $19.95 Pbk, $59.95 Hbk.

Hess, David J. (1994) *Samba in the Night: Spiritism in Brazil*, New York: Columbia University Press, $24.95 Hbk.

Hoynes, William (1994) *Public Television For Sale: Media, the Market, and the Public Sphere*, Boulder, CO: Westview, $18.95 Pbk, $55 Hbk.

Hufford, Mary (1994) editor, *Conserving Culture: A New Discourse on Heritage*, Champaign: University of Illinois Press, $14.95 Pbk, $37.50 Hbk.